Put any picture you want on any state book cover. Makes a great gift. Go to www.america24-7.com/customcover

Mom —

Our "Hoosier Heritage" all started with you and thanks so much for a strong foundation

Love, Greg
Christmas '06

JASPER
County Road 500 North slips over a hill on its way from Jasper to Ireland. Southern Indiana is characterized by a welter of knobs (steep hills), bottomlands, gorges, and valleys.
Photo by Andrew Otto, The Herald

Indiana 24/7 is the sequel to *The New York Times* bestseller *America 24/7* shot by tens of thousands of digital photographers across America over the course of a single week. We would like to thank the following sponsors, the wonderful people of Indiana, and the talented photojournalists who made this book possible.

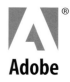

Adobe

LONDON, NEW YORK, MUNICH, MELBOURNE, and DELHI

Created by Rick Smolan and David Elliot Cohen

24/7 Media, LLC
PO Box 1189
Sausalito, CA 94966-1189
www.america24-7.com

First Edition, 2004
04 05 06 07 08 10 9 8 7 6 5 4 3 2 1

Published in the United States by
DK Publishing, Inc.
375 Hudson Street
New York, NY 10014

DK Publishing, Inc. offers special discounts for bulk purchases for sales promo-
tions or premiums. Specific, large-quantity needs can be met with special
editions, personalized covers, excerpts of existing guides, and corporate
imprints. For more information, contact:

Special Markets Department
DK Publishing, Inc.
375 Hudson Street
New York, NY 10014
Fax: 212-689-5254

Cataloging-in-Publication data is available
from the Library of Congress
ISBN 0-7566-0054-5

Printed in the UK by Butler & Tanner Limited

First printing, October 2004

POSEY COUNTY
Ground fog meets dawn in Posey County.
Separated from Illinois by the Wabash River
and from Kentucky by the Ohio River, the
county occupies Indiana's southwestern-
most corner.
Photo by Denny Simmons

INDIANA 24/7

24 Hours. 7 Days.
Extraordinary Images of
One Week in Indiana.

Created by Rick Smolan and David Elliot Cohen

DK Publishing

About the America 24/7 Project

A hundred years hence, historians may pose questions such as: What was America like at the beginning of the third millennium? How did life change after 9/11 and the ensuing war on terrorism? How was America affected by its corporate scandals and the high-tech boom and bust? Could Americans still express themselves freely?

To address these questions, we created *America 24/7*, the largest collaborative photography event in history. We invited Americans to tell their stories with digital pictures. We asked them to shoot a visual memoir of their lives, families, and communities.

During one week in May 2003, more than 25,000 professionals and amateurs shot more than a million pictures. These images, sent to us via the Internet, compose a panoramic yet highly intimate view of Americans in celebration and sadness; in action and contemplation; at work, home, and school. The best of these photographs, more than 6,000, are collected in 51 volumes that make up the *America 24/7* series: the landmark national volume *America 24/7*, published to critical acclaim in 2003, and the 50 state books published in 2004.

Our decision to make *America 24/7* an all-digital project was prompted by the fact that in 2003 digital camera sales overtook film camera sales. This techno-logical evolution allowed us to extend the project to a huge pool of photographers. We were thrilled by the response to our challenge and moved by the insight offered into American life. Sometimes, the amateurs outshot the pros—even the Pulitzer Prize winners.

The exuberant democracy of images visible throughout these books is a revela-tion. The message that emerges is that now, more than ever, America is a supersized idea. A dreamspace, where individuals and families from around the world are free to govern themselves, worship, read, and speak as they wish. Within its wide margins, the polyglot American nation manages to encompass an inexplicably complex yet workable whole. The pictures in this book are dedicated to that idea.

—*Rick Smolan and David Elliot Cohen*

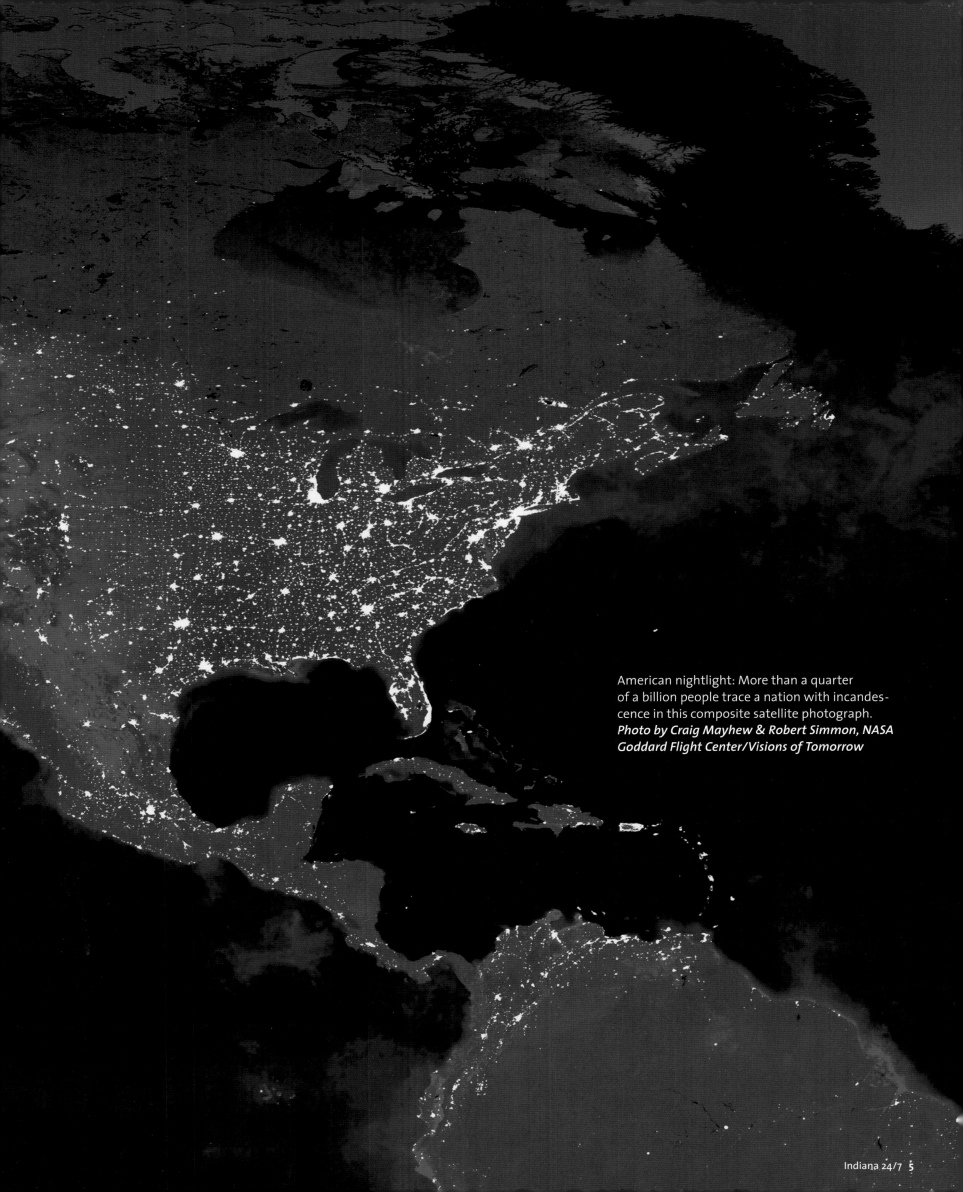

American nightlight: More than a quarter of a billion people trace a nation with incandescence in this composite satellite photograph.
Photo by Craig Mayhew & Robert Simmon, NASA Goddard Flight Center/Visions of Tomorrow

The Heartland's Mirror

By Dan Carpenter

Nobody exactly knows how "Hoosier" originated as a nickname for Indiana denizens, but a common theory is that it represents an early settler's muffled response to a knock at the cabin door: "Who's yar?"

Not much to build a cultural heritage on. But the homely handle is serendipitously apt when applied to perception and reality through history.

Who's there? Who's here? Who are Hoosiers, and how do they see themselves and their relatively modest space between the Great Lakes and the Ohio River?

Sometimes, it's as others see them, though Indianans generally don't kid themselves that the mirrors held up to the heartland by Hollywood, Madison Avenue, patronizing politicians, and a sentimentalized past are anything but distorted.

Sure, Indiana is agricultural, but it's more industrial. Of course, it's not the ethnic stew of the coasts; but it's a thick pot in its own right, from Slavic/Hispanic/African-American Gary to the Old Germanic vestiges along the Ohio—not to mention the descendants of its namesake people. Conservative? The state goes reliably Republican in presidential elections and trims its sails to evangelical Christianity in many aspects of civic life; but Democrats enjoy a full share of the state's elective offices at all levels. A highly discernible rainbow of faiths ranges from Catholic to Amish to Tibetan Buddhist.

As is amply illustrated in the palimpsest of pictures on these pages, Indiana may be exactly everything the stranger at the cabin door came looking for, unless he were to hang around for a closer inspection.

GREENFIELD
A big rig barrels past wheat and soybean farms on Interstate 70, which runs for 157 miles across the center of Indiana. The state is traversed by six interstate highways.
Photo by Mike Fender, The Indianapolis Star

The picturesque rural vitality that is the state's most flattering image in the world's eyes is real enough, especially in the rough-hewn woodlands of Brown County to the south and the oceanic prairie farms in the northern segment below the Chicagoland rust belt. Yet the countryside, like the factory economy, is an endangered treasure. The EPA will attest that few states have been less protective of their soil, air, and water.

The most conspicuous images in outsiders' minds—small-town high school basketball and a singular annual auto race—are valid, too. But both sports have thrived through adaptation, with the small schools of *Hoosiers* movie fame no longer being pitted against the Goliaths (which rarely lose in real life) and the Indy 500 now one of three yearly speed events, all moneymakers.

Indiana is not renowned for intellectual adventure, but great and thorny minds have sprouted in this temperate climate. Some, like the poet James Whitcomb Riley and the pharmaceutical pioneer Eli Lilly, may well be celebrated perpetually; others, such as socialist champion Eugene Debs and sex researcher Alfred Kinsey, find more honor at a distance. All attest to the fertility of this surprising hybrid of a state, credited by former Vice President Dan Quayle for his "traditional family values" and by irrepressible novelist Kurt Vonnegut for "my crazy ideas about socialism and pacifism."

Believe them both. A little over a decade from their bicentennial, Hoosiers are still asking not just who's yar, but what's. And the answer is, a lot more than all you expect.

Indianapolis native Dan Carpenter *has been a columnist for* The Indianapolis Star *since 1984. He also writes poetry and short stories. He and his wife, Mary, live in Indianapolis with children Patrick and Erin.*

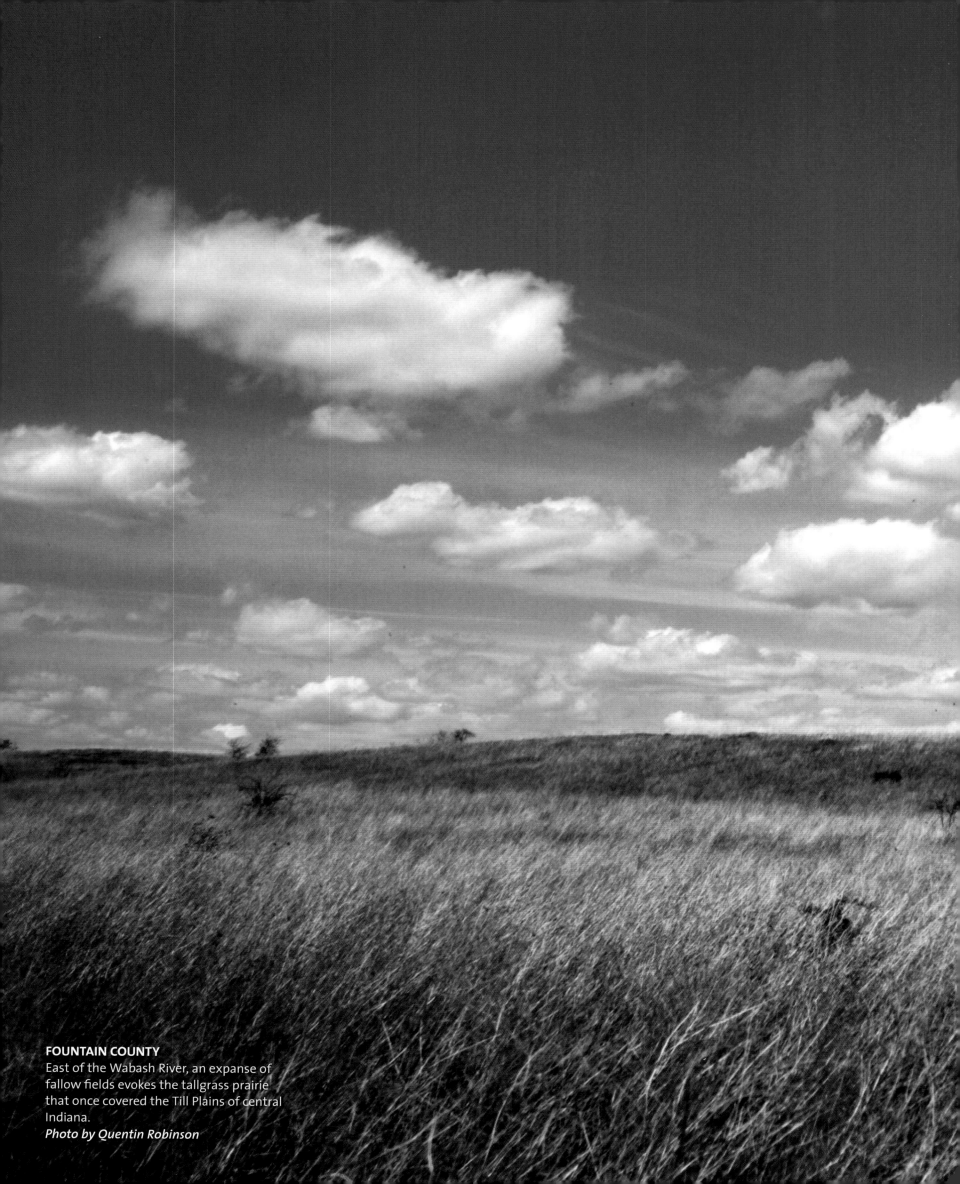

FOUNTAIN COUNTY
East of the Wabash River, an expanse of
fallow fields evokes the tallgrass prairie
that once covered the Till Plains of central
Indiana.
Photo by Quentin Robinson

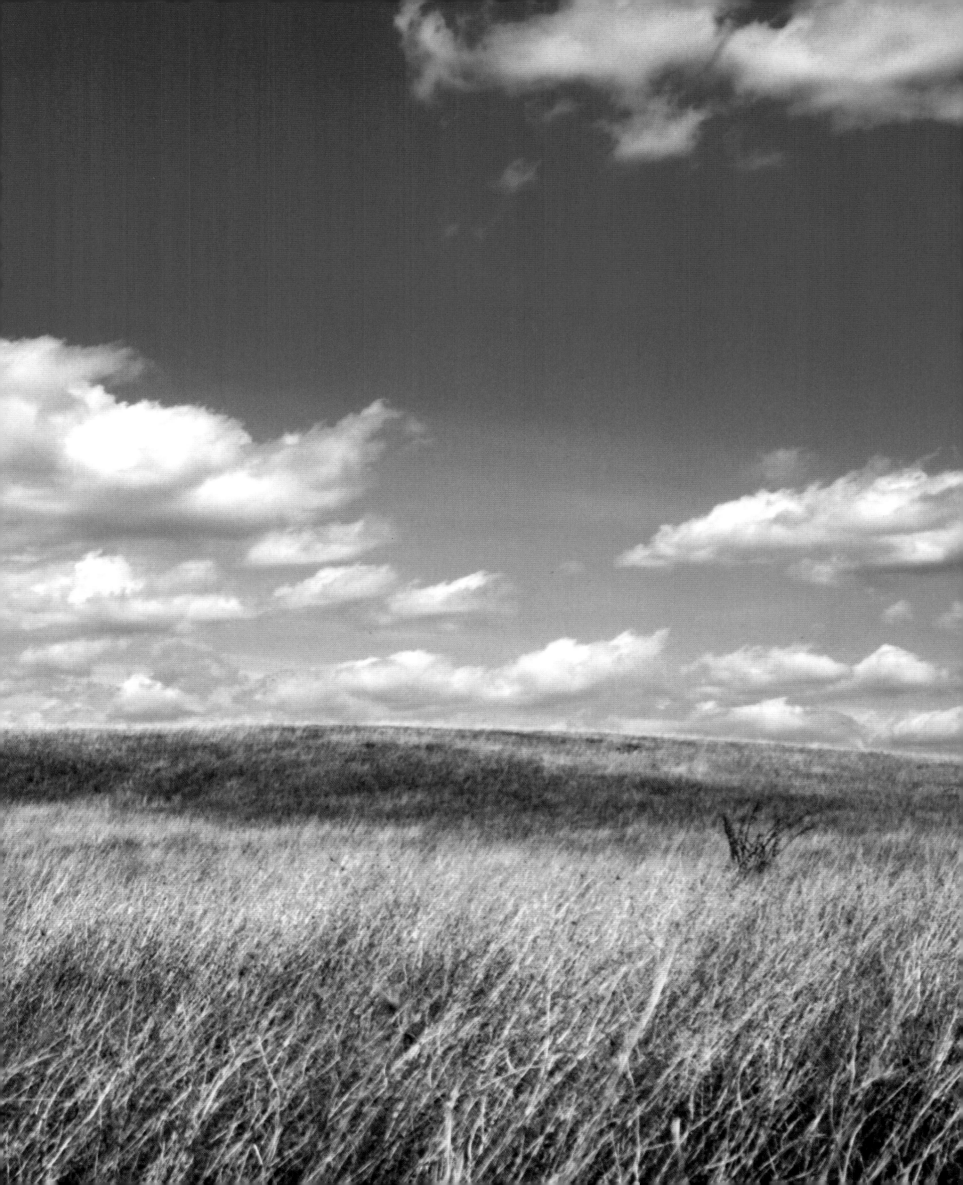

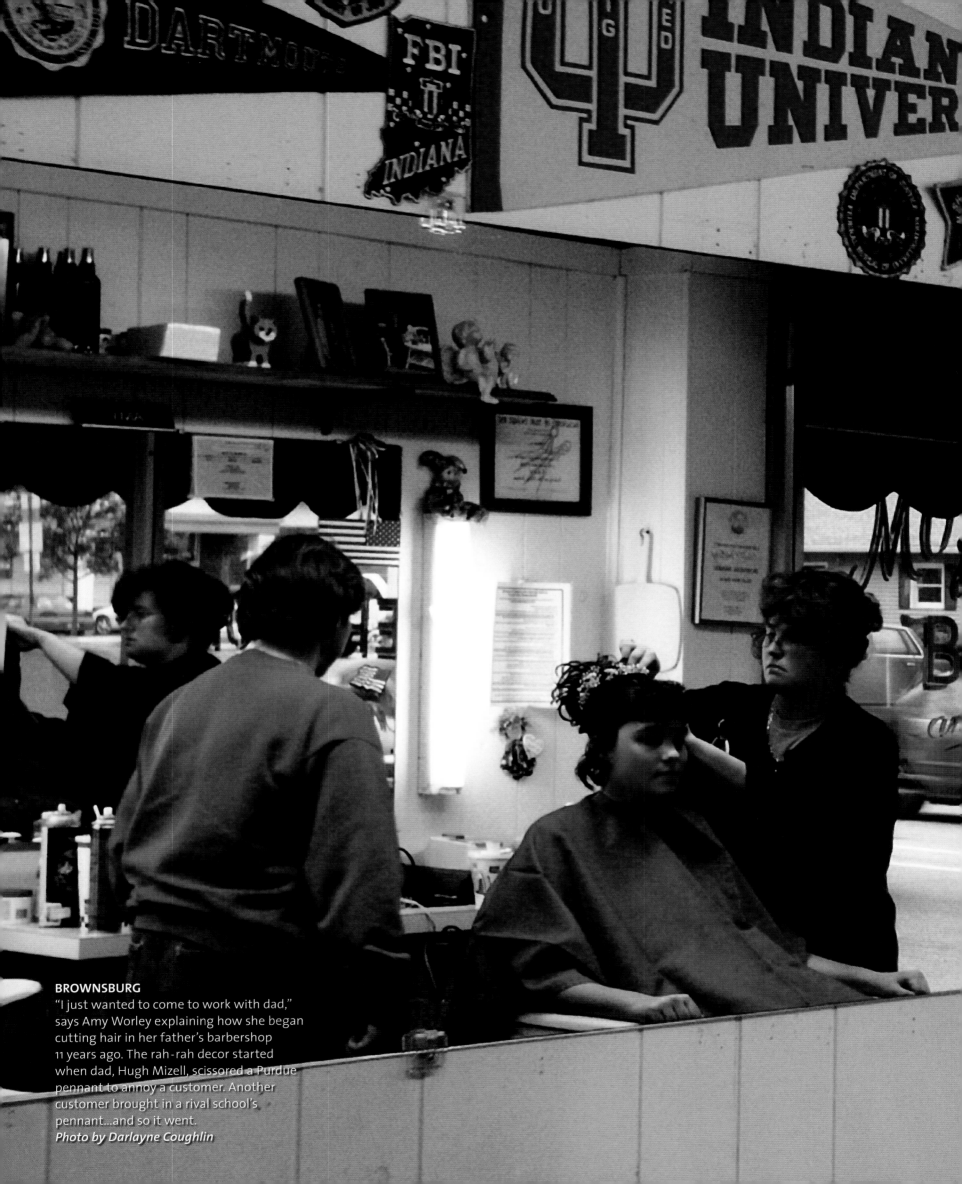

BROWNSBURG
"I just wanted to come to work with dad," says Amy Worley explaining how she began cutting hair in her father's barbershop 11 years ago. The rah-rah decor started when dad, Hugh Mizell, scissored a Purdue pennant to annoy a customer. Another customer brought in a rival school's pennant...and so it went.
Photo by Darlayne Coughlin

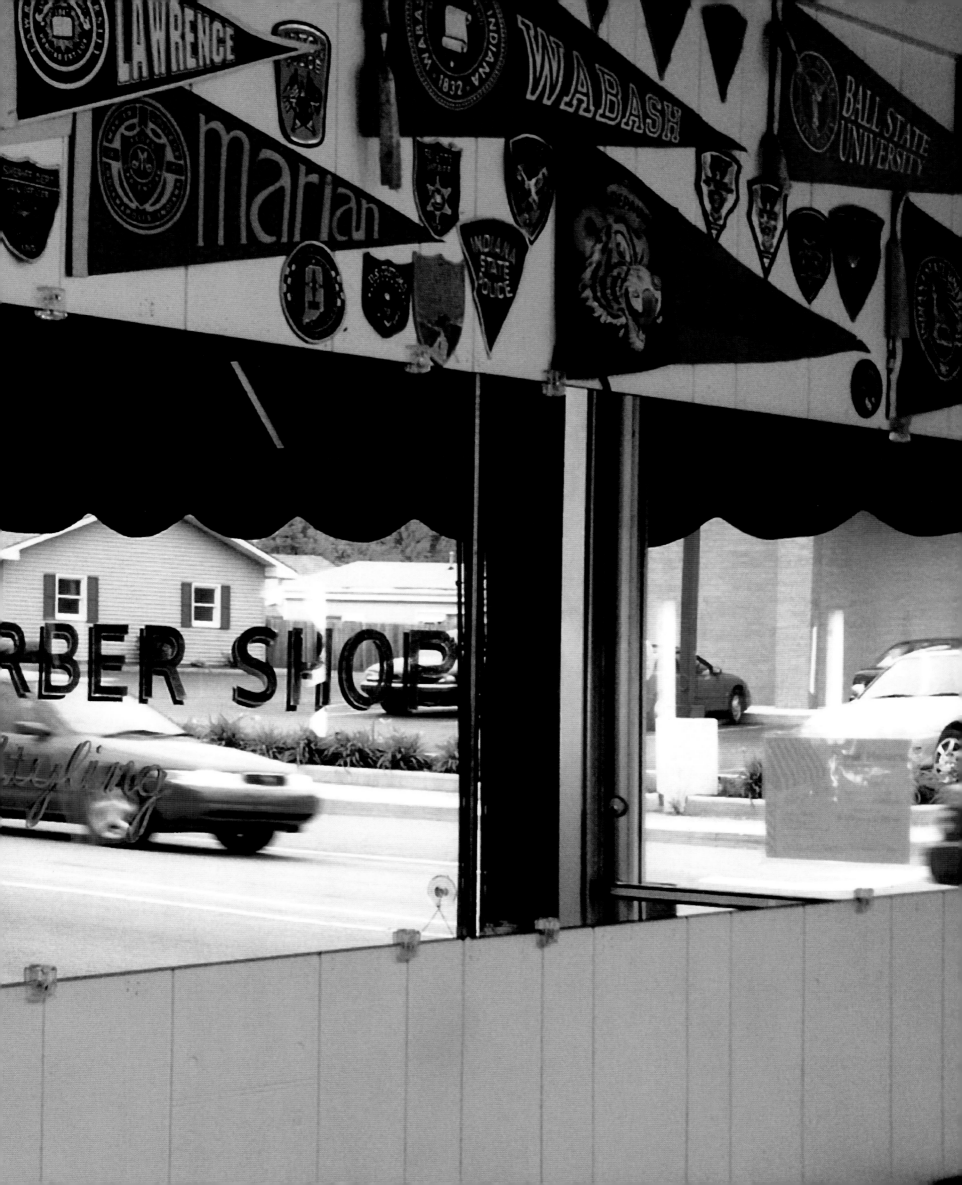

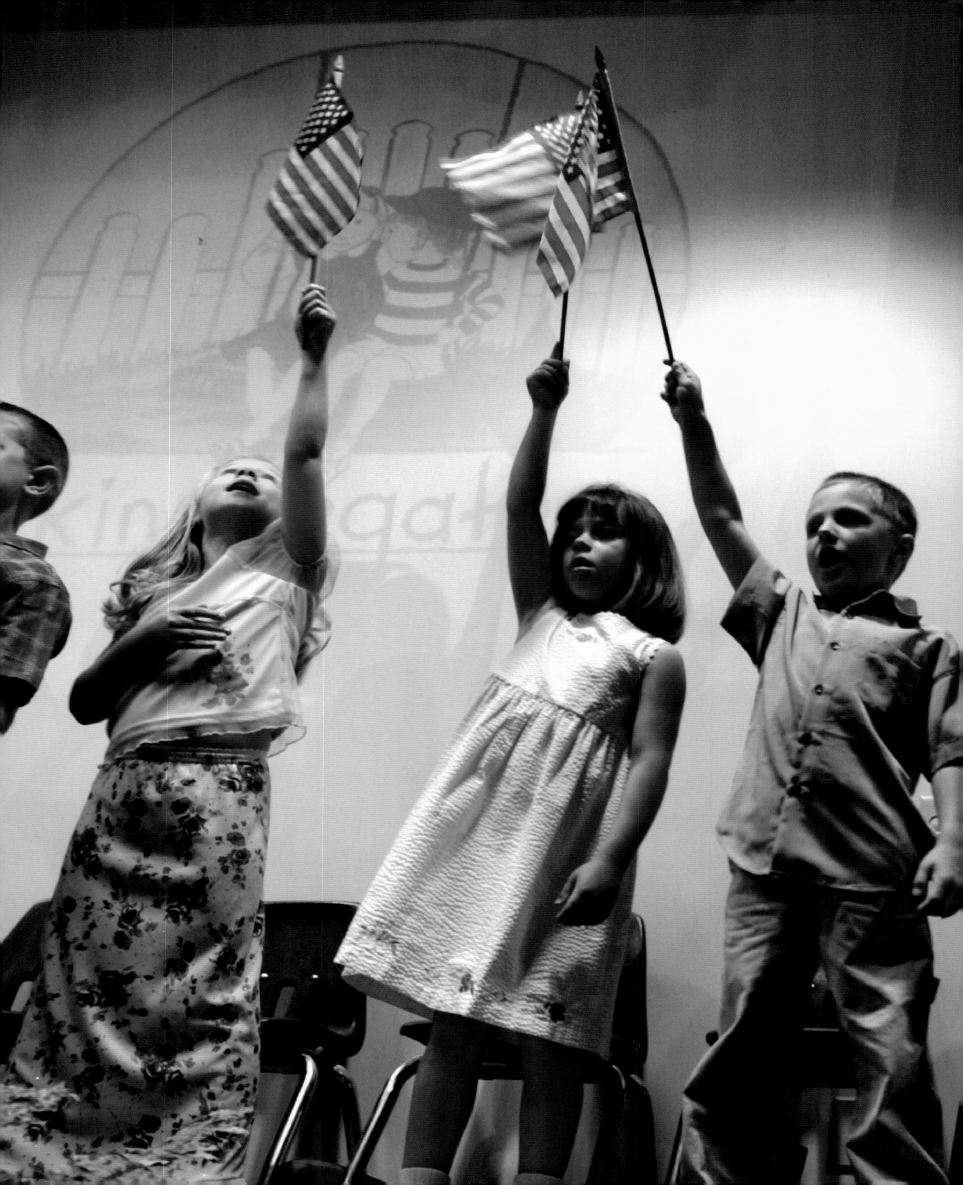

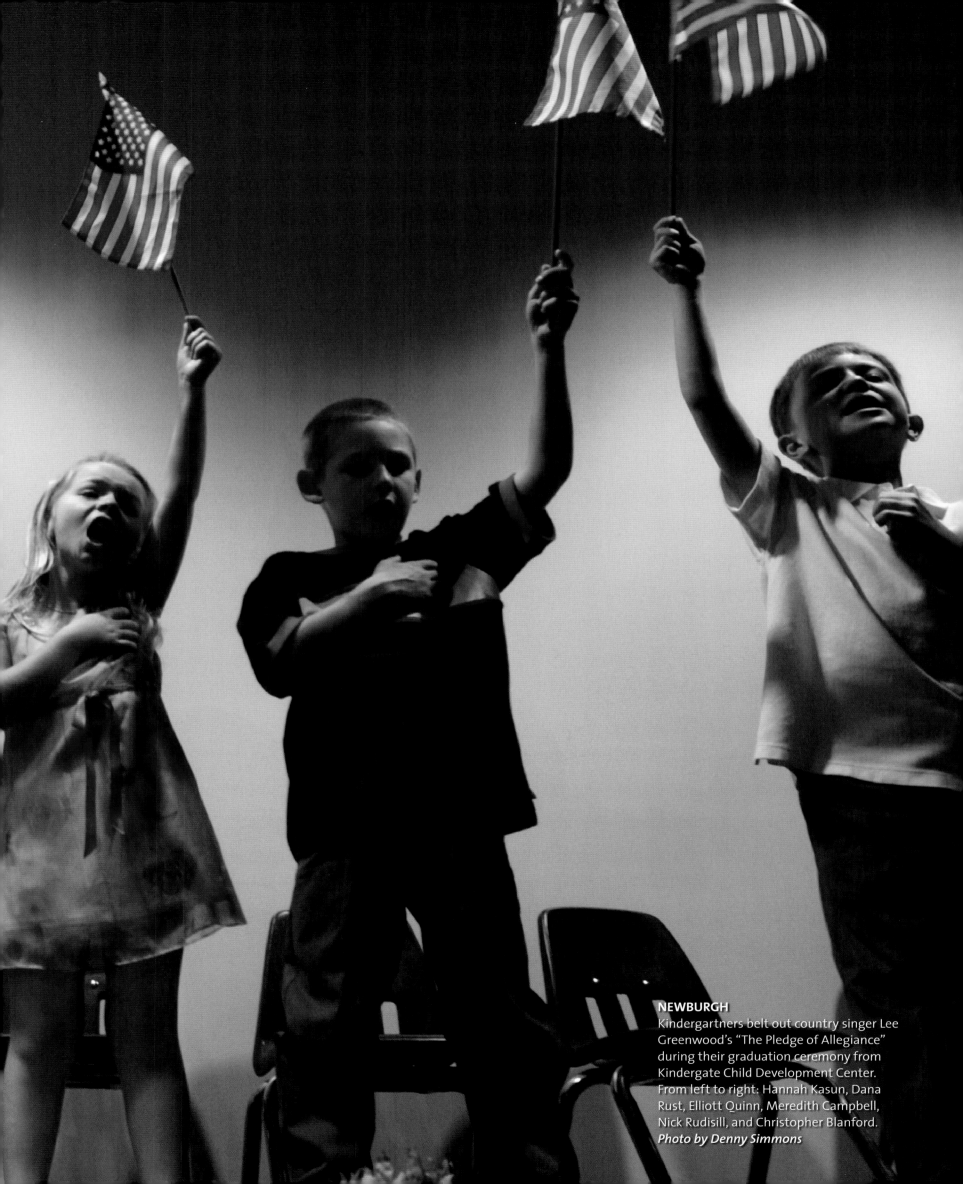

NEWBURGH
Kindergartners belt out country singer Lee Greenwood's "The Pledge of Allegiance" during their graduation ceremony from Kindergate Child Development Center. From left to right: Hannah Kasun, Dana Rust, Elliott Quinn, Meredith Campbell, Nick Rudisill, and Christopher Blanford.
Photo by Denny Simmons

RISING SUN
At the end of Main Street, a 12-by-18-foot steel mesh American flag hangs in a park pavilion overlooking the Ohio River. Since it was unfurled after 9/11, the flag has gone dark only once, when the annual Christmas tree displaced it. There was such an uproar in Rising Sun that the flag is now permanent.
Photo by Jeremy Hogan

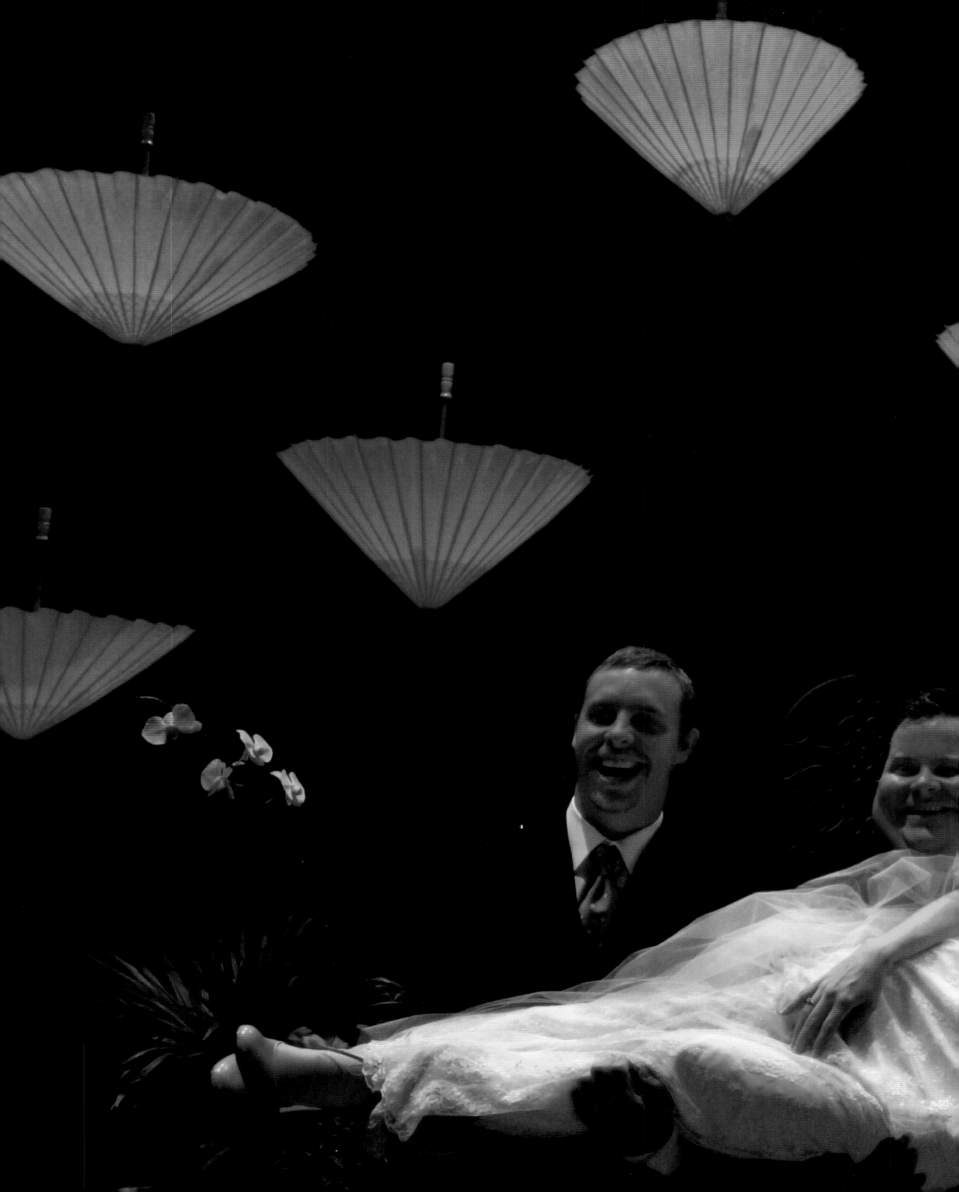

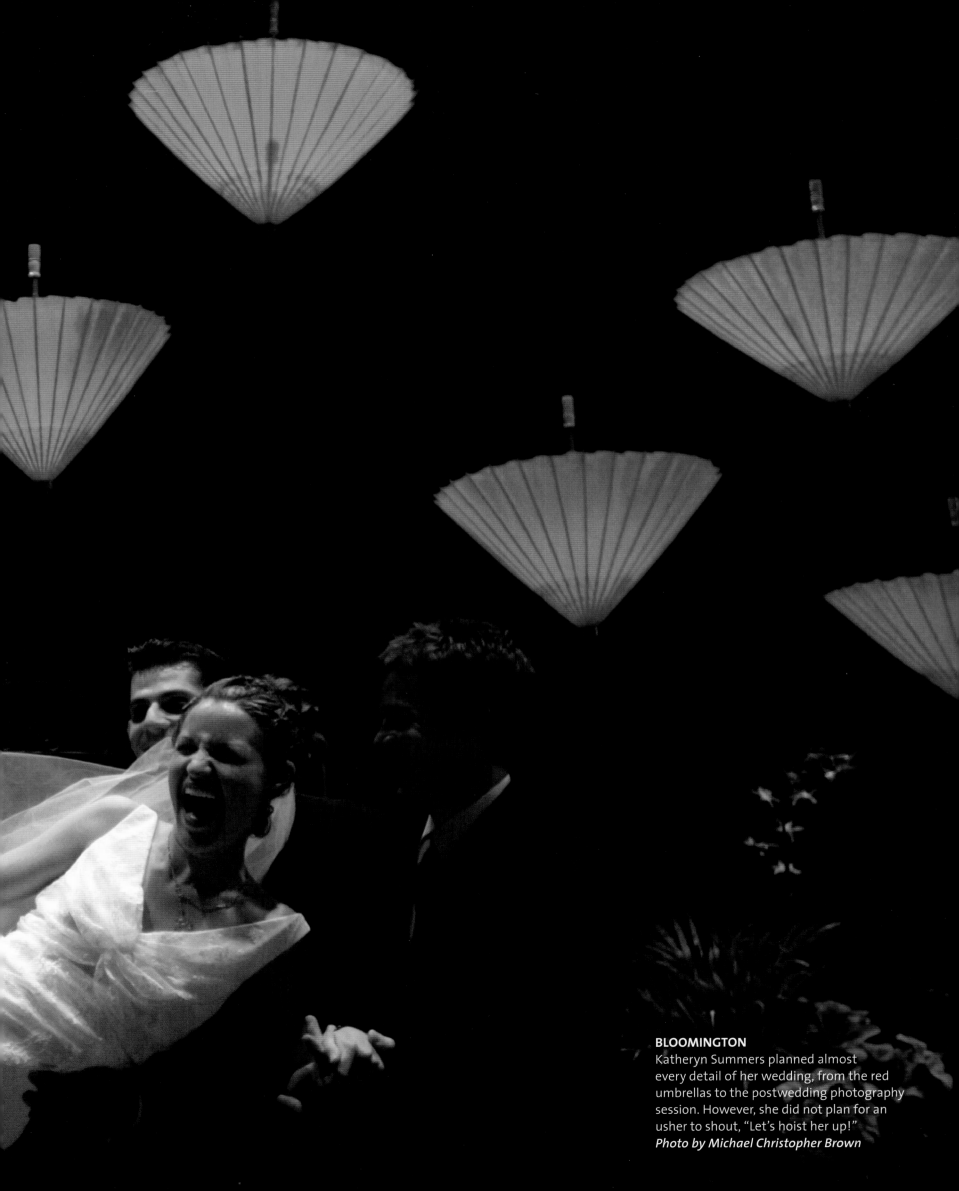

BLOOMINGTON
Katheryn Summers planned almost every detail of her wedding, from the red umbrellas to the postwedding photography session. However, she did not plan for an usher to shout, "Let's hoist her up!"
Photo by Michael Christopher Brown

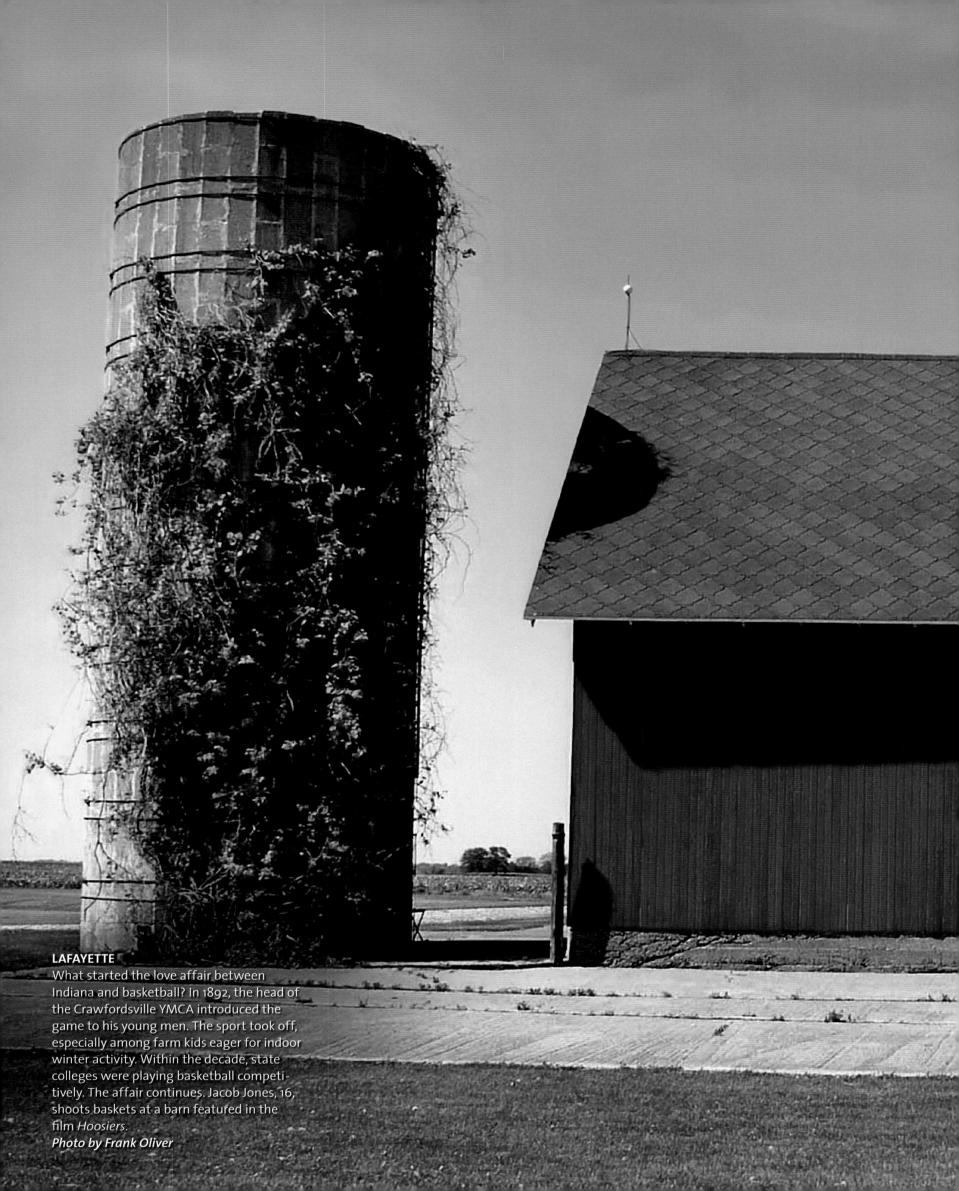

LAFAYETTE

What started the love affair between Indiana and basketball? In 1892, the head of the Crawfordsville YMCA introduced the game to his young men. The sport took off, especially among farm kids eager for indoor winter activity. Within the decade, state colleges were playing basketball competitively. The affair continues. Jacob Jones, 16, shoots baskets at a barn featured in the film *Hoosiers*.

Photo by Frank Oliver

Hearth & Home

EVANSVILLE

Merrick Barker suffers from a severe seizure disorder, is autistic, and has not spoken since he was 15 months old. Grandmother Sue Swank takes care of the 4-year-old and his sister Jasmine, 11. In December 2003 Merrick will receive a basal nerve implant, which, it is hoped, will alleviate his seizures.

Photo by Kevin Swank

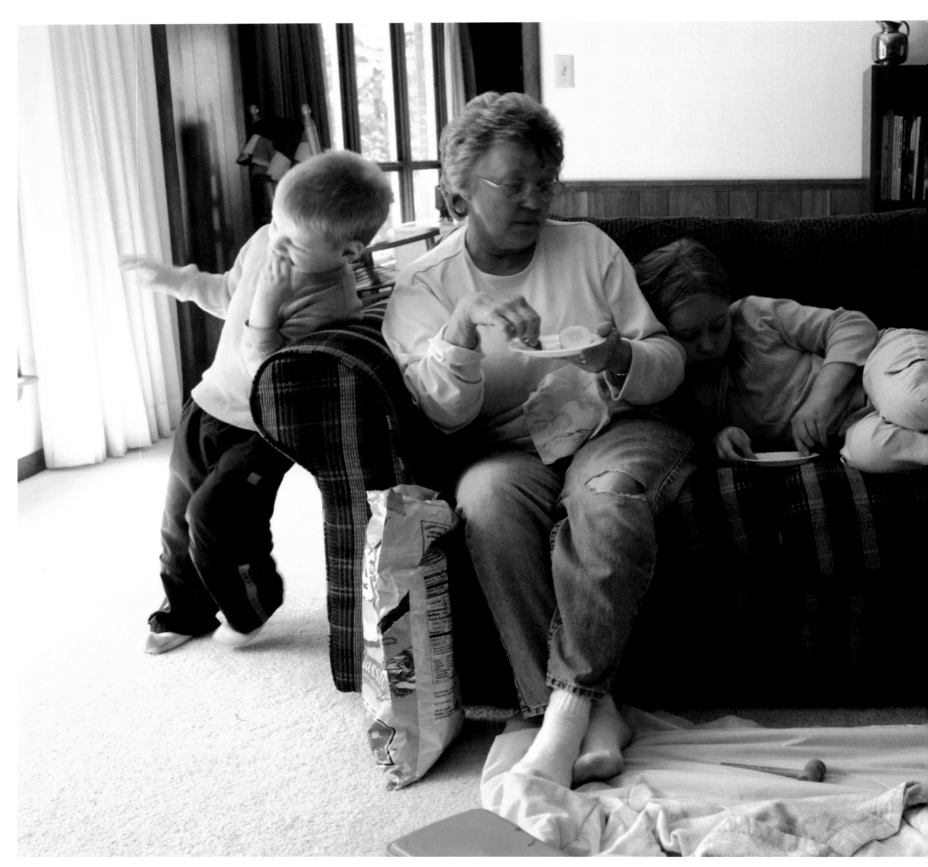

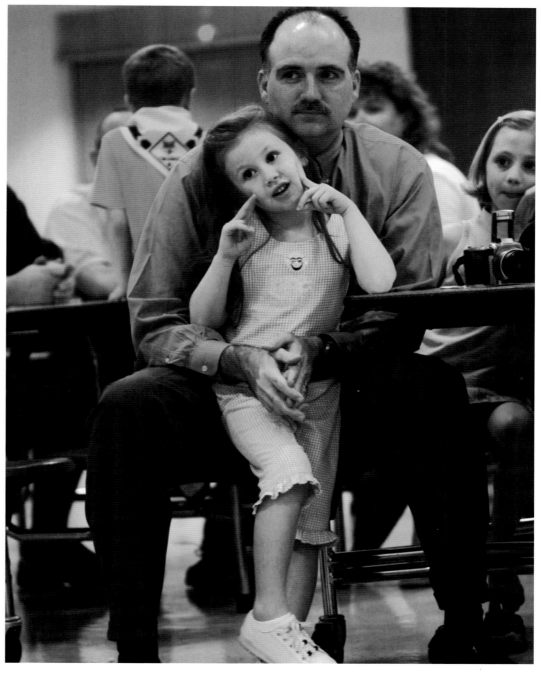

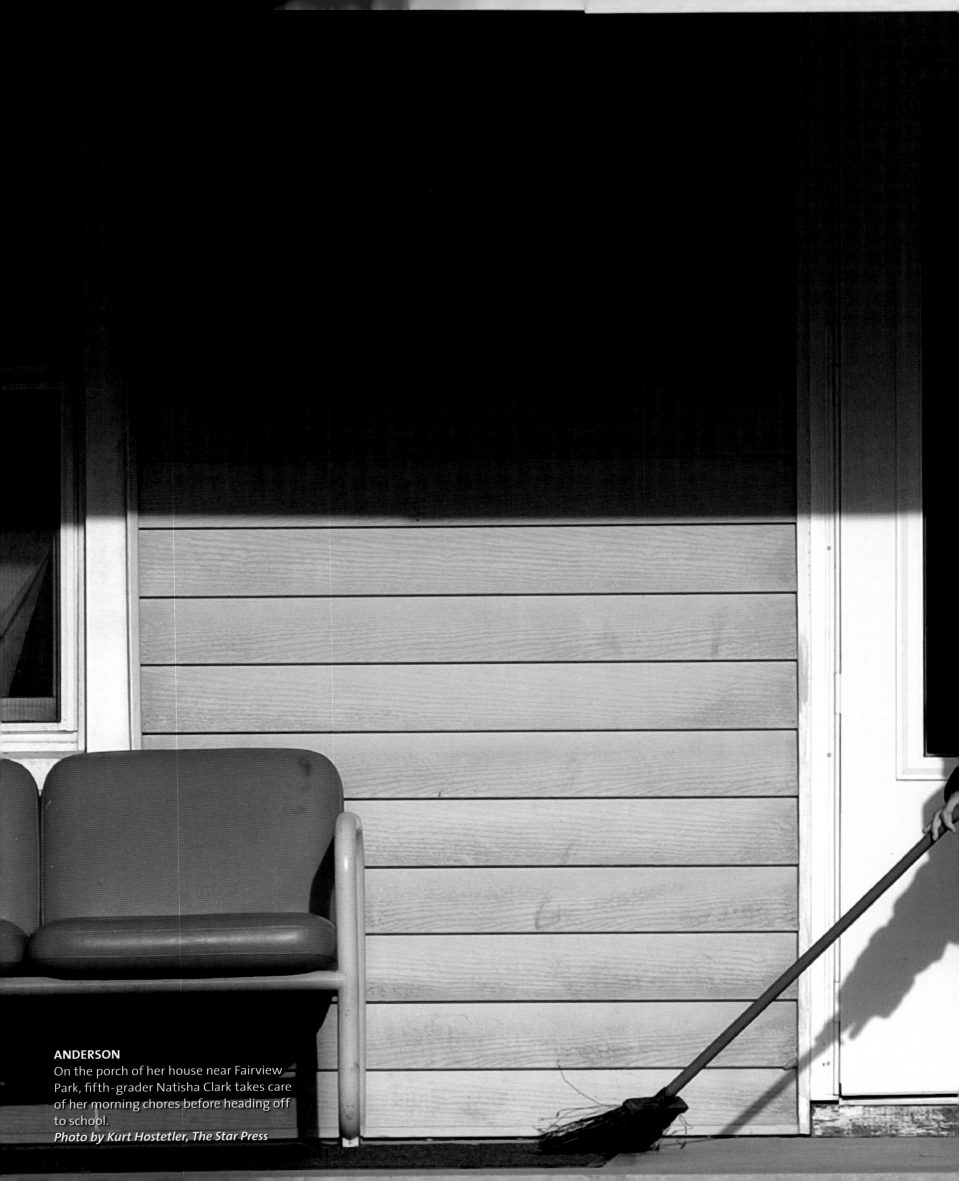

ANDERSON
On the porch of her house near Fairview Park, fifth-grader Natisha Clark takes care of her morning chores before heading off to school.
Photo by Kurt Hostetler, The Star Press

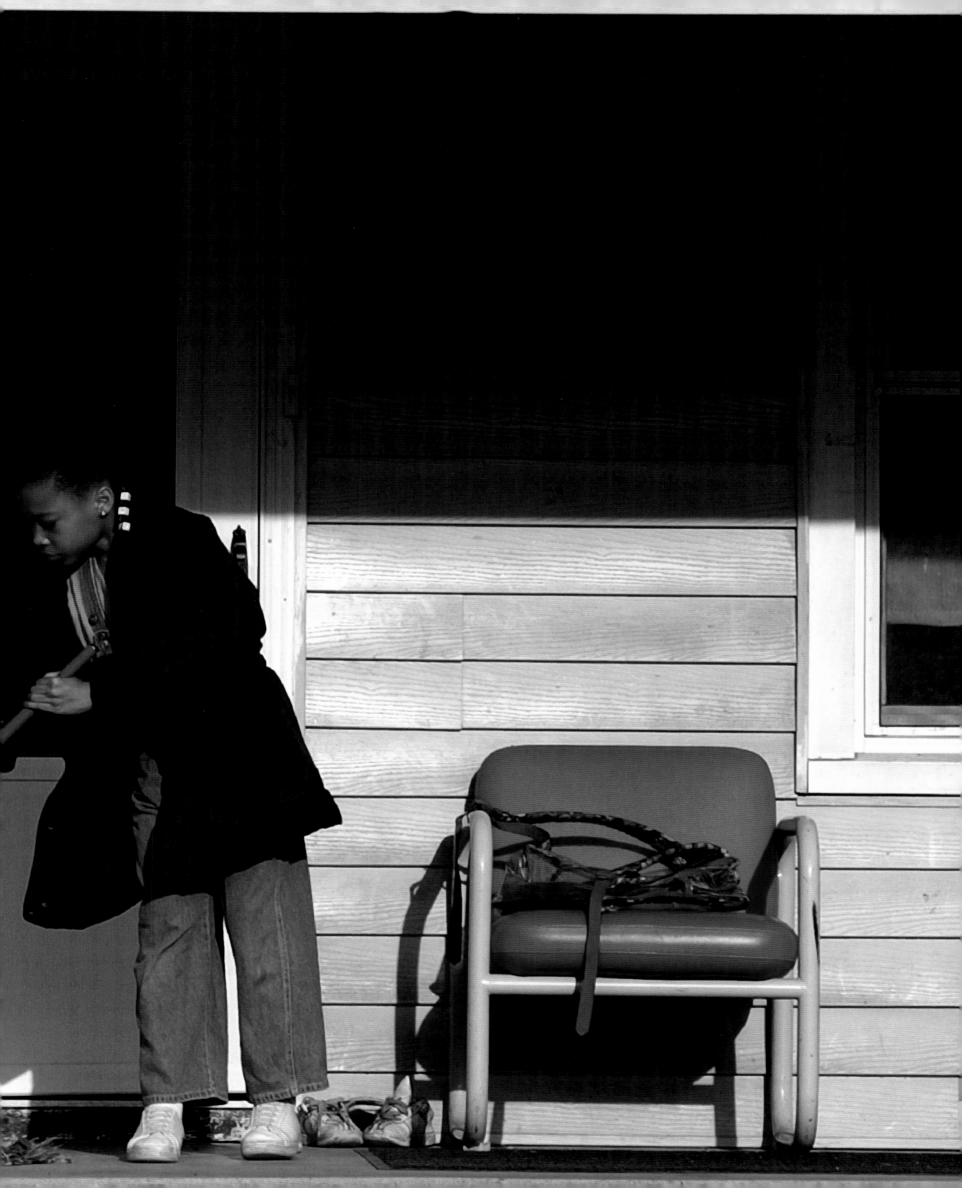

BLOOMINGTON

Once a month, 4-year-old twins Rachel and Ryan Huemann join their mom Lourdes, a pediatrician, for their favorite shopping trip: to Sam's Club for pet supplies. The kids look forward to the outing because they get to ride the big cart with the dog food, cat food, and kitty litter.
Photo by Jeremy Hogan

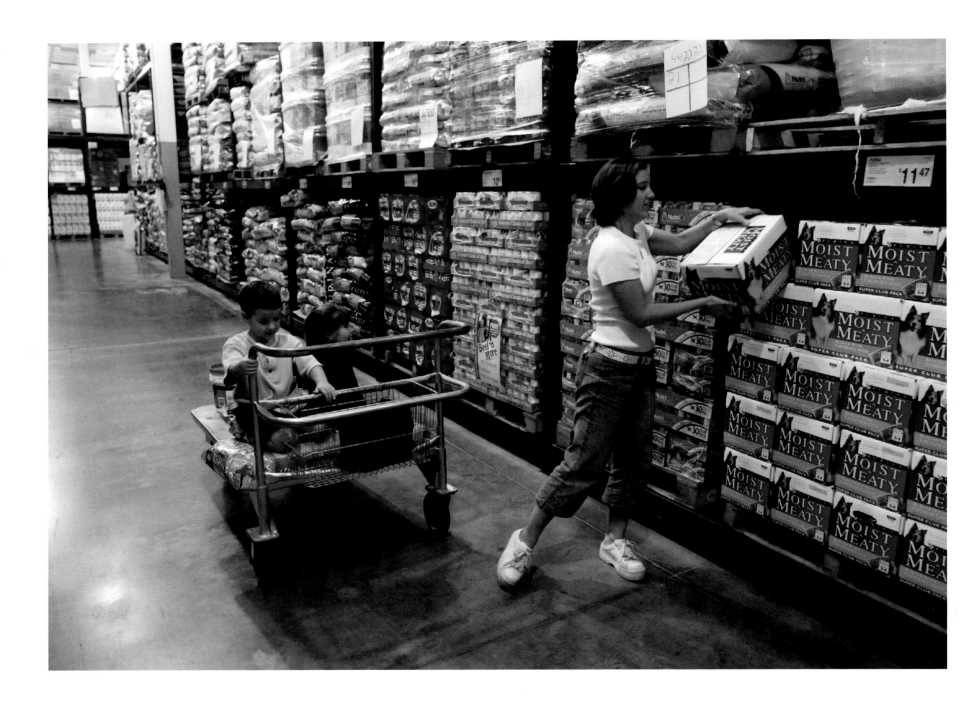

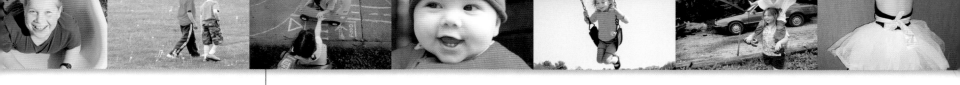

EVANSVILLE

Annie McCool, 5, hands Ethan Withrow, 3, an invisible Happy Meal at this make-believe McDonald's drive-thru, which Ethan's father Bret drew in their driveway. Drive-thru purchases account for more than 50 percent of fast food sales in the U.S.

Photo by Vincent Pugliese

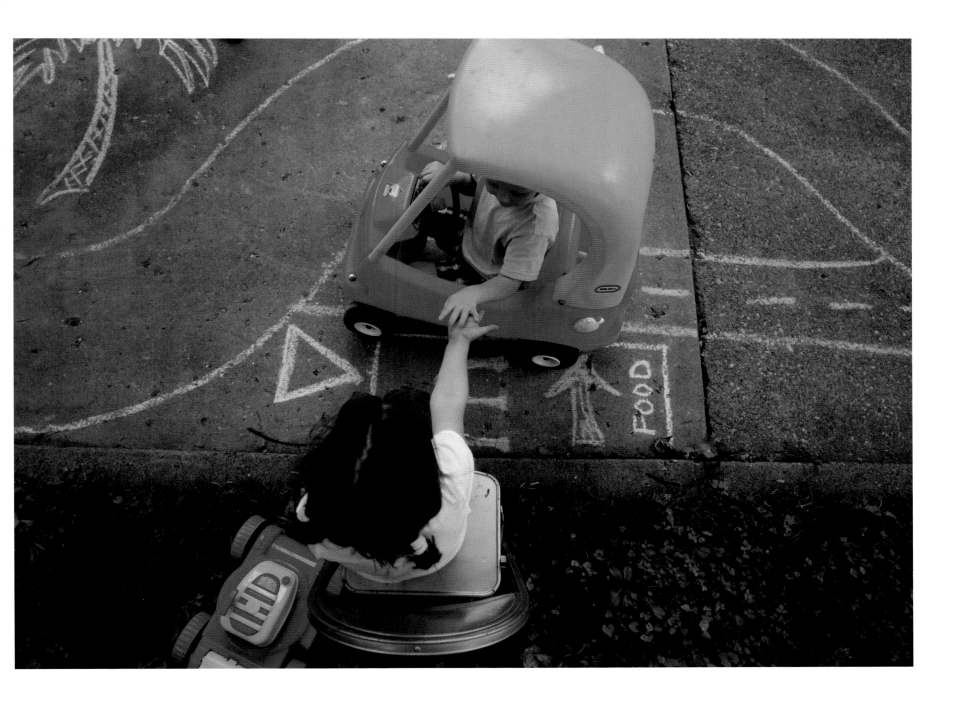

EVANSVILLE
Five is enough. When the Morses take their
year-old quadruplets and older son out to
eat, logistics are paramount. Mom Kelli
steers Sierra and Landon toward a table at
the Golden Corral. That leaves Dawson, on
the left, his sister Briann, and 3-year-old
Bryce. Handling them are dad Jonathan,
Kelli's parents, and her aunt. In sum: one
adult per child.
Photo by Elizabeth Fisco

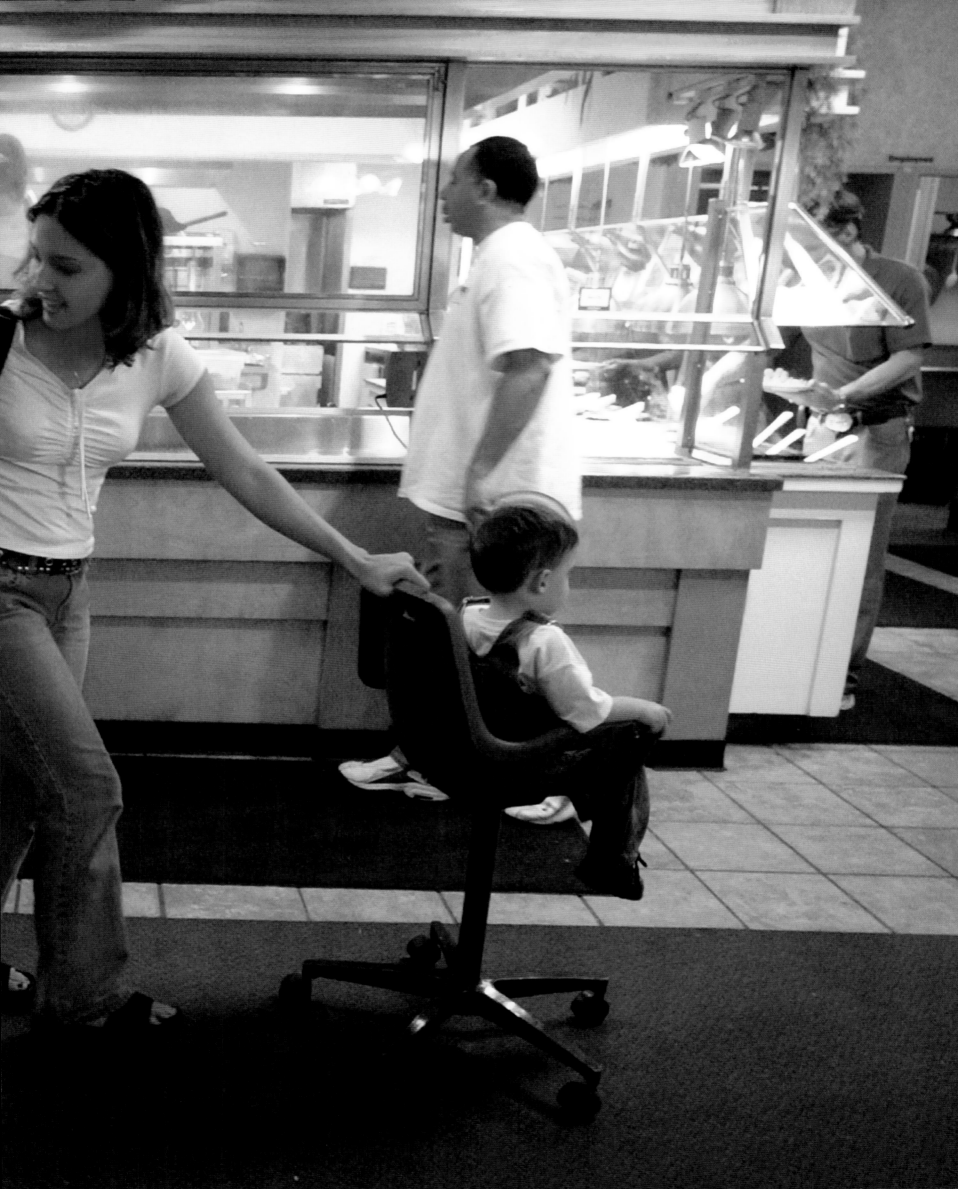

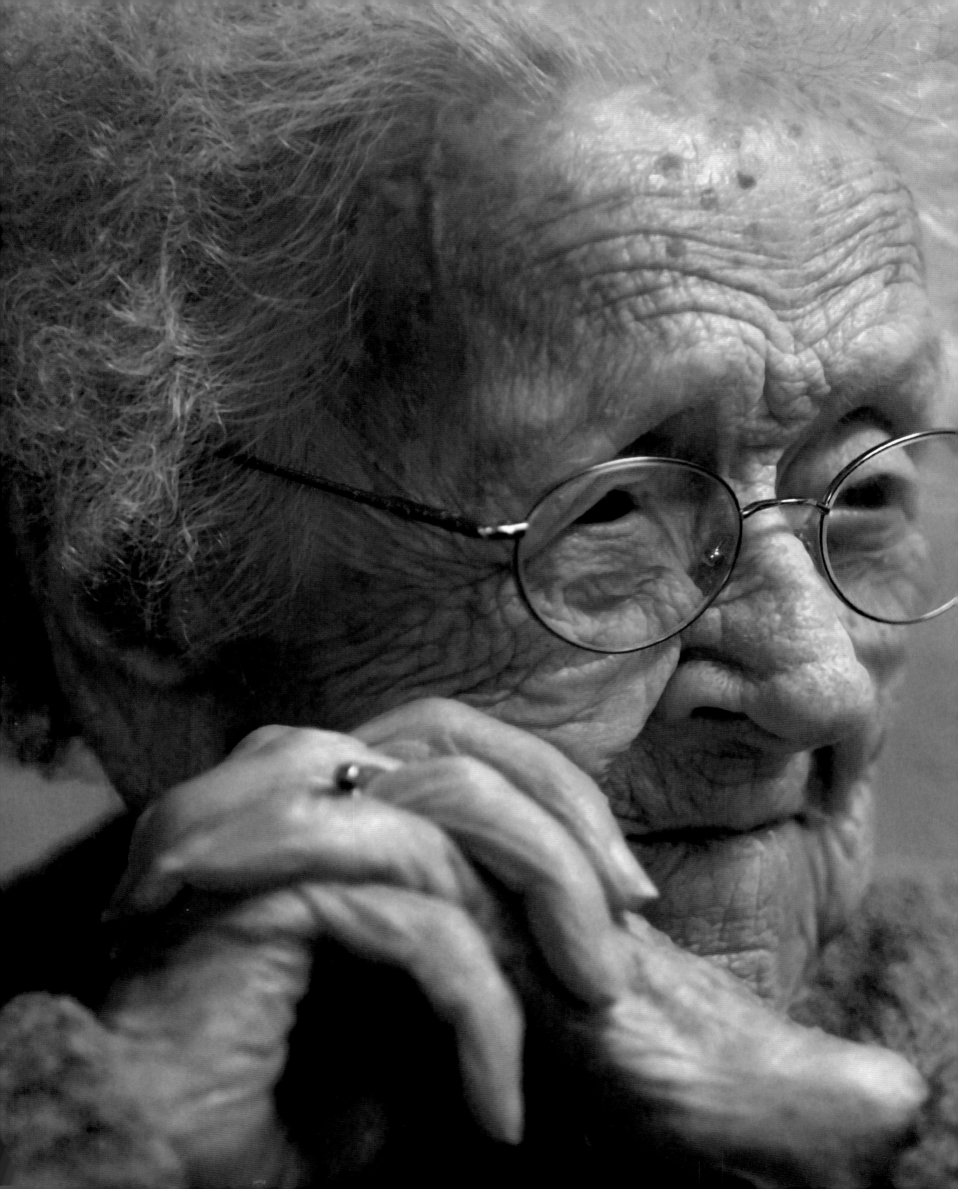

PETERSBURG

Minnie Kearby, 110, has seen three centuries and presides over four generations of offspring. In 1920, she voted in the first presidential election after the passage of the 19th Amendment. An independent woman, she lived in her own house until moving into the Petersburg Healthcare and Rehab Center at age 105.

Photo by David Pierini, The Herald

WADESVILLE

Five of the nine Koester kids join dad Raymond for breakfast, served up by mom Teresa. The homeschooled children take classes from Bob Jones University via satellite TV. They also do household chores and help out around the farm. And it all runs smoothly, right? "By the grace of God," says Teresa. "I was not born organized."

Photo by Denny Simmons

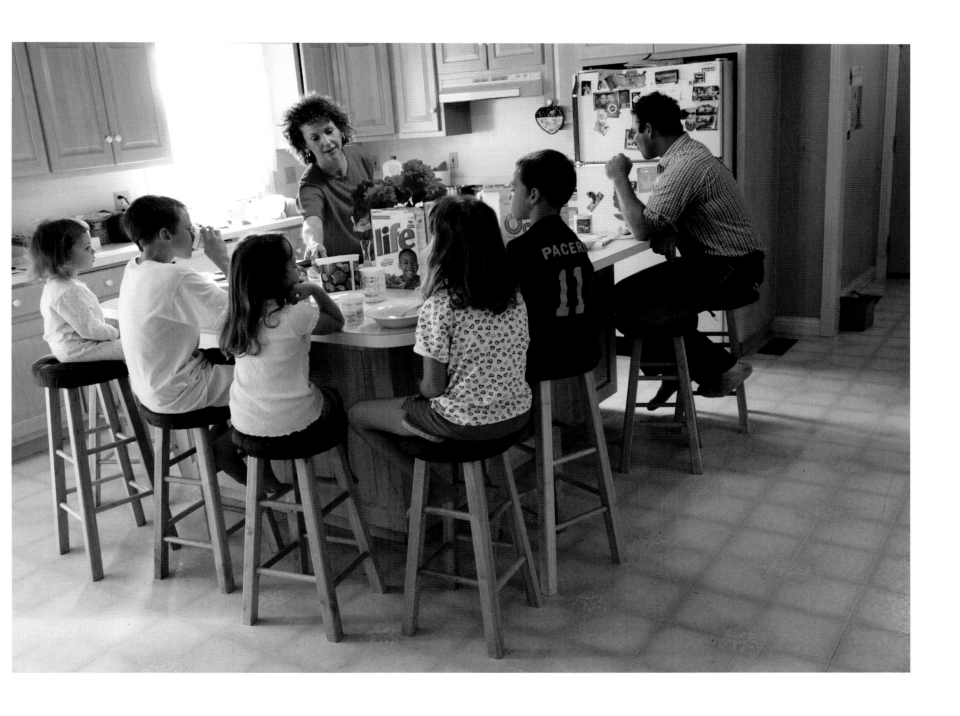

ANDERSON
Perched on feed grain sacks, Chase Earlywine and
Karley Fridley, both 5, pursue literary interests
while waiting for their siblings to finish a practice
ride with the Ruff Ryders, a local 4-H horse and
pony club.
Photo by Jeri Reichanadter

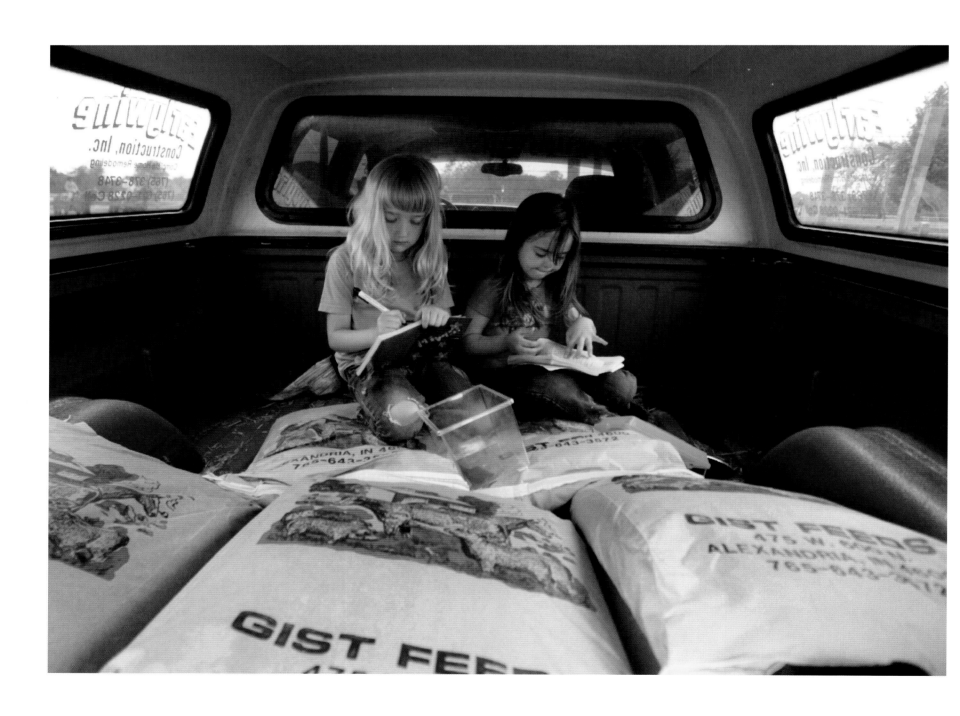

WADESVILLE

The fourth of nine children, Sam Koester, 12, wakes up at 4:30 a.m. to milk cows on the family's dairy farm. He does it again in the afternoon after completing his homeschooling studies. Sam shares the milking duties with brothers Matt and Lukas.

Photo by Denny Simmons

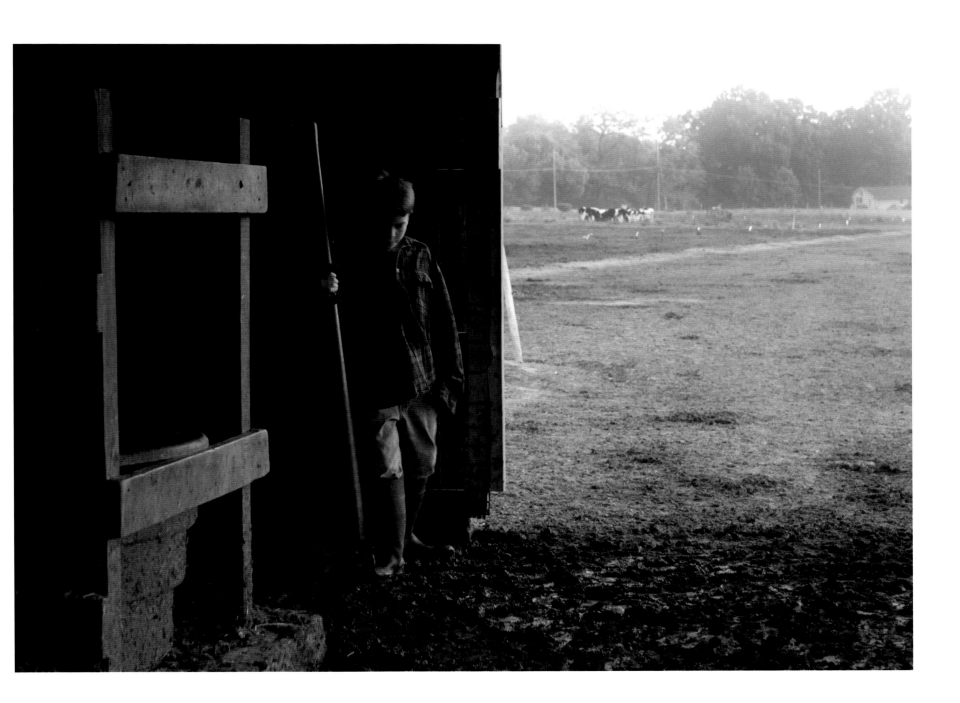

The year 2003 marked a turning point in the history of photography: It was the first year that digital cameras outsold film cameras. To celebrate this unprecedented sea change, the *America 24/7* project invited amateur photographers—along with students and professionals—to shoot and, via the Internet, submit digital images. Think of it as audience participation. Their visions of community are interspersed with the professional frames throughout this book. On the following four pages, however, we present a gallery produced exclusively by amateur photographers.

EVANSVILLE The Engelbrecht Orchard in northern Evansville is known for its 60 acres of apple trees—red delicious, golden delicious, Jonathan, and Royal Gala. *Photo by Jeff Osborne*

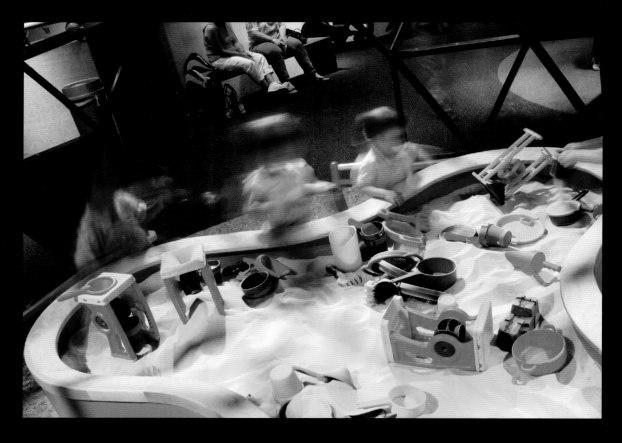

INDIANAPOLIS At the interactive Children's Museum of Indianapolis, kids explore science, history, culture, and art. And sometimes, they just play in the sand. *Photo by Jeremy Bingham*

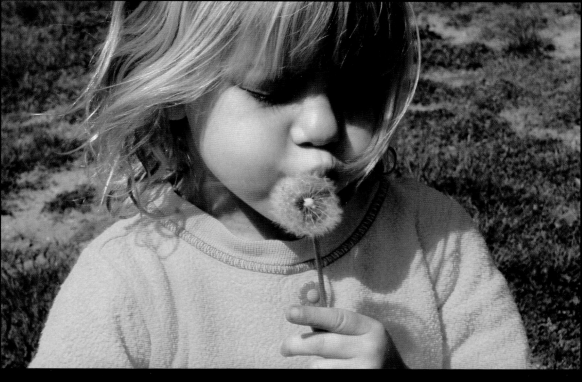

VALPARAISO On the first nice day of spring, Colleen "Beanie" Averill, 5, makes a dandelion wish for either an American Girl doll or ice cream. *Photo by Barb Averill*

INDIANAPOLIS Stacy Souter, 30, of Flagstaff, Arizona, hangs out in the backyard during a family reunion at her cousin's Central Street home. *Photo by Lisa Lamberson*

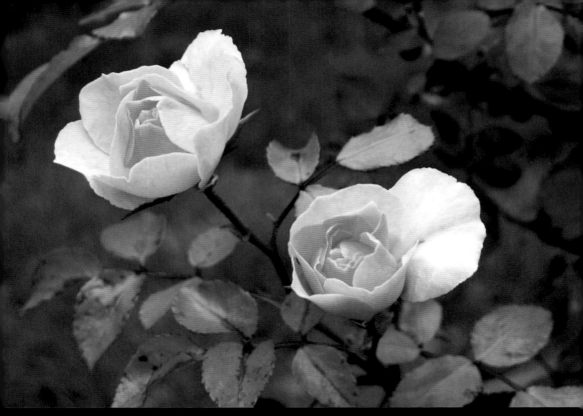

EVANSVILLE Elementary school librarian Kathy Osborne's 9-year-old rose garden is a reliable source of spring color. *Photo by Jeff Osborne*

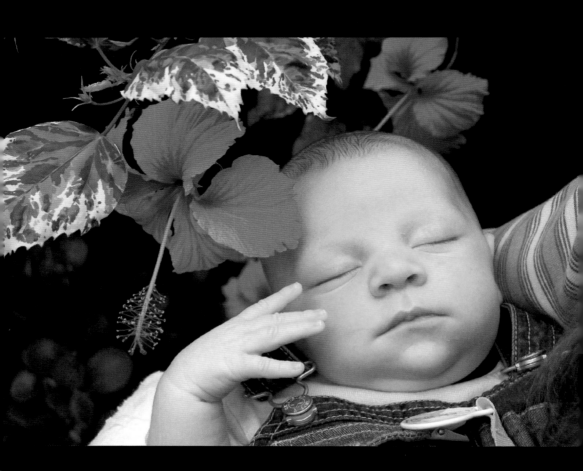

FORT WAYNE At the Foellinger-Freimann Botanical Conservatory in Fort Wayne, Dillon Jackson, 1 month old, keeps on snoozing despite the tickle of snowflake hibiscus. *Photo by Don Gagnon*

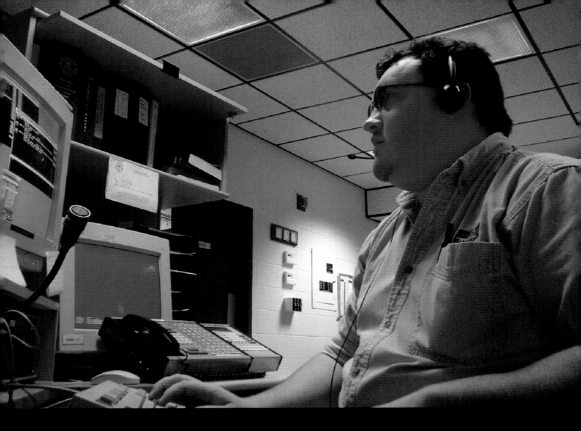

SOUTH BEND Apart from the occasional high-speed pursuit or river rescue call, police dispatcher Daniel Tinkel says his job is pretty routine, although once he talked a mother through the delivery of her daughter's baby. *Photo by Daniel Tinkel*

SOUTH BEND Lamplight graces the face of 2-year-old Kristina Rose Rea. *Photo by Juliane K. Rea*

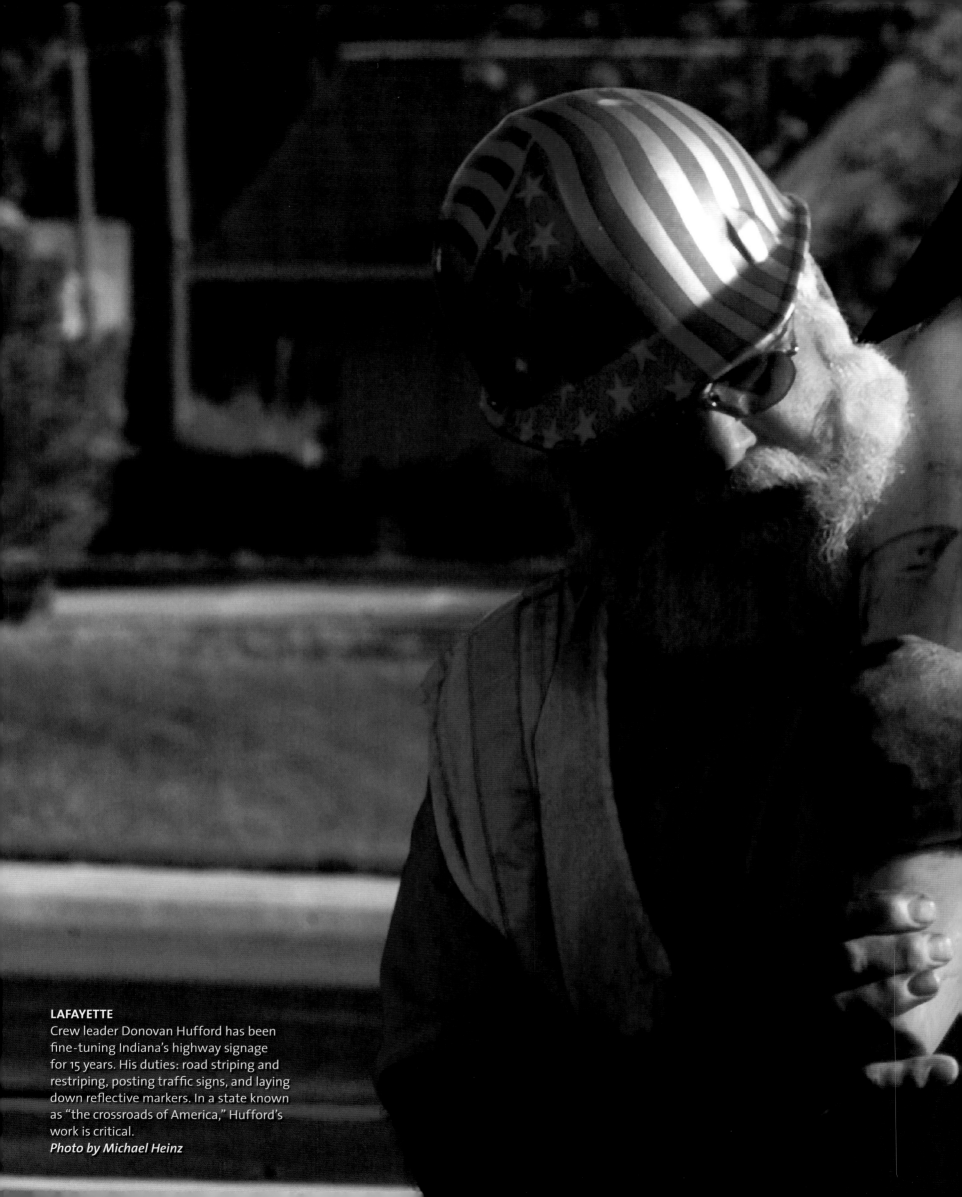

LAFAYETTE
Crew leader Donovan Hufford has been fine-tuning Indiana's highway signage for 15 years. His duties: road striping and restriping, posting traffic signs, and laying down reflective markers. In a state known as "the crossroads of America," Hufford's work is critical.
Photo by Michael Heinz

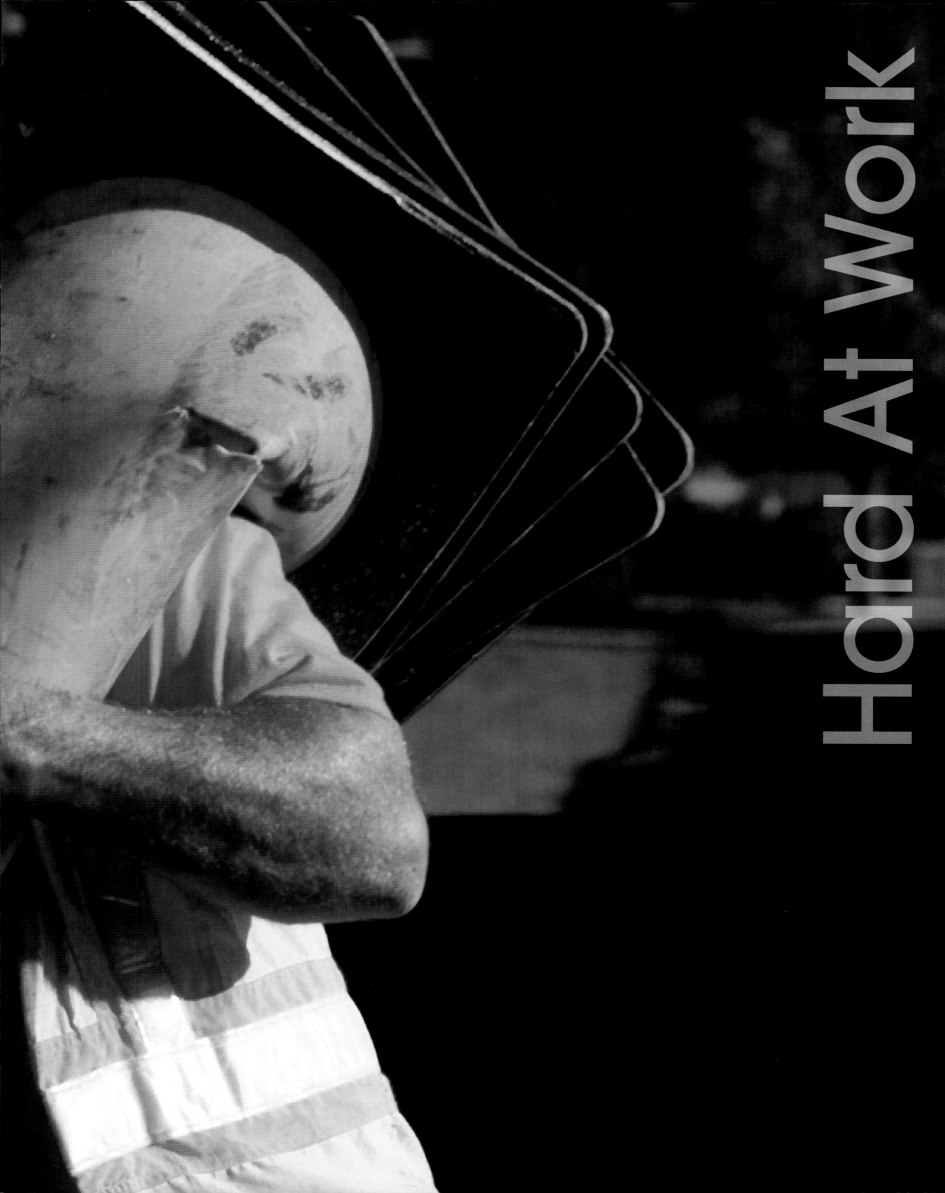

Hard At Work

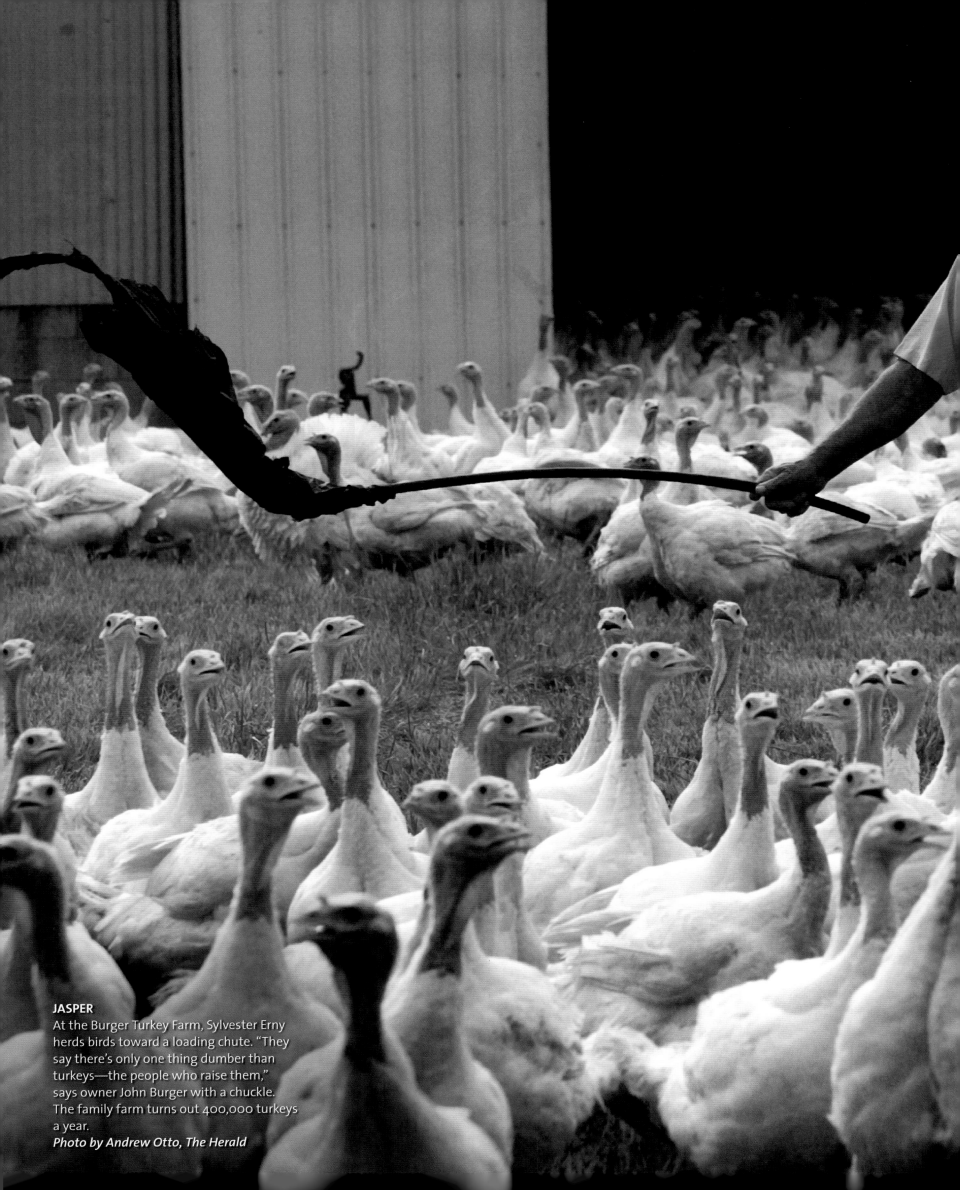

JASPER
At the Burger Turkey Farm, Sylvester Erny herds birds toward a loading chute. "They say there's only one thing dumber than turkeys—the people who raise them," says owner John Burger with a chuckle. The family farm turns out 400,000 turkeys a year.
Photo by Andrew Otto, The Herald

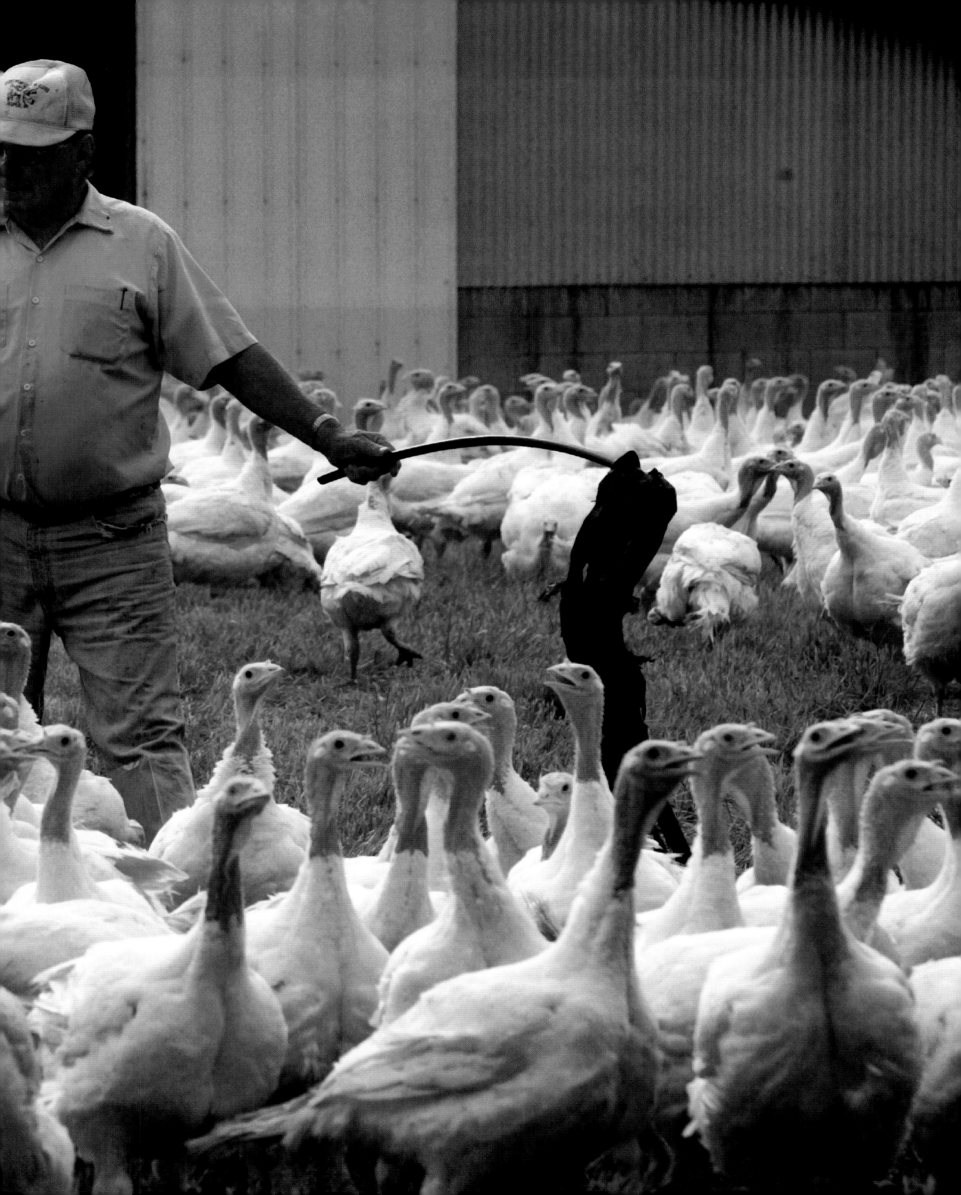

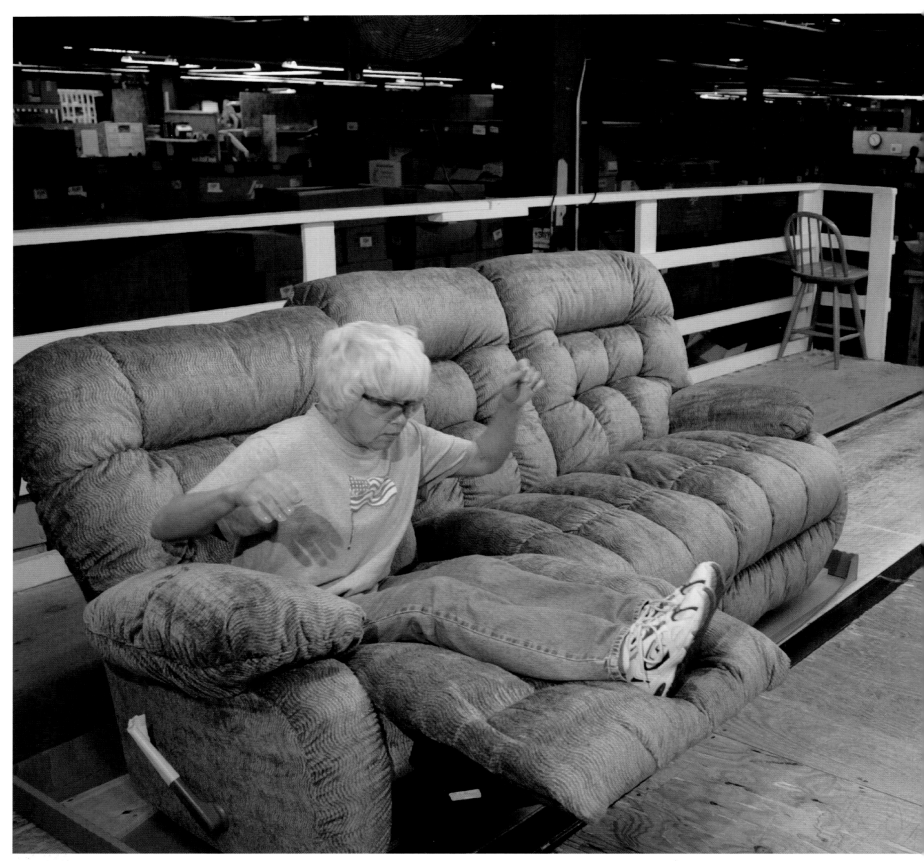

FERDINAND

Not-so-lazy girl: Mary Davis throws herself into her work at Best Chairs, Inc. Davis, 50, has been sitting down on the job for nearly three years, testing as many as 300 sofas and loveseats every day. Her greatest occupational hazard? Slippery new vinyl.

Photos by David Pierini, The Herald

JASPER

Using lumber from locally grown white oak, walnut, cherry, and maple trees, Jasper Desk has produced high-quality office furniture since 1876. Cipriano Cital, one of the company's 125 employees, works as a top rubber, polishing and adding filler to pieces like this Georgian walnut desk. The furniture industry is the largest employer in Dubois County.

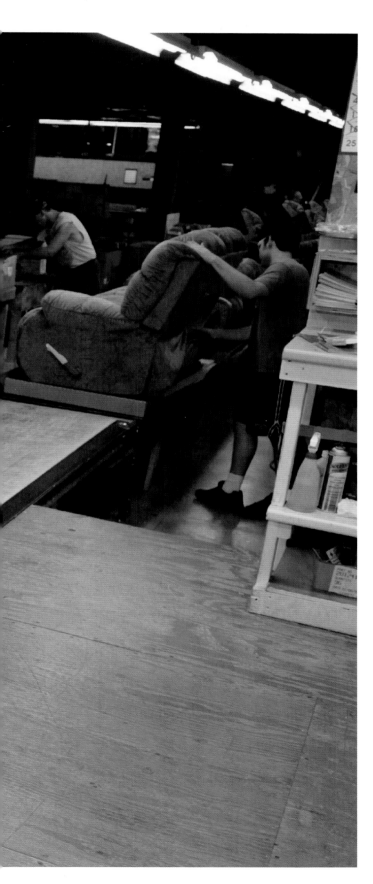

GREENFIELD

Hancock County has its share of crime. For especially dangerous situations, the county sheriff's department has initiated Special Weapons and Tactics (SWAT) training for its officers. The team keeps its collective aim sharp with monthly training sessions.
Photos by Tom Strickland

GREENFIELD

SWAT team member Detective Sergeant Brad Burkhart practices a residential entry using a Glock 21 semiautomatic pistol with attached flashlight. Burkhart is in charge of criminal warrant investigations. "I track people down once I have a warrant for them," says the 15-year veteran.

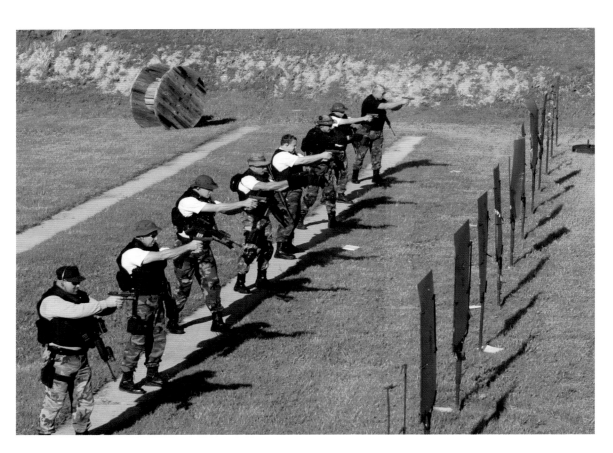

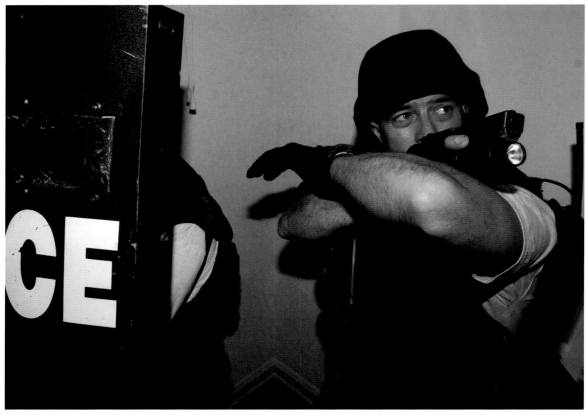

GREENFIELD

The Hancock County Sheriff's Department Honor Guard practices gun handling and flag placement. The unit's duties vary, from assisting at memorial services for fallen officers to posting colors at political events to marching in the county 4-H parade. The group was formed in response to the September 11 terrorist attacks.

GREENFIELD

Before events and practice sessions, members of the Honor Guard inspect each other for neatness. Deputy Trent Smoll gets an OK from Deputy Bridget Foy after she straightens his tie. "His tends to be the worst," she says. The only woman among six grooming-challenged men, Foy now packs a lint brush.

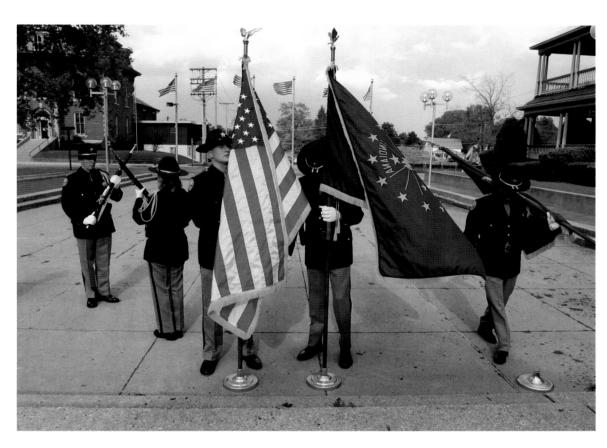

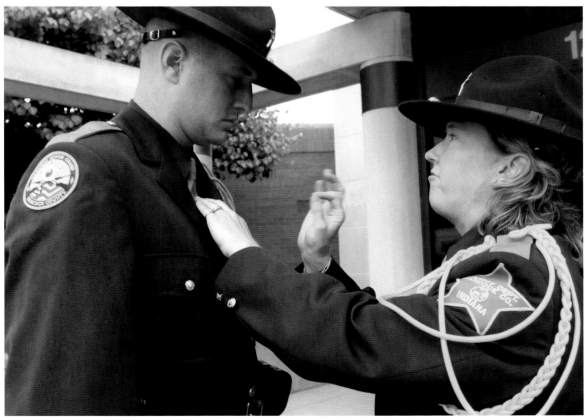

CAMMACK

"Kids come first," says Pete Davis of Pete's Grocery. "Other customers have to wait." Kids choose treats from a well-stocked candy counter. The bottom shelf holds the penny candies. Davis, 72, started working at the store when he was 13. He bought it when he was 27 and still runs it alone.
Photo by Joe Krupa, The Star Press

$5,000 REWARD

FOR INFORMATION LEADING TO THE ARREST AND CONVICTION OF PERSONS RESPONSIBLE FOR THE THEFT (3/28/03) OF 4 MOTORCYCLES

2001 FAT BOY–PURPLE

2002 883 SPORTSTER HUGGER–BLACK

2002 883 ANNIVERSARY TWO TONE SILVER & BLA

2003 FAT BOY (90 ANNIVERSARY)

250 CC HONDA DIRT BIKE

COLUMBIA CITY

At the Autoliv manufacturing plant, material handler David J. Smith transports a rack of newly molded urethane steering wheels to a holding area for the assembly department. The plant assembles 5,000 to 6,000 wheels a day for the Big Three American automakers, as well as for car companies in Canada, Mexico, Japan, and Taiwan.
Photo by Steve Linsenmayer,
The Fort Wayne News-Sentinel

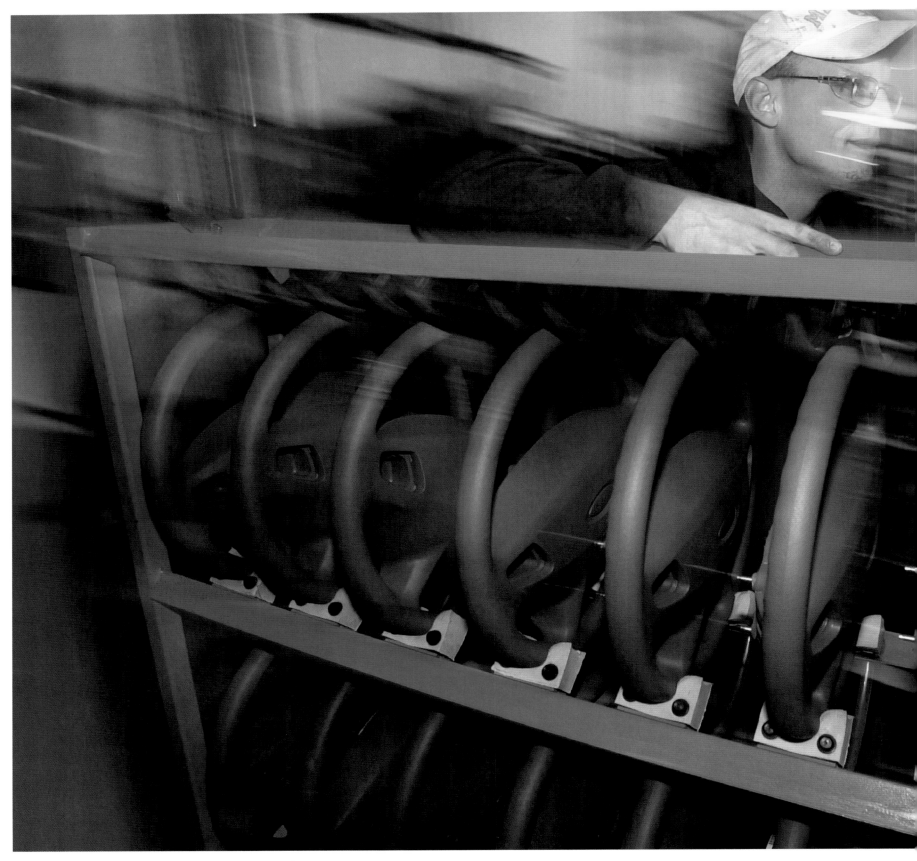

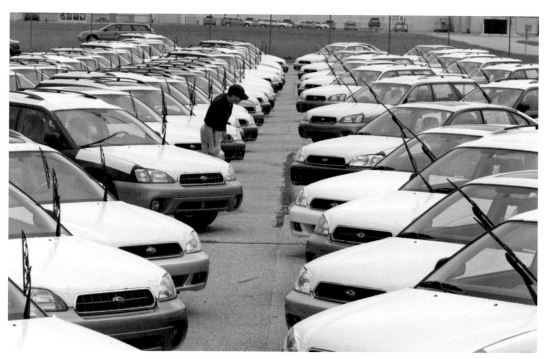

LAFAYETTE

Christopher Morris inspects a swarm of Subarus before they are shipped to dealers. Indiana was a leader in car manufacturing—think Studebaker—until Michigan trumped the trade a half century ago. Thanks to a 20-year economic initiative, there are now four assembly plants in Indiana that roll out Subarus, GM light trucks, Toyotas, and Hummers.
Photo by Frank Oliver

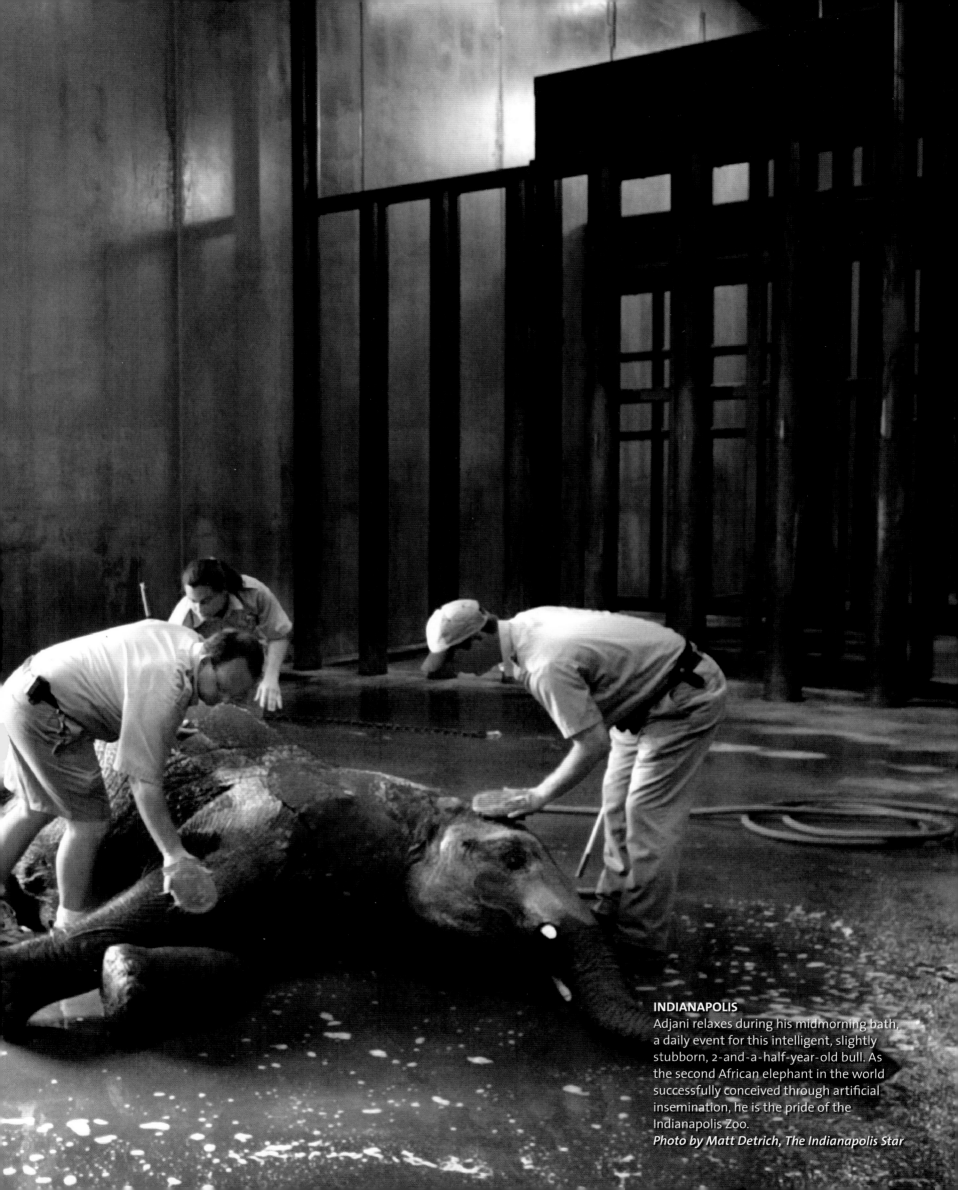

INDIANAPOLIS
Adjani relaxes during his midmorning bath, a daily event for this intelligent, slightly stubborn, 2-and-a-half-year-old bull. As the second African elephant in the world successfully conceived through artificial insemination, he is the pride of the Indianapolis Zoo.
Photo by Matt Detrich, The Indianapolis Star

Venus di Milo she's not, but Flora's arms do tend to fall off each morning when Bazbeaux Pizza employee Galen Denney sets her up outside the downtown restaurant. The former Blocks department store clotheshorse directs customers to the entrance (once her arms are secured, that is).
Photo by Matt Detrich, The Indianapolis Star

AURORA
The Cincinnati band Shadows of '56—featuring Randall Houser as Elvis—captured first place in the rock-and-roll division at Aurora's first annual Party Gras. The all-day outdoor music event had eight bands, a hog roast, and the ever-popular corn hole contest (aka beanbag toss).
Photo by Jeremy Hogan

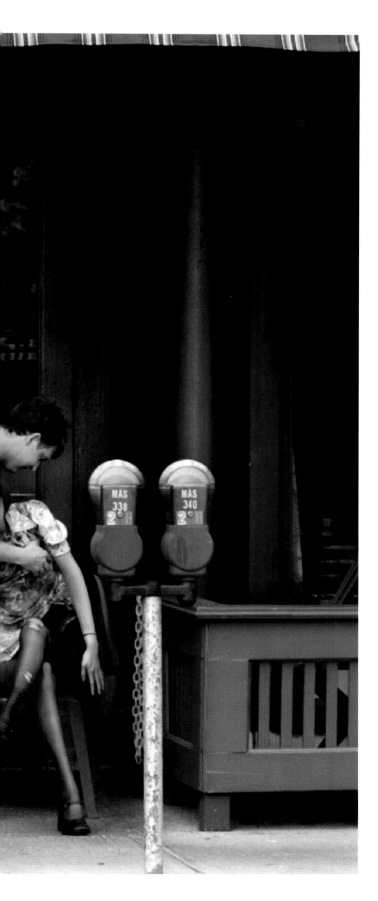

TERRA HAUTE

With help from his daughter Marsha Nasser, 89-year-old Disco Ernie gets ready for another outing as Terra Haute's senior stripper. He first publicly dropped his drawers 25 years ago while filling in for one of the male dancers at Mister Bo's nightclub. A regular at bridal showers and birthday parties, he learned his moves as an Arthur Murray dance instructor.

Photos by Mike Fender, The Indianapolis Star

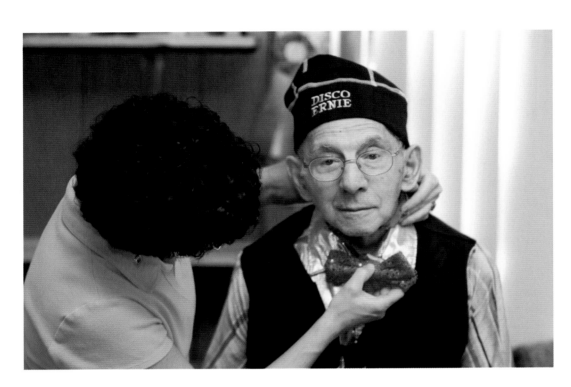

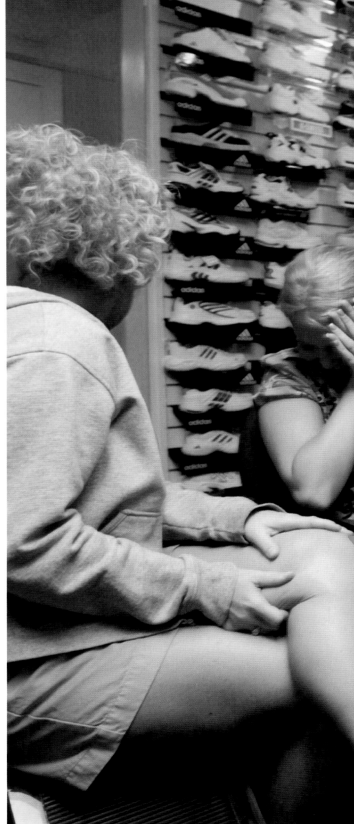

TERRA HAUTE

The boom box starts, Ernie loses some clothes, and the women turn their heads in embarassment—the usual start to one of his performances. But by the time Ernie strips to his Speedo, socks, and shoes, some relax enough to dance with him. This performance was for soon-to-be-married Renee Rohloff (third from left) who works at Pacesetter Sports.

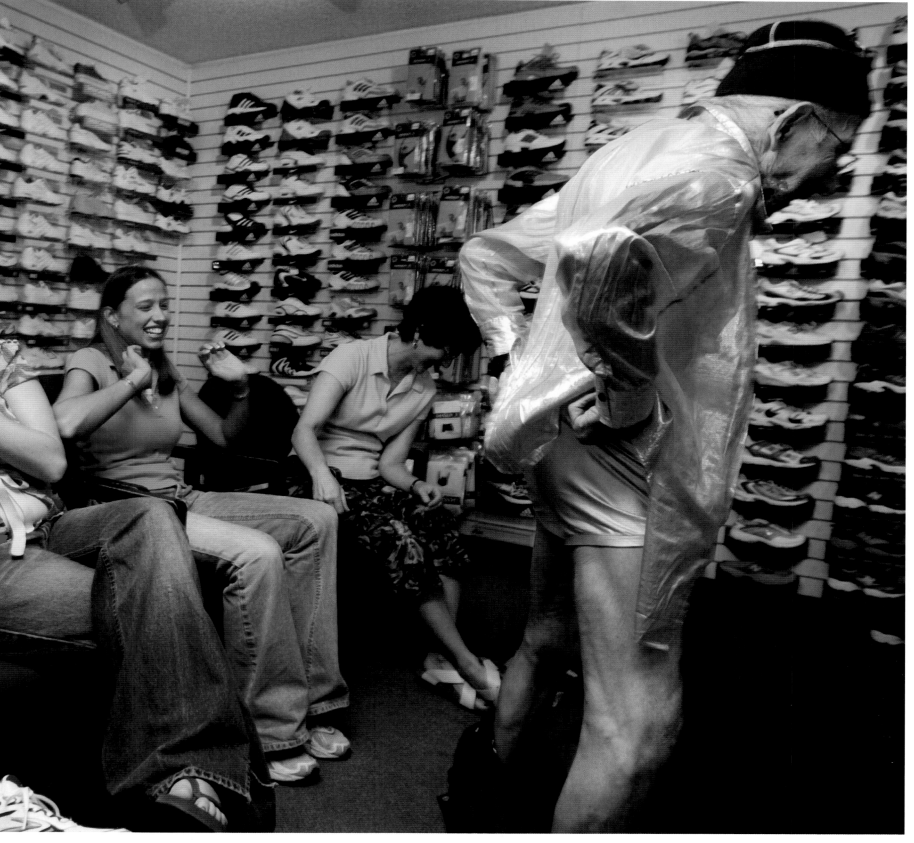

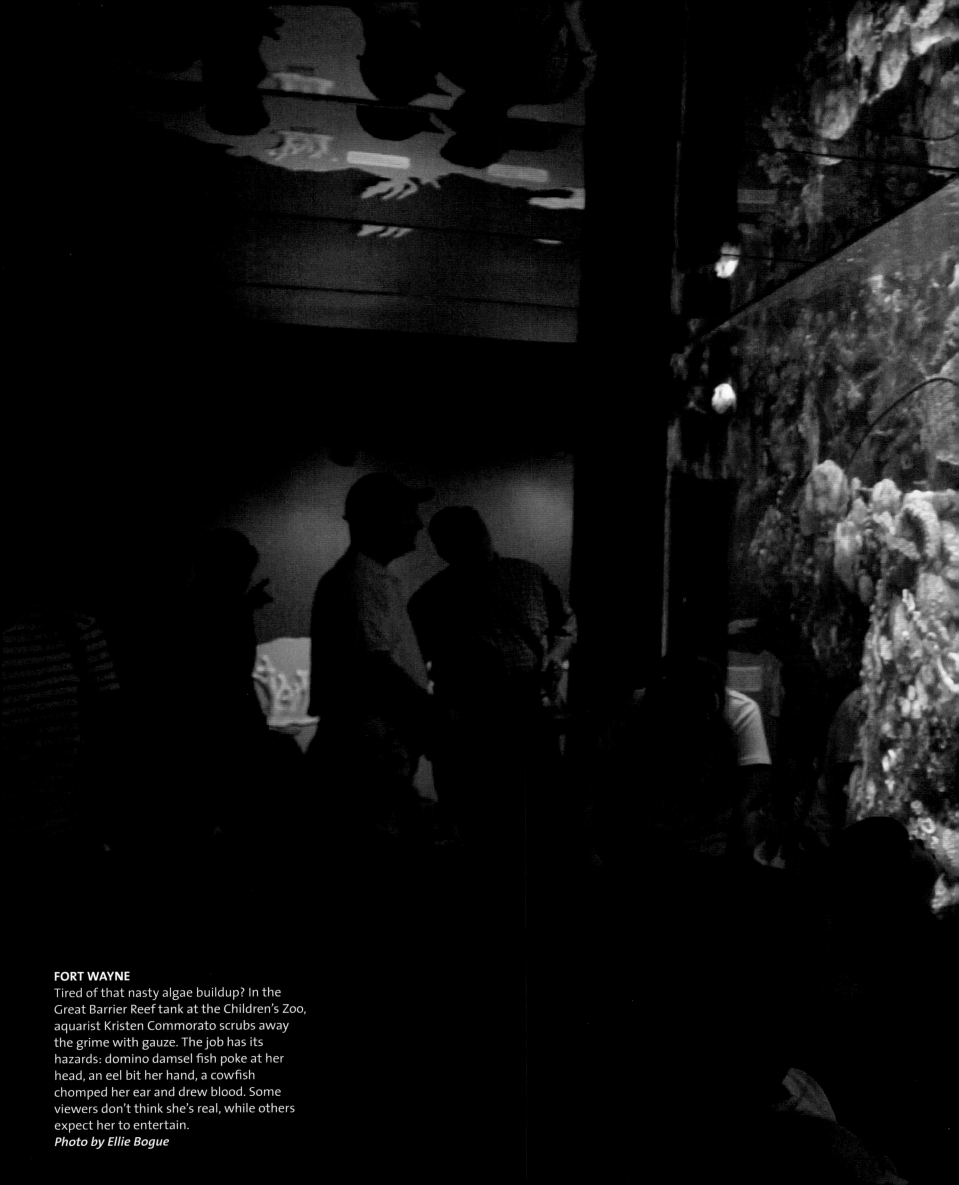

FORT WAYNE
Tired of that nasty algae buildup? In the Great Barrier Reef tank at the Children's Zoo, aquarist Kristen Commorato scrubs away the grime with gauze. The job has its hazards: domino damsel fish poke at her head, an eel bit her hand, a cowfish chomped her ear and drew blood. Some viewers don't think she's real, while others expect her to entertain.
Photo by Ellie Bogue

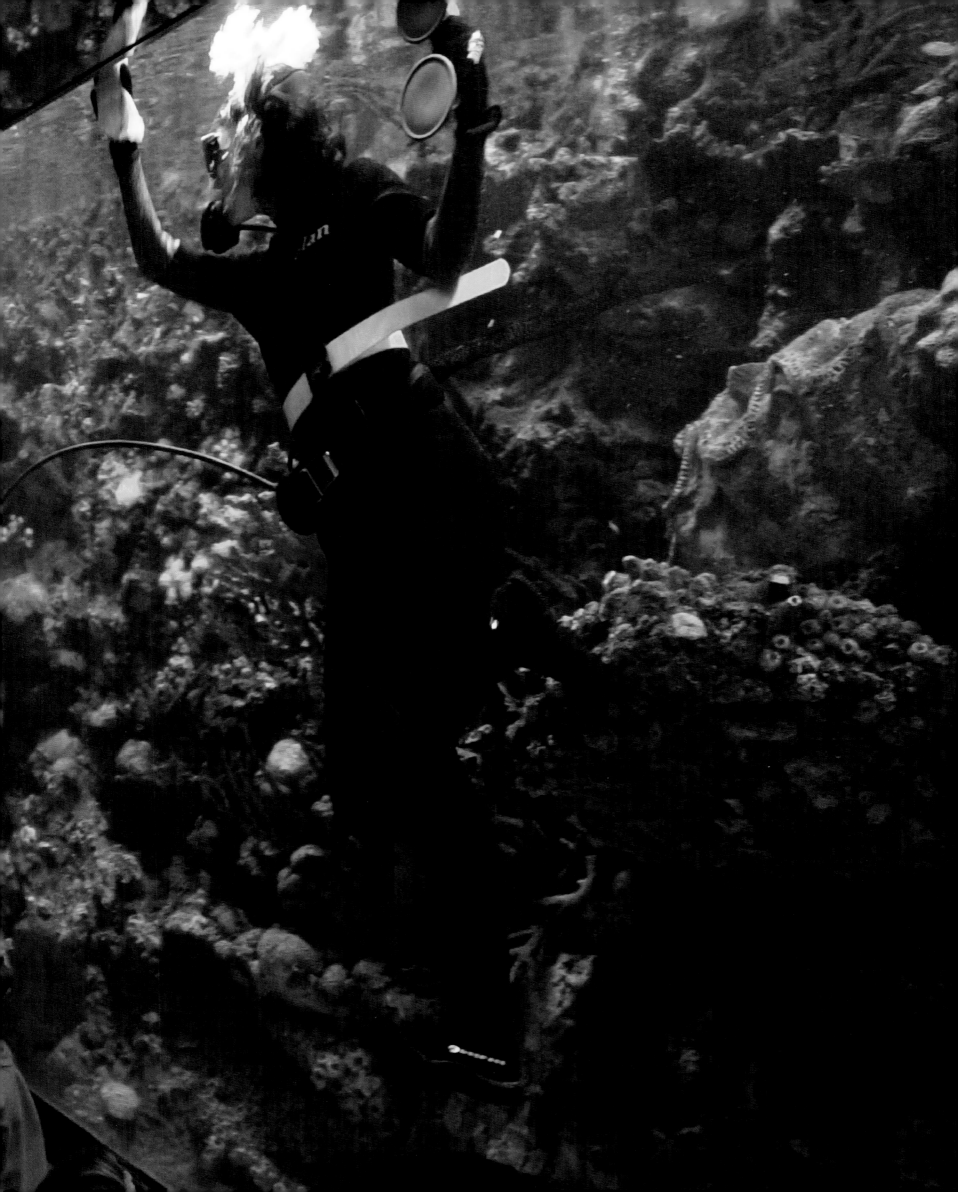

BLOOMINGTON

For 30 years, sculptor Dale Enochs, 51, has used Indiana limestone as his artistic medium. These twin 800-pound sculpted obelisks represent what he calls "the horror of war in Iraq." They're headed for display at DePauw University's Peeler Art Center.

Photos by Dan Uress

BLOOMINGTON

With a diamond blade saw, Enochs begins to rough out a human head for another piece in his series, *Thoughts on War.* Enochs puts in up to 80 hours a week in his studio, located in a barn behind his farmhouse.

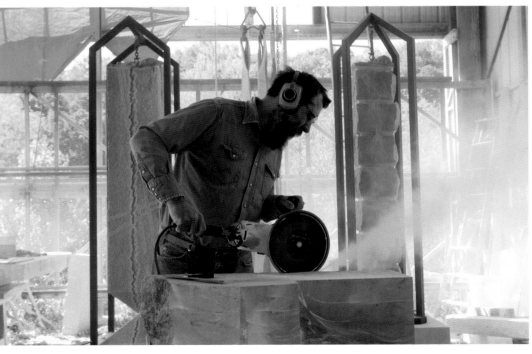

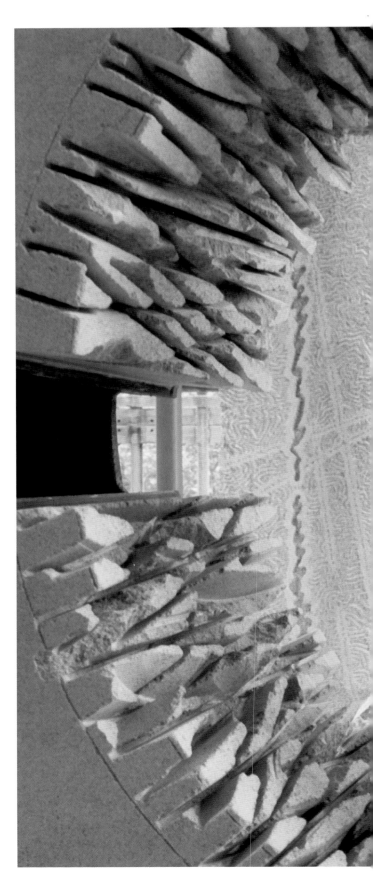

BLOOMINGTON

Enochs chisels an intricate limestone filigree for a commissioned piece he's calling *Ryujin*, destined for a Japanese garden in Indianapolis. "Ryujin" is the Japanese name for the water spirit, or the water dragon. By alternating between commissioned and personal projects, Enochs has managed to support himself as an artist since the mid-1980s.

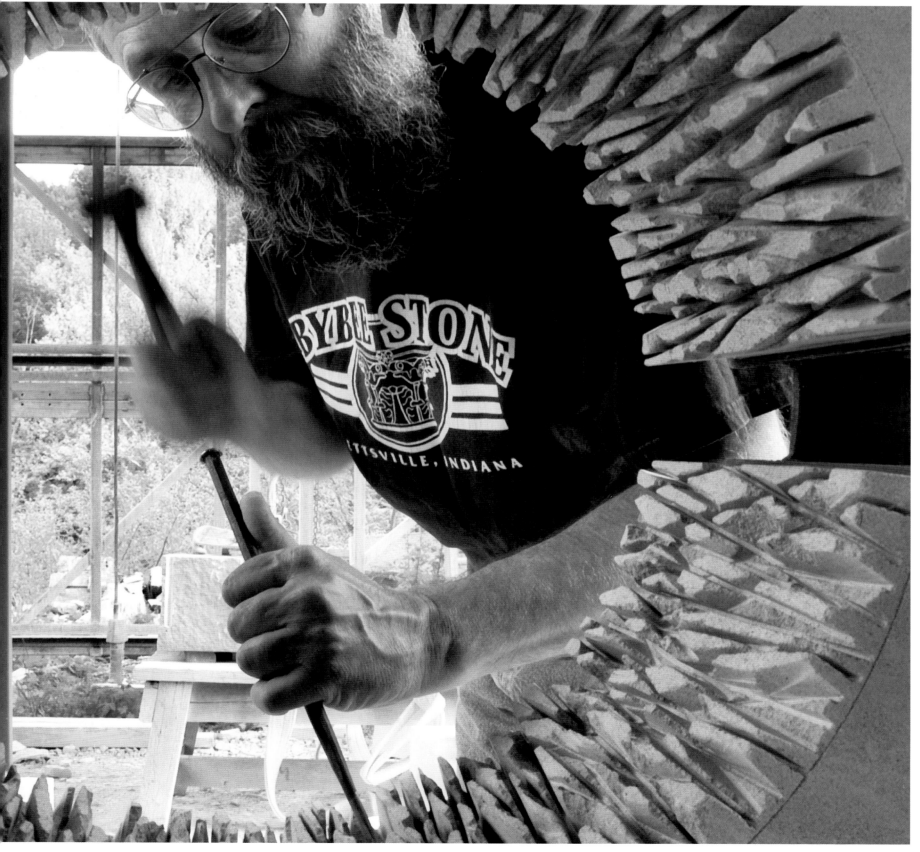

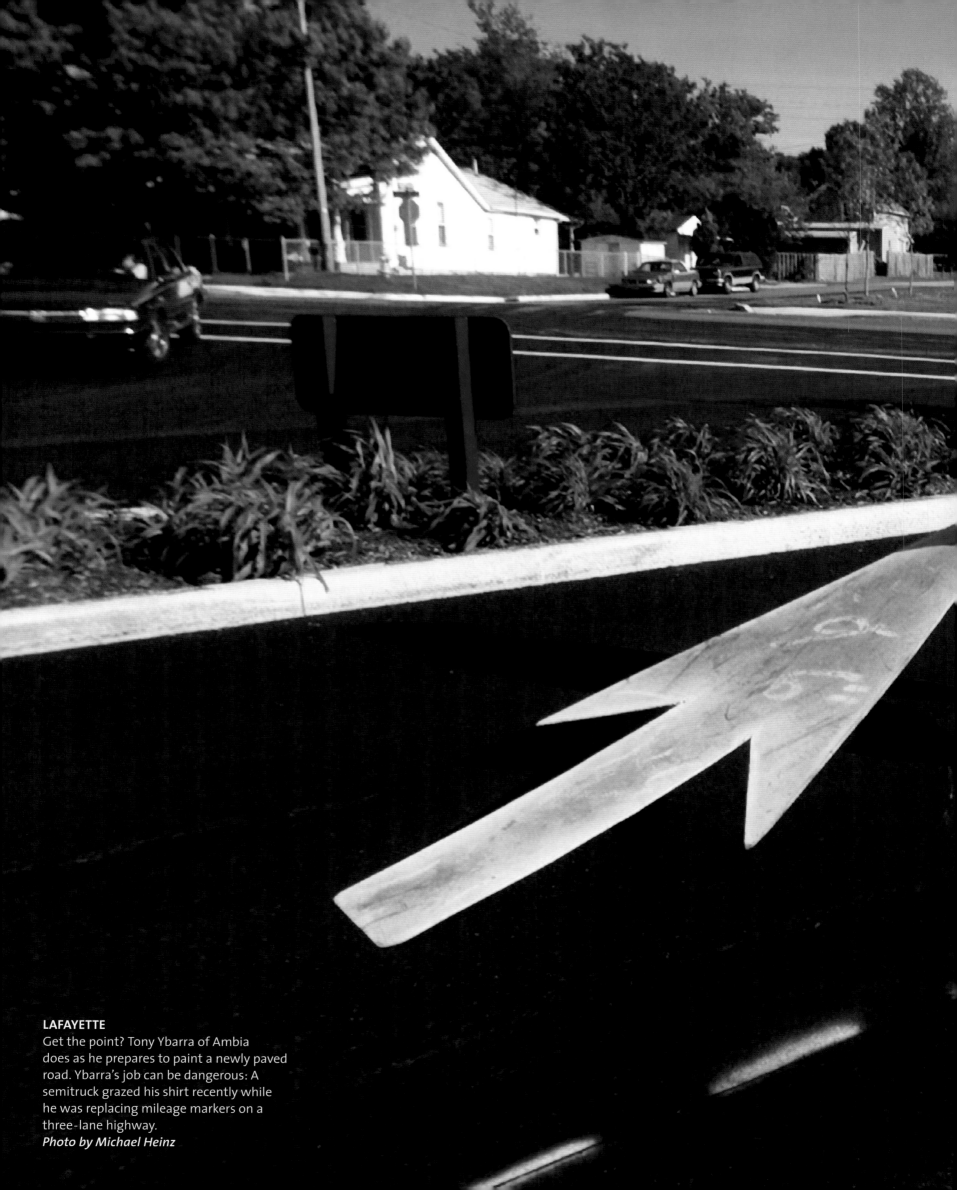

LAFAYETTE
Get the point? Tony Ybarra of Ambia
does as he prepares to paint a newly paved
road. Ybarra's job can be dangerous: A
semitruck grazed his shirt recently while
he was replacing mileage markers on a
three-lane highway.
Photo by Michael Heinz

GARY

A ladle filled with molten iron charges the basic oxygen furnace at the Gary Works Number 2 Q-BOP (Basic Oxygen Process) shop. Covering almost 4,000 acres on the south shore of Lake Michigan, Gary Works employs about 6,500 people and is U.S. Steel's largest manufacturing plant. It has the capacity to produce 7.7 million tons of raw steel annually.
Photos by Jeffrey D. Nicholls

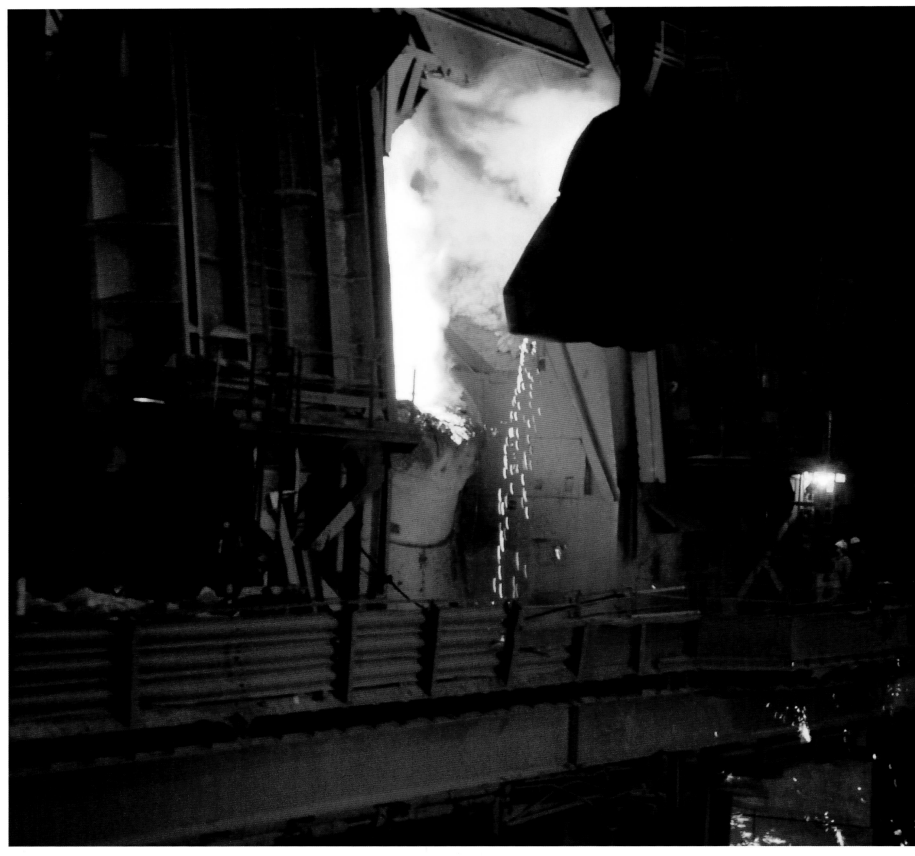

GARY

Allen Wozniak, Louis Heller, and Gregory Diehl run "The Pulpit" at Gary Works. They monitor the Number 2 Caster Complex and watch for emergencies—like a "breakout" of 3,000-degree liquid steel during the cooling process.

GARY

Before molten steel can be turned into everything from cars to cans, it passes through the Number 2 Caster Complex. A sample is taken from the caster mold, and the mixture is checked to make sure it's what the customer ordered.

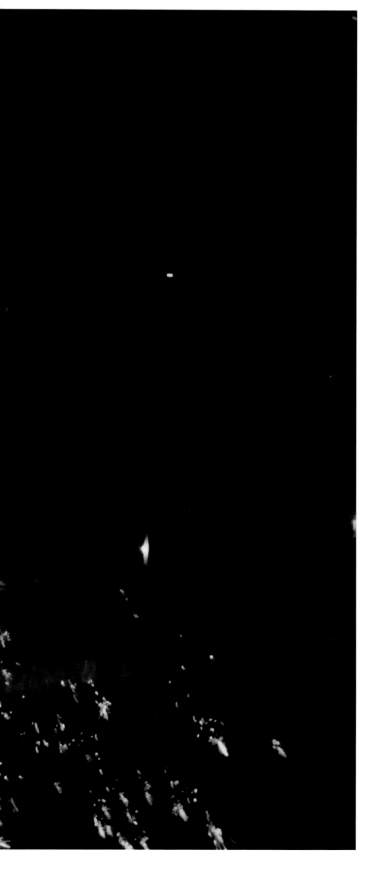

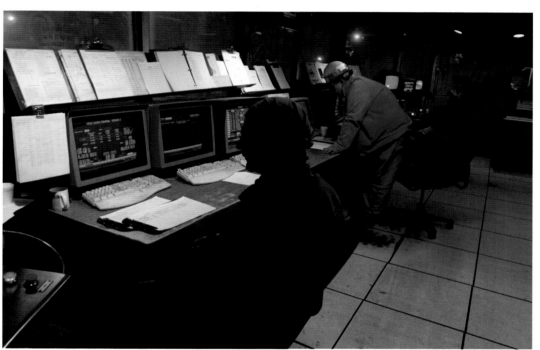

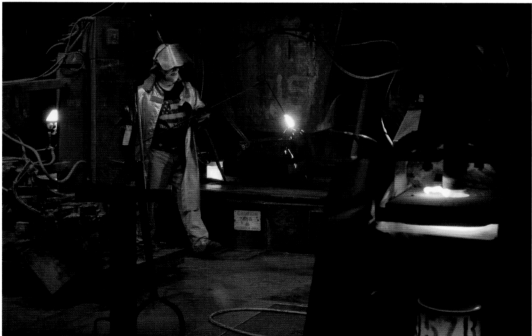

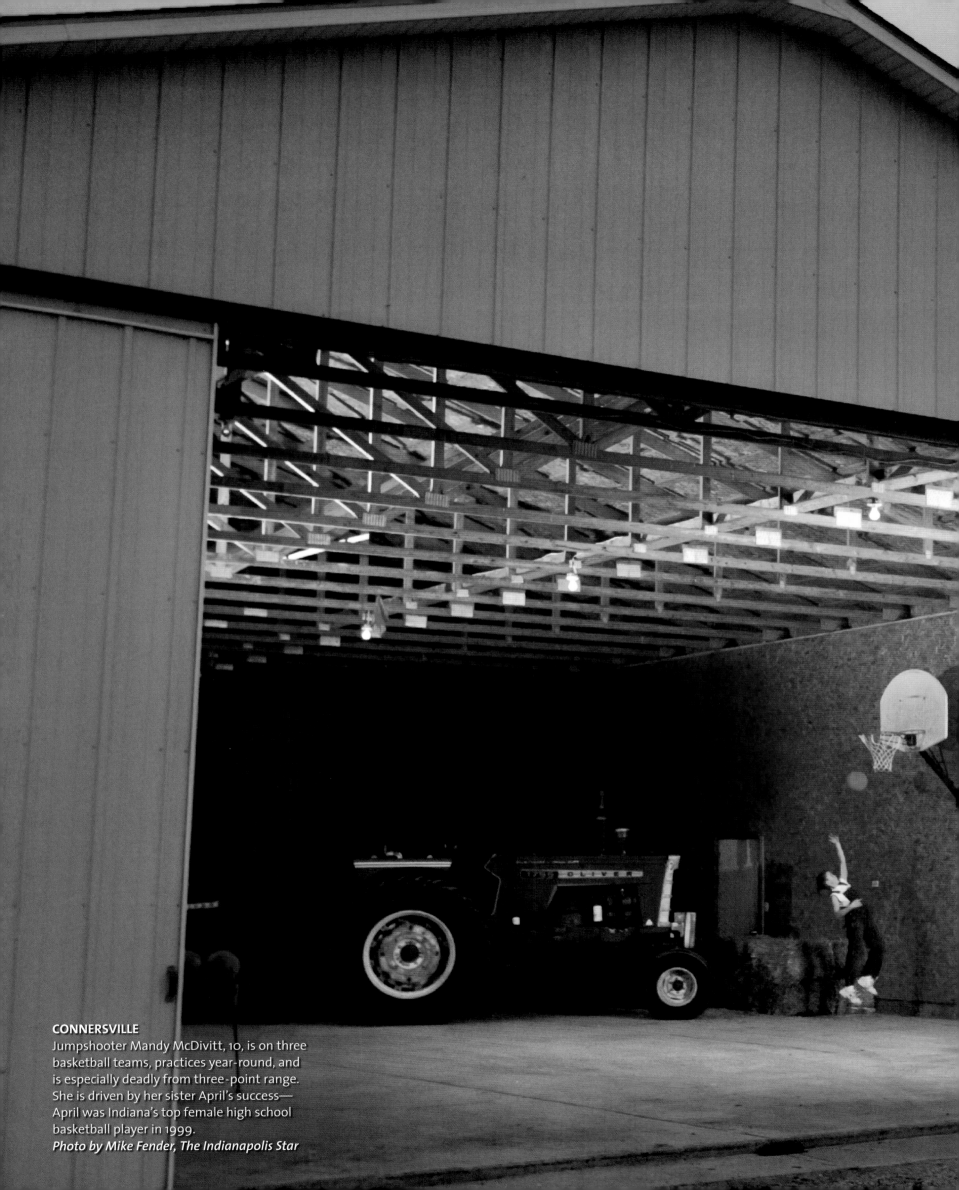

CONNERSVILLE
Jumpshooter Mandy McDivitt, 10, is on three basketball teams, practices year-round, and is especially deadly from three-point range. She is driven by her sister April's success— April was Indiana's top female high school basketball player in 1999.
Photo by Mike Fender, The Indianapolis Star

Indiana At Play

NOBLESVILLE

Hoosier Hysteria: Indiana's annual high school basketball championship tournament recently converted from a winner-take-all to a four-class system. Sadly, the new format precludes the possibility of a small-town team whupping a big-city school. Still, Noblesville eighth-graders Josh Kaskel, Matt Glover, and Cody Pennington dream of the day they'll shoot a layup for a winning trophy.
Photo by Kurt Hostetler, The Star Press

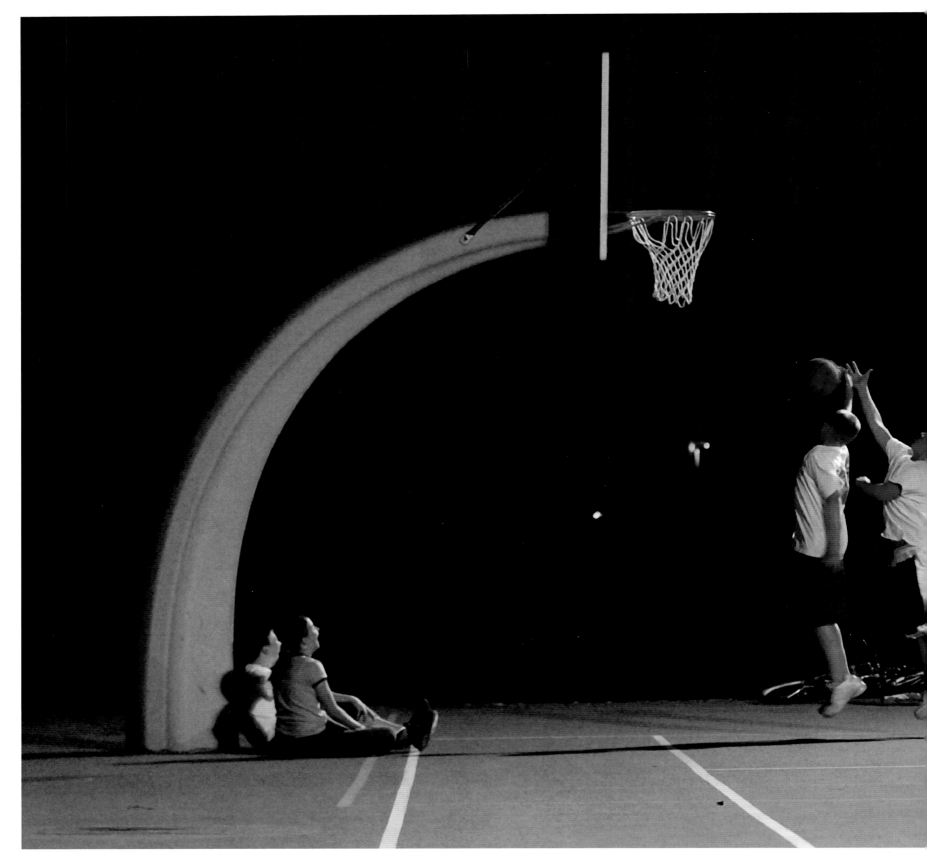

BLOOMINGTON
On the court at the Crestmont Housing Project and elsewhere, foul weather or no, it's always time for b-ball. Indiana put five college teams in the 2002 NCAA Division I championship.
Photo by Jeremy Hogan

EVANSVILLE
Shadow play: During an afternoon pickup game at Fulton Park, Marico Nann goes up against Lamont Davis for a hook shot.
Photo by Vincent Pugliese

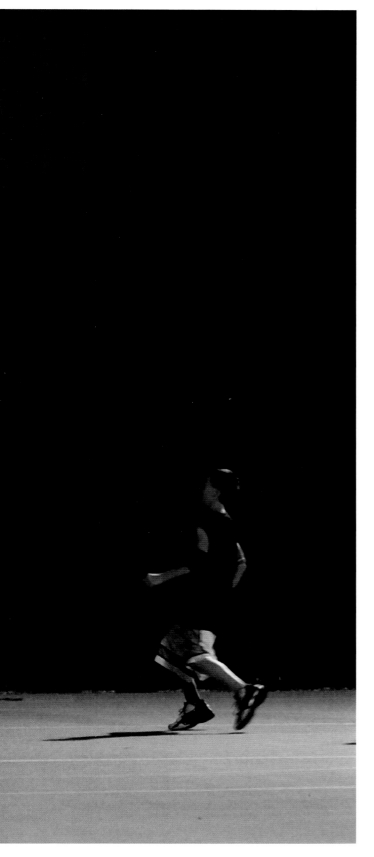

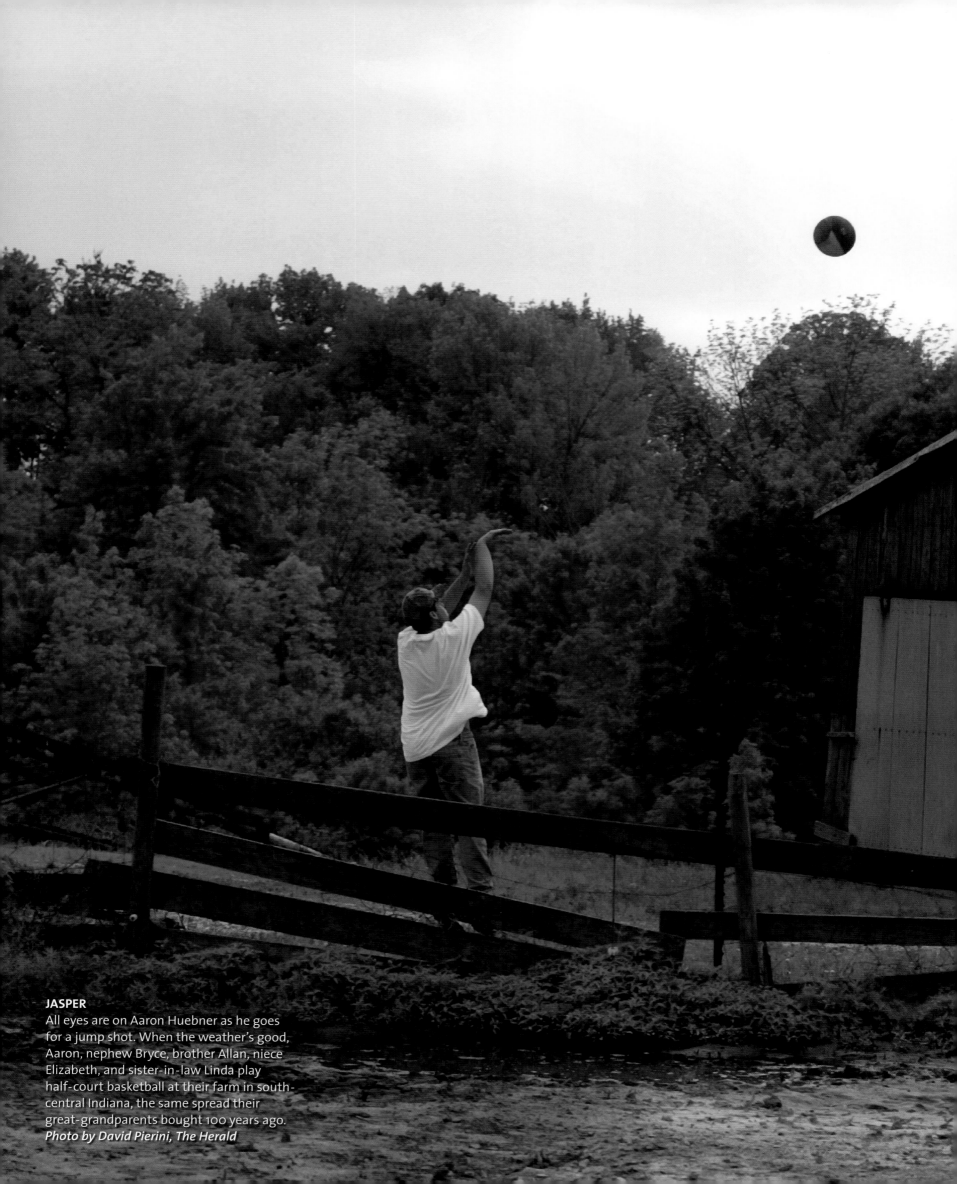

JASPER
All eyes are on Aaron Huebner as he goes for a jump shot. When the weather's good, Aaron, nephew Bryce, brother Allan, niece Elizabeth, and sister-in-law Linda play half-court basketball at their farm in south-central Indiana, the same spread their great-grandparents bought 100 years ago.
Photo by David Pierini, The Herald

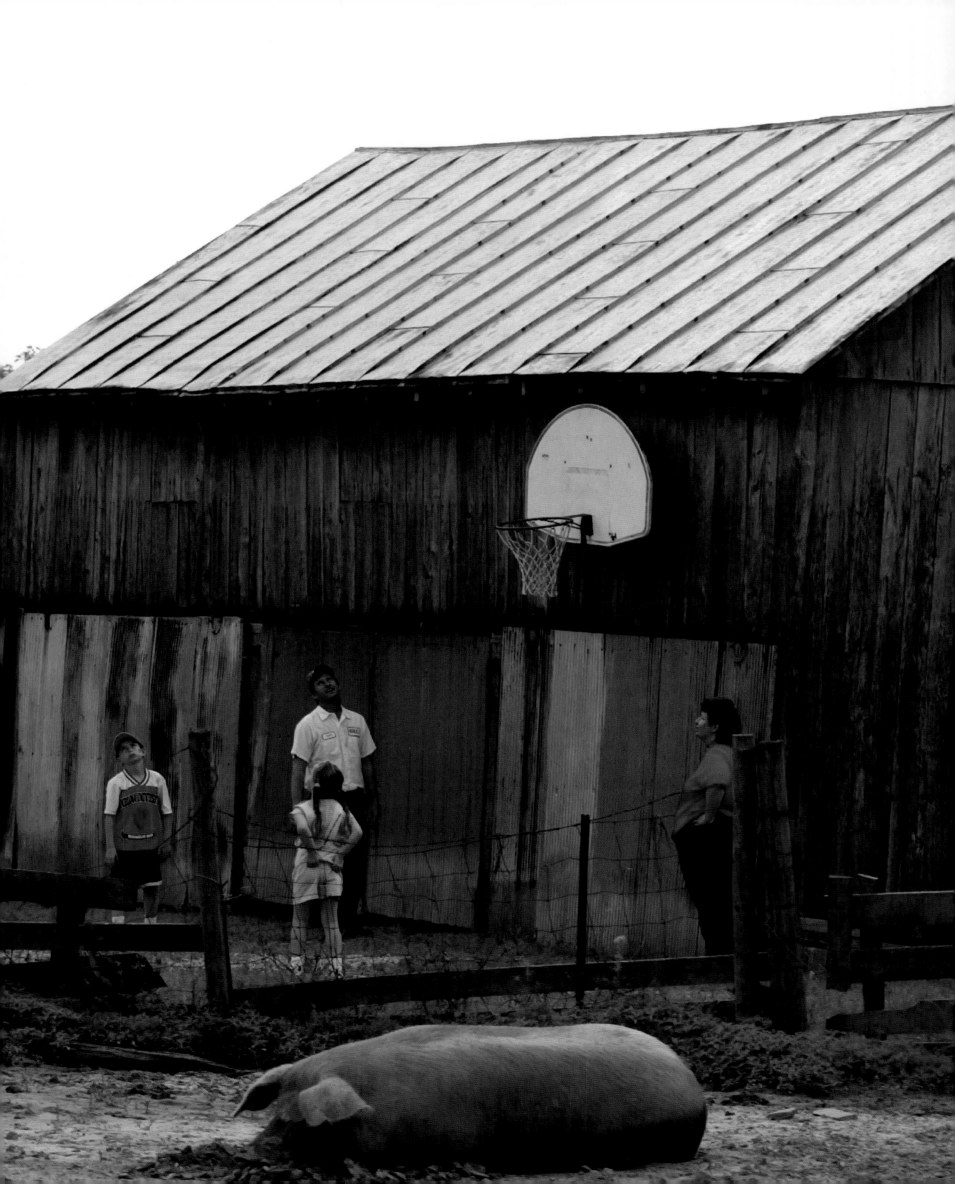

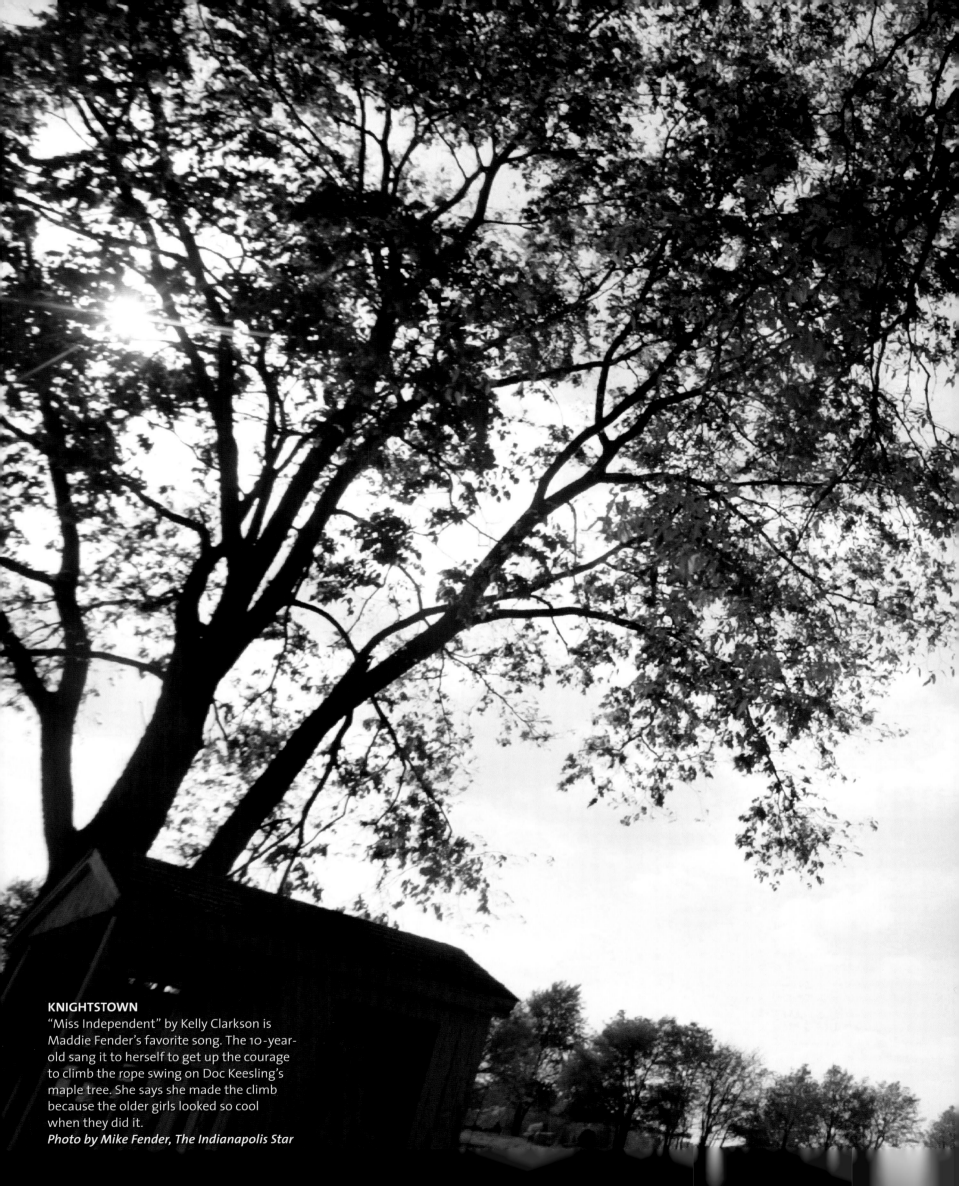

KNIGHTSTOWN
"Miss Independent" by Kelly Clarkson is Maddie Fender's favorite song. The 10-year-old sang it to herself to get up the courage to climb the rope swing on Doc Keesling's maple tree. She says she made the climb because the older girls looked so cool when they did it.
Photo by Mike Fender, The Indianapolis Star

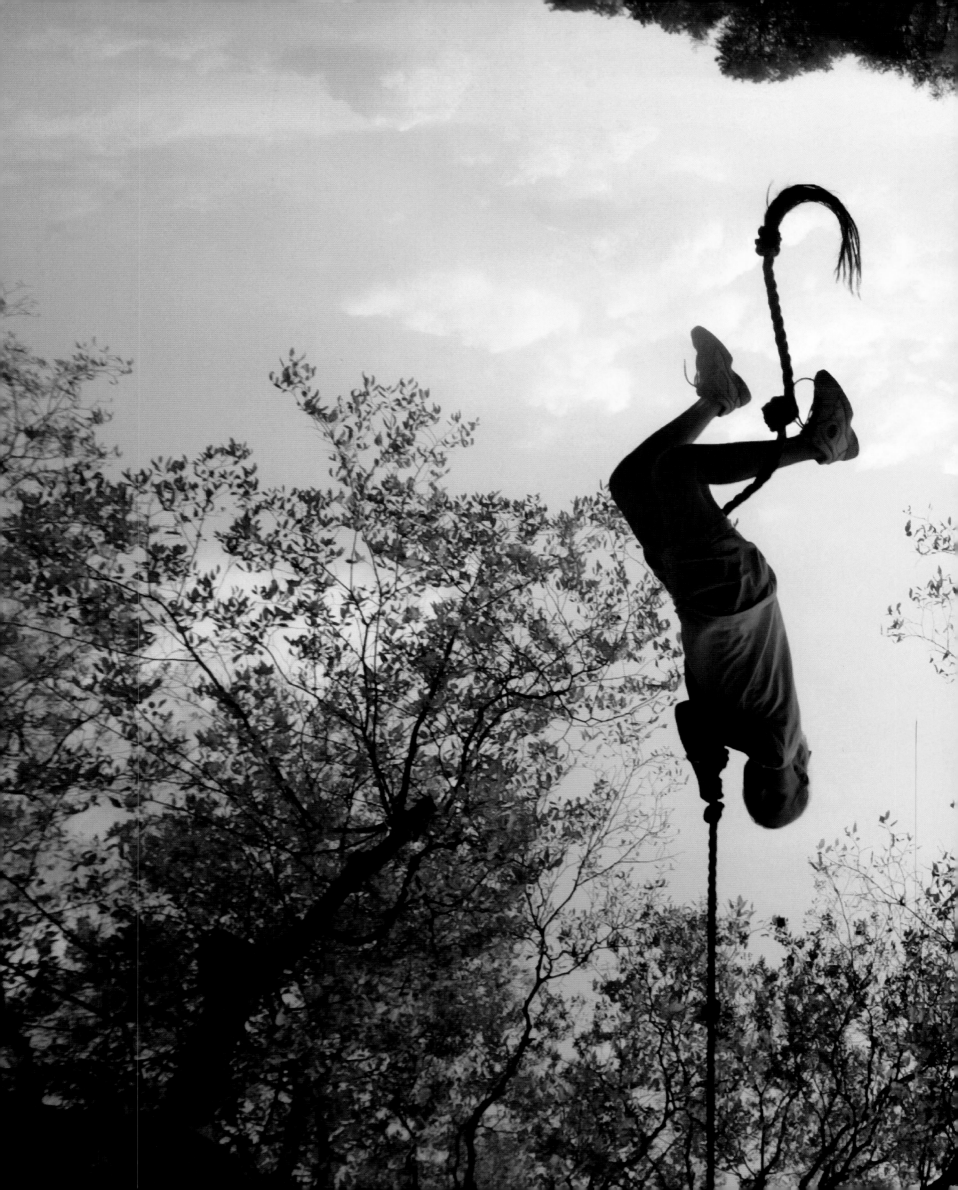

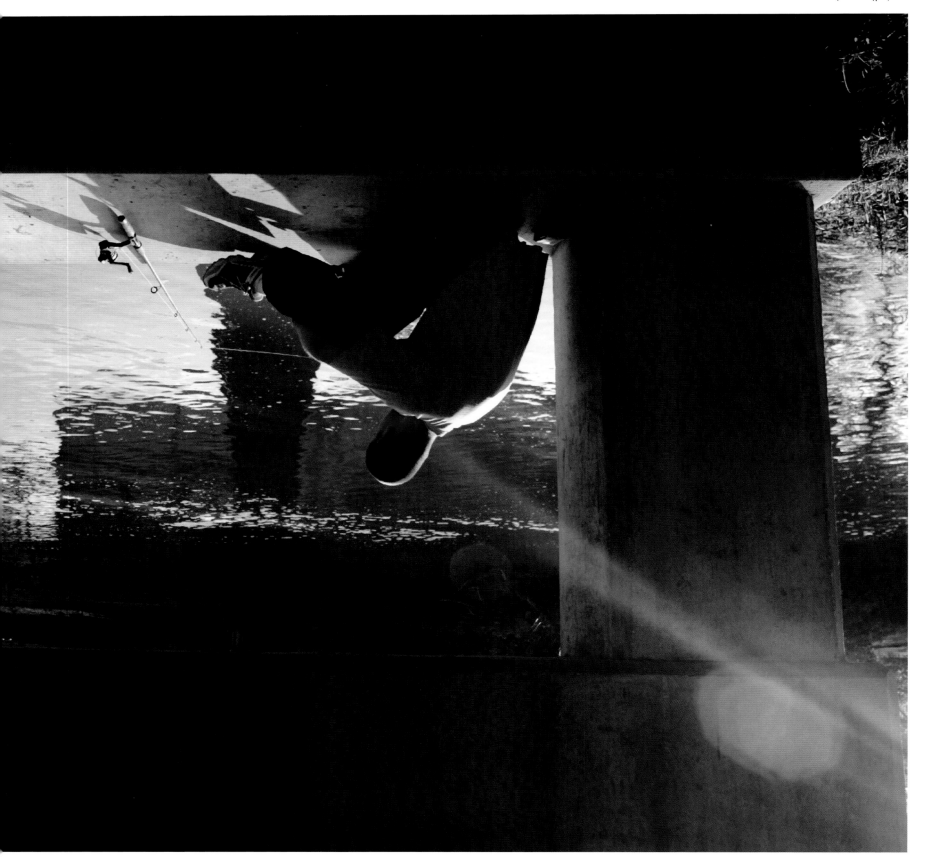

JASPER

Fisherman Ronnie Newkirk, 22, waits patiently
for the nibble of a catfish or perch on the 138-
mile Pakota River, a tributary of the Wabash River.
The area around the Pakota, habitat of the rare
Indiana crayfish, was home to the Kickapoo
people in the 19th century.
Photo by David Pierini, The Herald

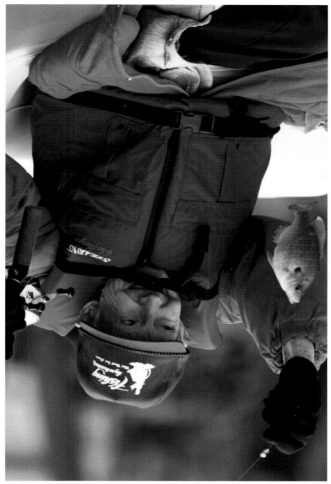

LAKE FREEMAN

Rosie the Riveter: Dorothy Rose, former riveting machine operator, has fished since she was old enough to hold a pole, and, at 87, she sees no reason to stop. She accepts all invitations including one from Fishing Has No Boundaries, a group that organizes fishing trips for people with handicaps.

Photo by Frank Oliver

KOKOMO

During a weekend of races, Wes Gordon, 12, and Laine Hite, 10, find time for Nintendo in the Gordon family's hauling trailer. The boys race quarter midgets, miniature race cars that go up to 40 mph, and they are the top competitors in their age group of 9- to 16-year-olds. Wes's grandpa gave him his first quarter midget when he was 4.

Photo by Tim Bath, Kokomo Tribune

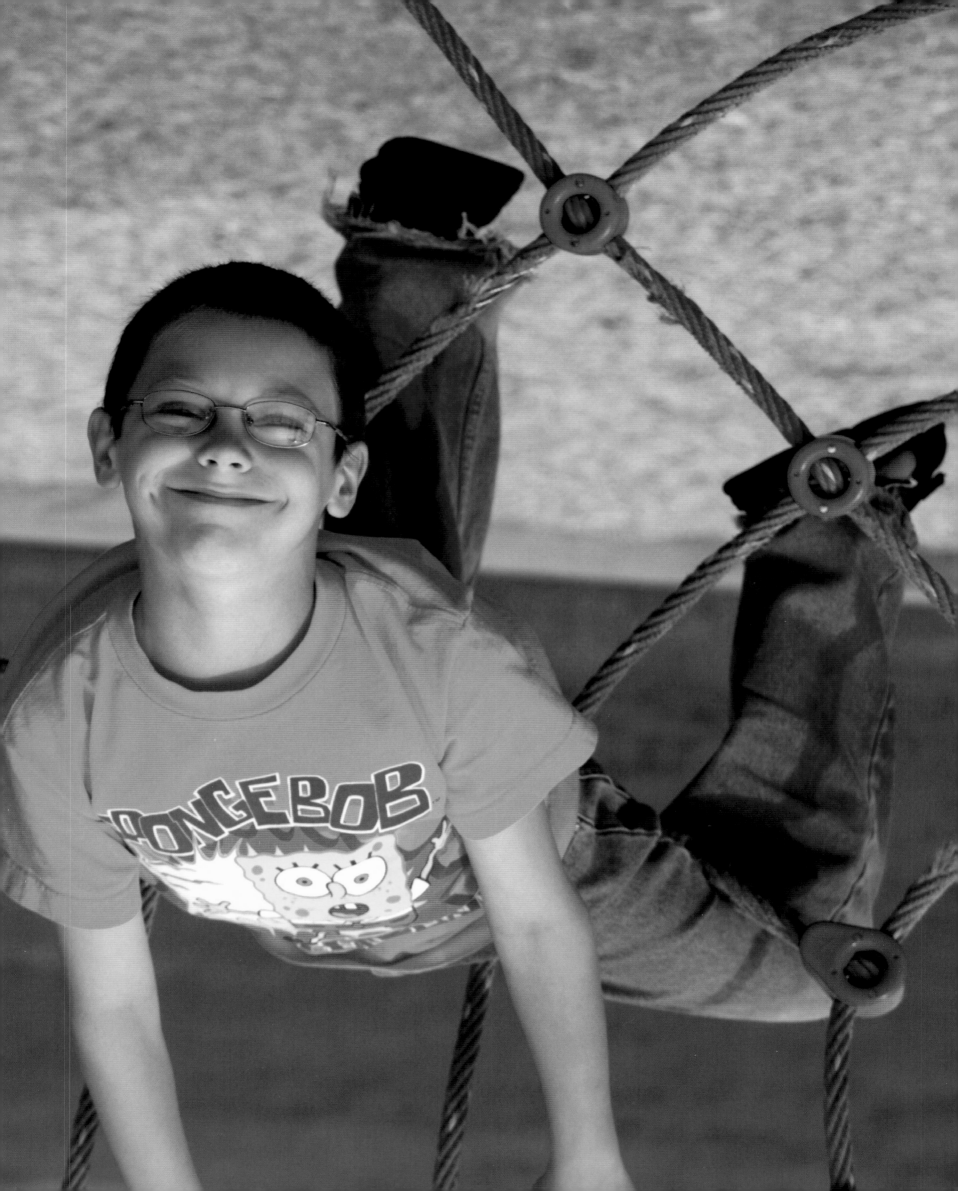

LAFAYETTE

Nathan Carerro, 8, goes for the head rush at SIA Playground in Columbian Park. Opened in 1999, the playground was built with a $150,000 donation from Subaru-Isuzu Automobile, Inc. The plant, which opened in Lafayette in 1987, employs more than 2,500 people.
Photo by Quentin Robinson

FISHERS

The late afternoon sun silhouettes Cassandra and Alejandro Rodriguez during older brother Daniel's Little League game at Holland Memorial Park.
Photo by Matt Detrich,
The Indianapolis Star

ST. LEON

We are the champions! The South Dearborn Middle School girls' track team, led by Coach Bill McClure, celebrates its win at the Sunman Dearborn Invitational, the last big meet of the season.
Photo by Chris Smith

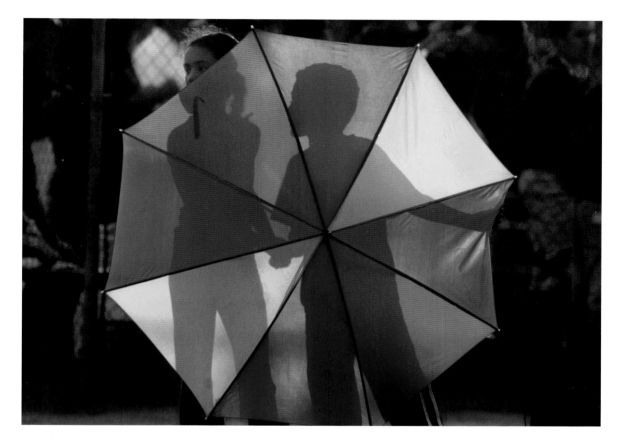

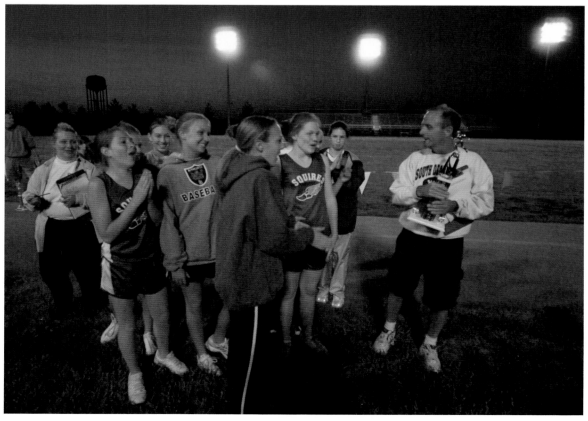

SCHEREVILLE
Carpenter Ray Wardell, 65, learns some new moves at the Second Street Dance Studio, which teaches everything from the fox-trot to the hustle. On weekends, Wardell, who's single, drives 40 miles from his Lake Station home to dance clubs in Chicago. "There's not much dancing around here," he explains.
Photo by Jeffrey D. Nicholls

Every year, the Borg-Warner Trophy gains another face: the winner of the Indy 500. Silver portraits of every champion since 1911 cover the 92-pound, 5-foot 2-inch cup. Commissioned in 1936 by the Borg-Warner Automotive Company, it permanently resides in the Motor Speedway Hall of Fame. Winners of the race take away an 18-inch replica called a "Baby Borg."

Photos by Mike Fender, The Indianapolis Star

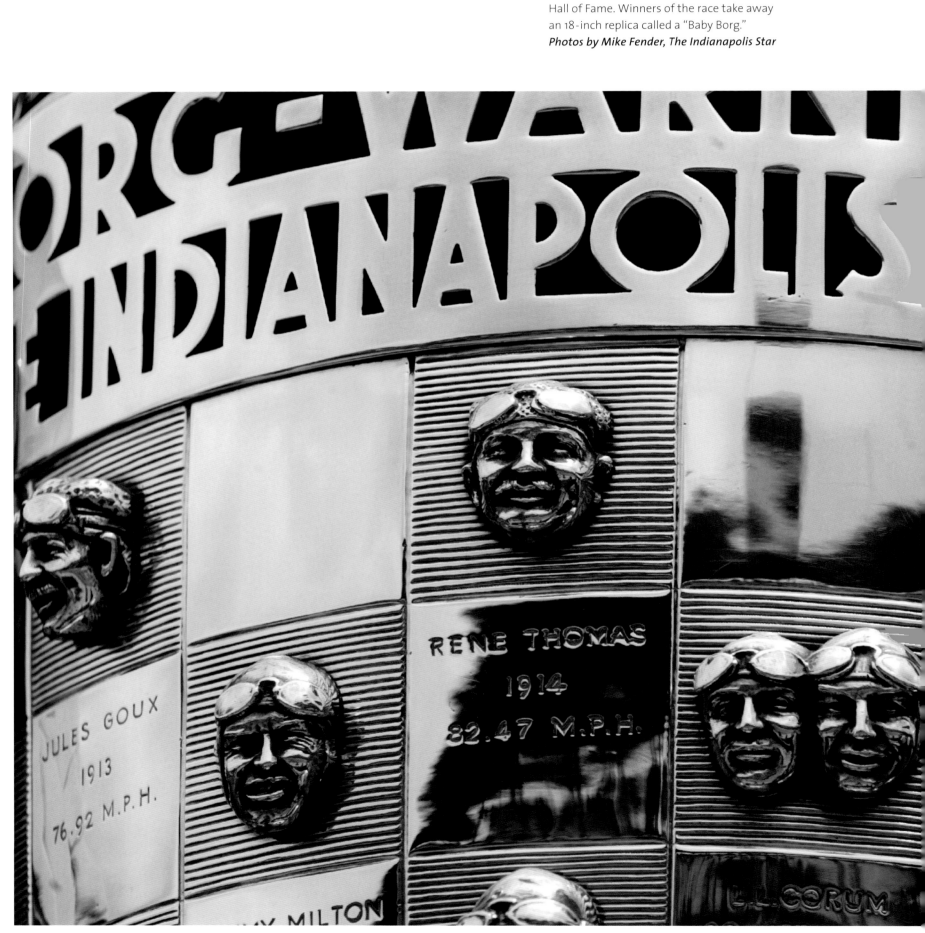

INDIANAPOLIS

After tech inspection, pit crew members push an Indy car onto the track for a qualifying lap. Cars must continually meet strict measurement standards during the "30 days of May"—the three weeks of time trials that hone the field to 33 of the best drivers in the world. These drivers meet at the Indianapolis 500 Mile Race held Memorial Day weekend.

INDIANAPOLIS

Three-year-old Tyler Ezell didn't quite "pass tech" in his souped-up Radio Flyer. Cars that do make the field travel "the Brickyard" at speeds up to 240 mph in the straightaways. The Indianapolis Motor Speedway got its nickname from the 3.2 million bricks originally used to build the 2.5-mile track in 1911.

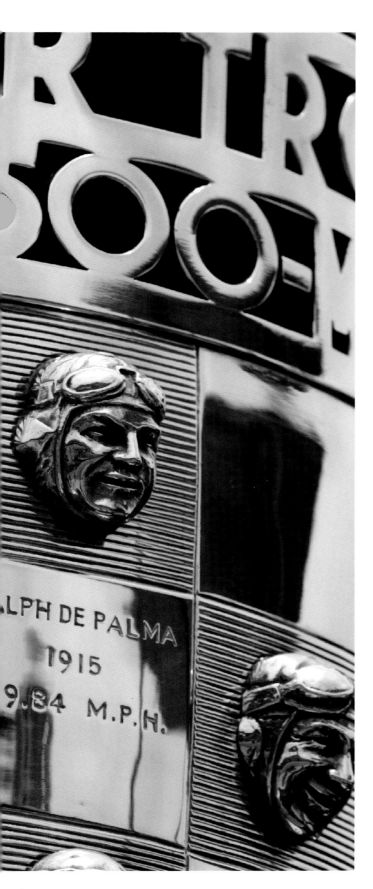

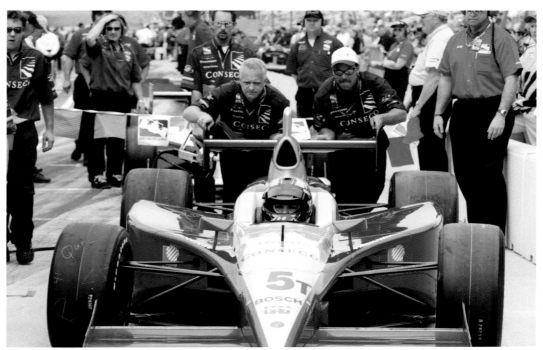

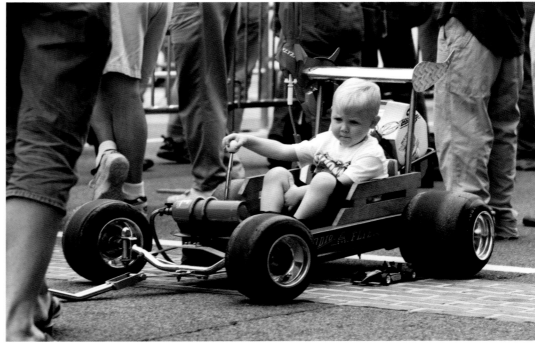

INDIANAPOLIS

It's the last day of qualifying for the "Greatest Spectacle in Racing" and Austin Schambers, 7, with souvenir flag in hand, watches the action from the front stands. On race day, the Indianapolis Motor Speedway fills with 400,000 people, the largest crowd at any single-day sporting event in the world.

Photo by Mike Fender, The Indianapolis Star

INDIANAPOLIS

Brazilian-born rookie Airton Dare, 25, had the slowest qualifying time of the 33 drivers in the 87th Indy 500, but it still earned him a spot on the legendary Foyt racing team—and this cooler of ice water. Looking on is teammate A.J. Foyt IV, 19.

Photo by Joe Krupa, The Star Press

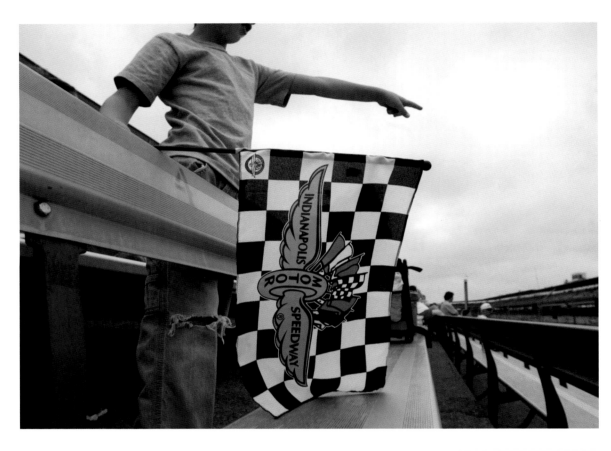

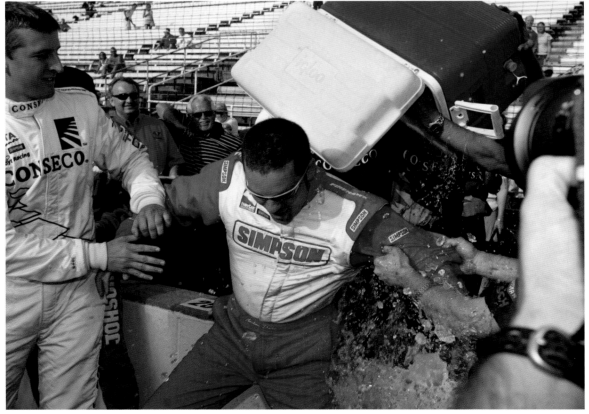

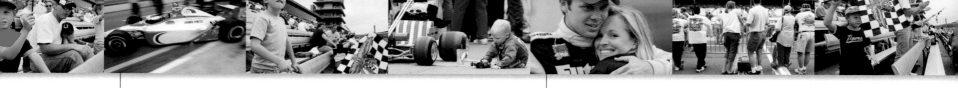

INDIANAPOLIS

At the beginning of his qualifying lap, up-and-coming driver Jimmy Kite, 27, blasts off, accelerating from 0 to 100 mph in four seconds. Stakes are high: The Indy 500 purse is $10 million, with the winner taking home $1.3 million.

Photo by Mike Fender, The Indianapolis Star

INDIANAPOLIS

After winning the Infinity Pro Series Freedom 100, Ed Carpenter hugs his mom, Laura George, in the winner's circle. The Pro series is the equivalent of the minors for the Indy Racing League and the Indianapolis 500.

Photo by Joe Krupa, The Star Press

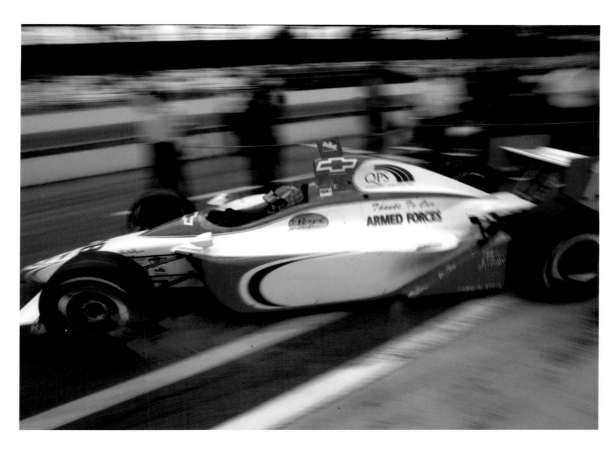

LAFAYETTE
Intercollegiate crew began as a male sport with the first formal matchup between Harvard and Yale in 1853. One hundred and fifty years later, the Purdue University women's crew team, ranked sixth in the nation, sweeps up the Wabash River, all muscled concentration.
Photo by Michael Heinz

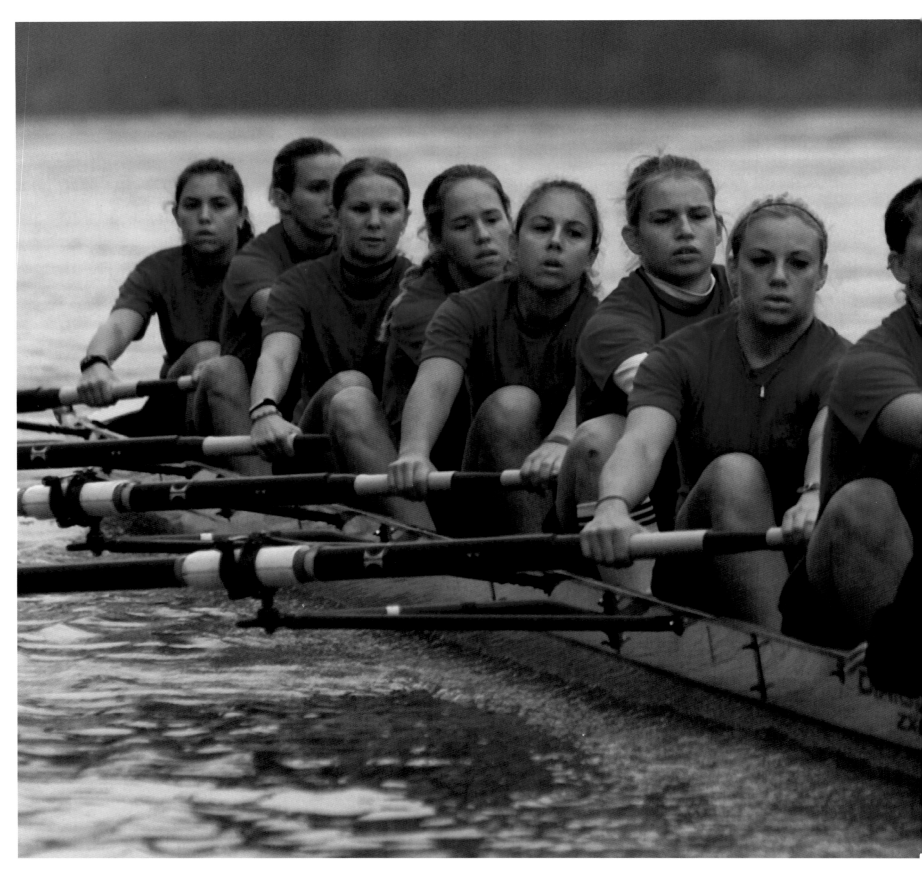

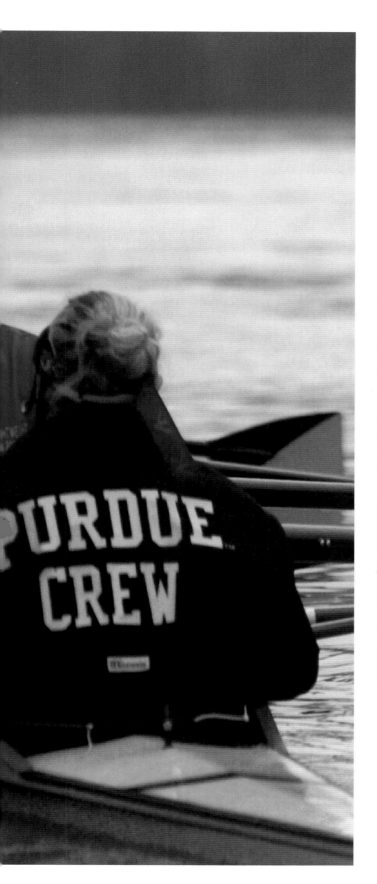

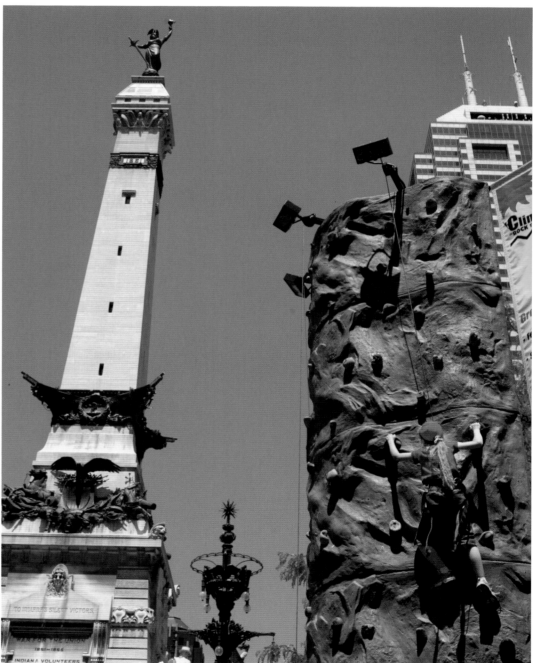

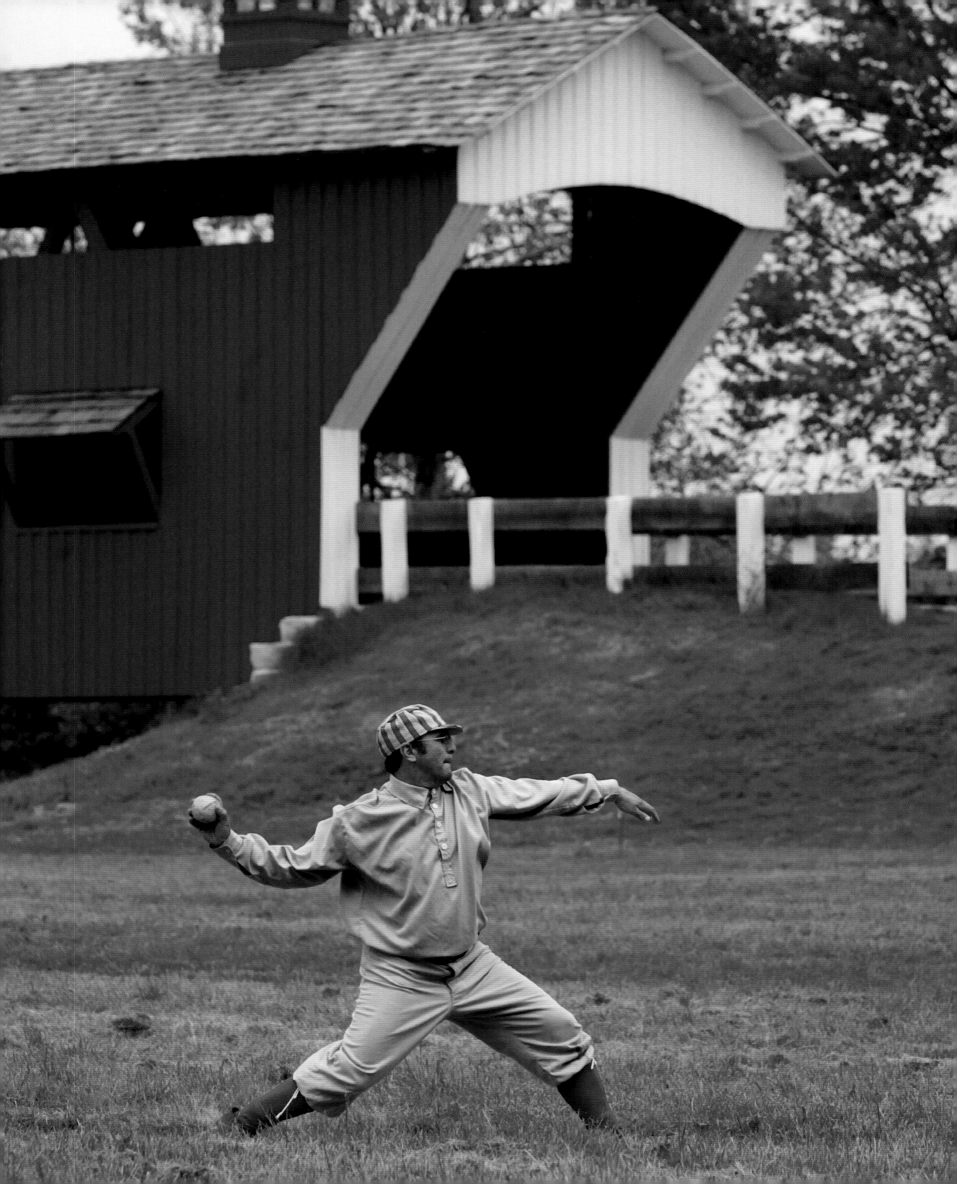

FISHERS

Stepping back in time, Dale Tomasi, a member of the White River Base Ball Club, dons period garb and plays glove free. His vintage baseball team plays according to rules first published in 1860. The playing field backs up to Cedar Chapel bridge, one of 91 covered bridges in the state.

Photo by Mike Fender,
The Indianapolis Star

NEWBURGH

Sarah Heitzman, 6, watches from the dugout as her team, High Pointe Rehab, takes on Art's Glass in a Newburgh Girls Softball League game. The 4- to 6-year-olds get five pitches to hit. If they miss them, they hit off the tee.

Photo by Denny Simmons

GREENFIELD

Cat fight: The Rushville High School Lions line up before an evening game against the Greenfield-Central High School Cougars. As mighty as they look, the visiting Lions lost to the Cougars, 2 to 1.

Photo by Tom Strickland

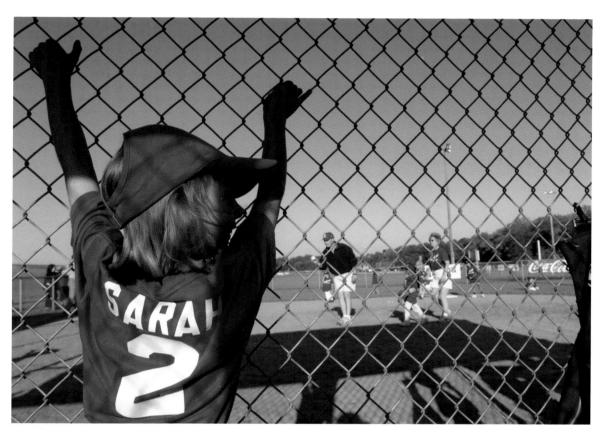

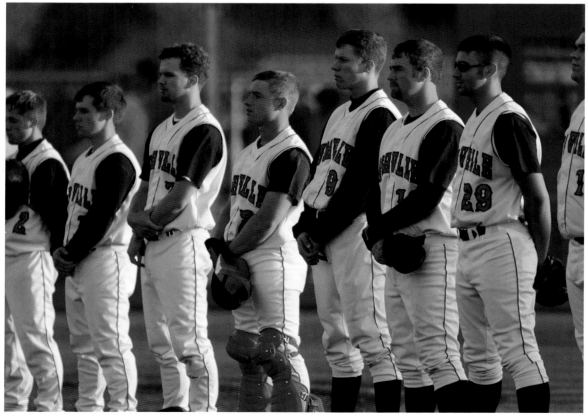

FERDINAND

Hugo Wagner has been pitching—and winning—
horseshoes in the Ferdinand Horseshoe League
for 37 years, collecting many trophies. His secret:
"They tell me my shoe turns one-and-a-half
times, then spins open at the stake."

Photo by Andrew Otto, The Herald

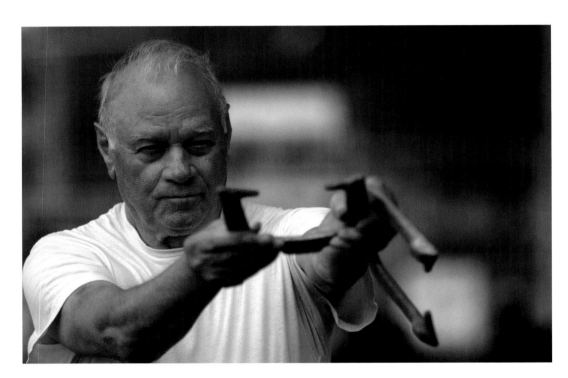

HAMMOND

For more than 40 years, the Lost Marsh of Hammond was used for discarded slag (a nontoxic byproduct of steel making). In 1999, the city council approved a $4.9 million bond to redevelop the land. The multiuse recreational area includes wetlands, two golf courses, and a driving range, which Serafin Garcia of Hobart uses to hone his swing.
Photo by Jeffrey D. Nicholls

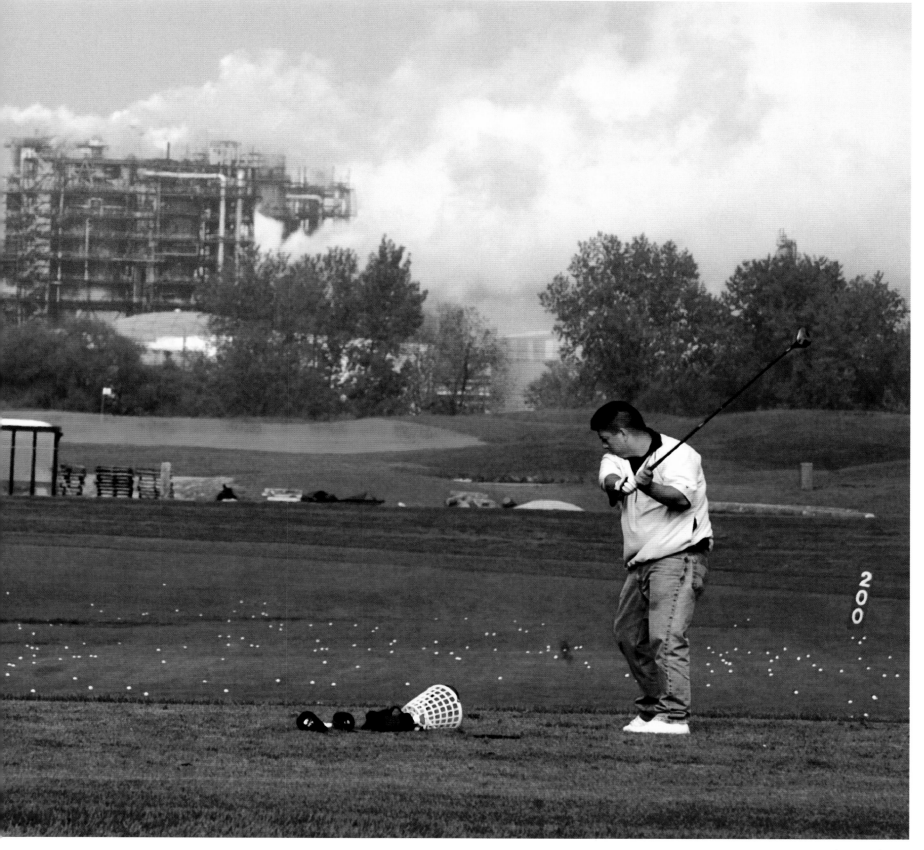

KNIGHTSTOWN

Rock 'n' roll: The annual picnic for Knightstown
High School's seniors (parents and siblings can
come, too) sports tractor-tire rolls, volleyball and
soccer games, and a slip 'n' slide with a dunking
pool. Teacher Daryl Keesling hosts the fête every
year at his 120-acre farm.

Photo by Mike Fender, The Indianapolis Star

DUBOIS

Having a field day: Second-graders Taylor Hopf,
Quinton Hawes, and Nicole Dodd cheer after
winning a tug-of-war at the Dubois Elementary
School's annual Field Day at the end of the
school year.

Photo by David Pierini, The Herald

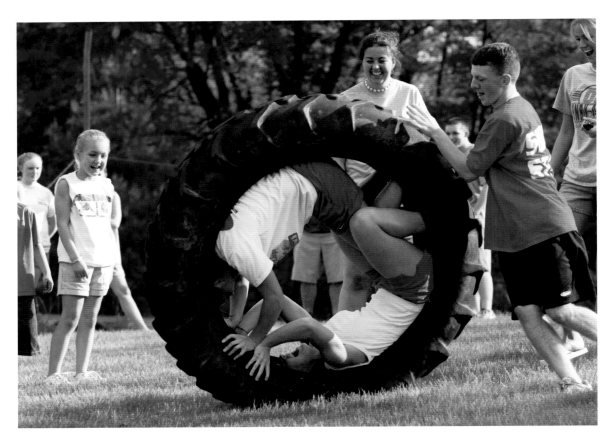

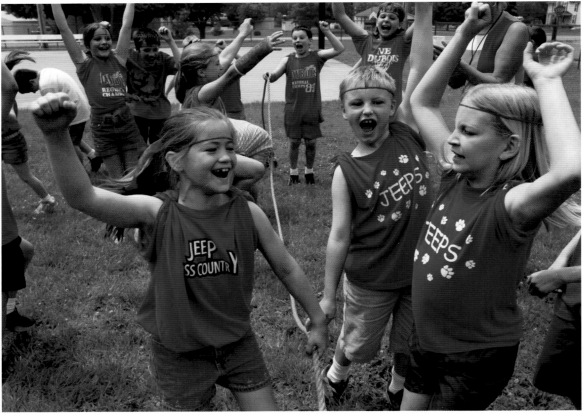

KOKOMO

Corinna Cottingham, 10, plays Pass the Orange at the Kokomo Flipsters' annual slumber party. The gymnastics center's first all-nighter, held 12 years ago, attracted 30 girls. In 2003, it drew 200. The entertainment? Games, contests, pizza, and movies.

Photo by Tim Bath, Kokomo Tribune

HUNTINGBURG

Southridge High School football player Matt Lueken, 16, vents after pressing his personal best: 245 pounds. Teammate Craig Seib spots. The record was set during a game of S-I-S-S-Y (the weightlifting version of H-O-R-S-E), invented by Southridge coach and weight room mentor Steve Winkler.

Photo by Andrew Otto, The Herald

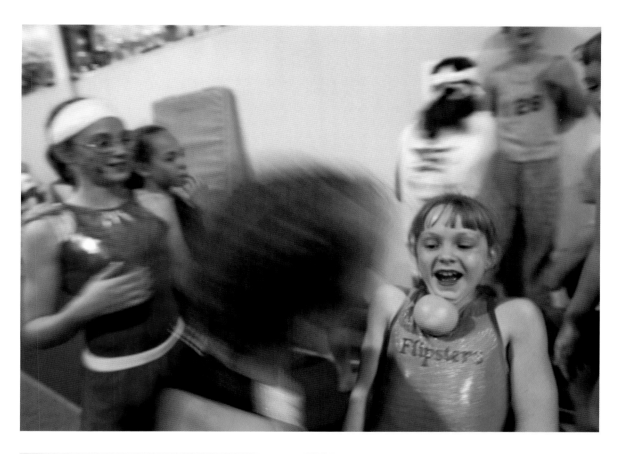

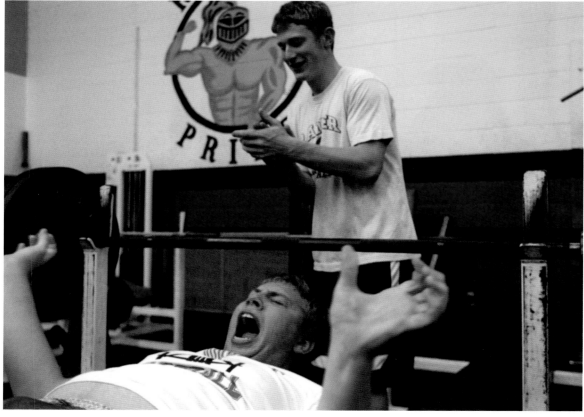

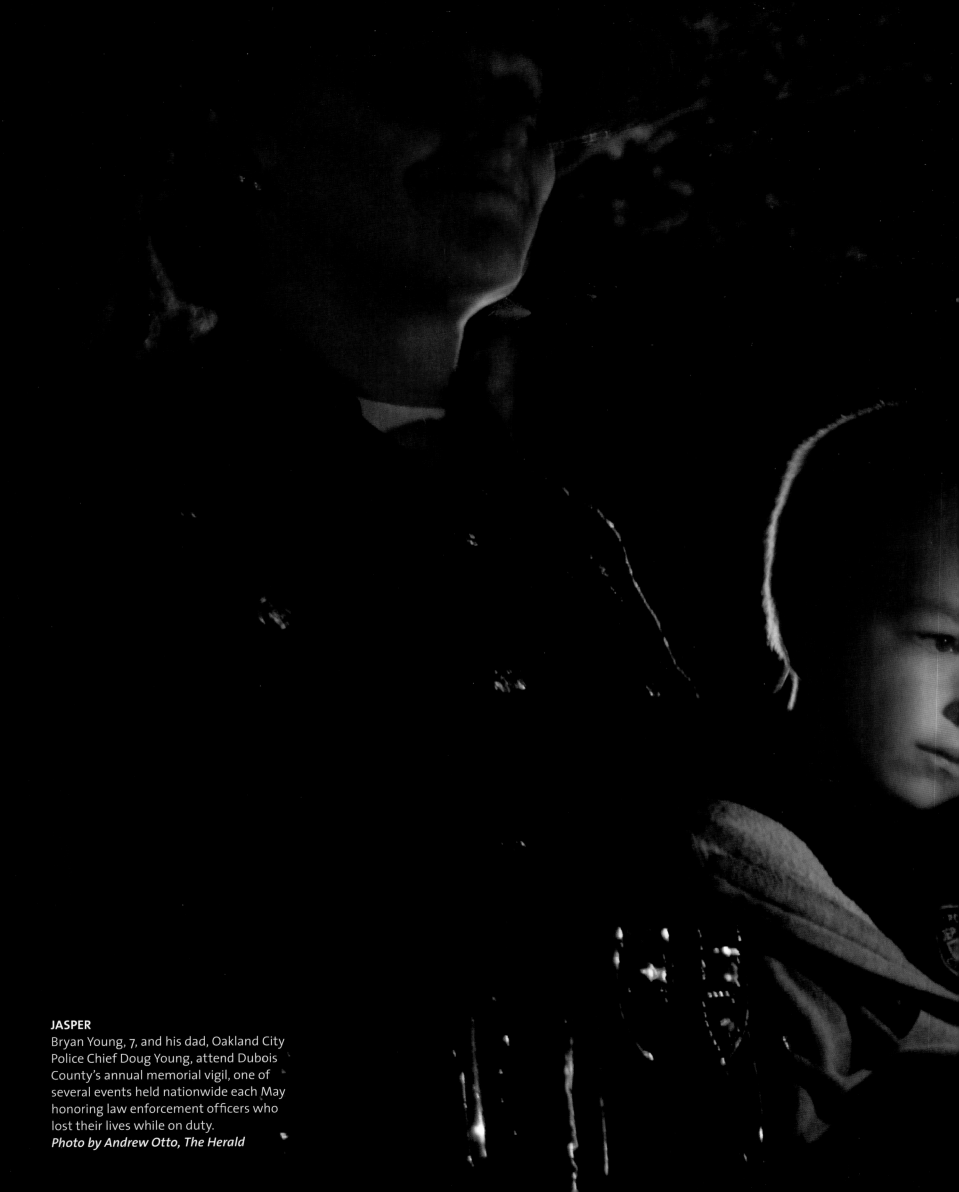

JASPER
Bryan Young, 7, and his dad, Oakland City Police Chief Doug Young, attend Dubois County's annual memorial vigil, one of several events held nationwide each May honoring law enforcement officers who lost their lives while on duty.
Photo by Andrew Otto, The Herald

Reason To Believe

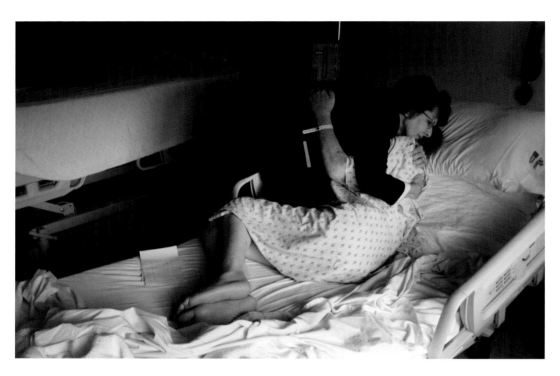

LAFAYETTE
Sister Raphael Kochert, a chaplain at St. Elizabeth Medical Center, embraces Rose Widup, a kidney dialysis patient. Sister Raphael taught grade school for decades but wanted "to use talents I wasn't using." She initially felt helpless with patients but learned to listen to them. "I let God do the rest."
Photo by Frank Oliver

BLOOMINGTON

Traveling Buddhist monk and artist Kalsang Jenpa rests quietly in his room at the Tibetan Cultural Center, after a long day painting intricate designs on the center's new temple. Former Indiana University instructor Thubten Norbu, the Dalai Lama's elder brother, opened the 90-acre retreat in 1979 to promote Tibetan culture in the Midwest.
Photo by Jeremy Hogan

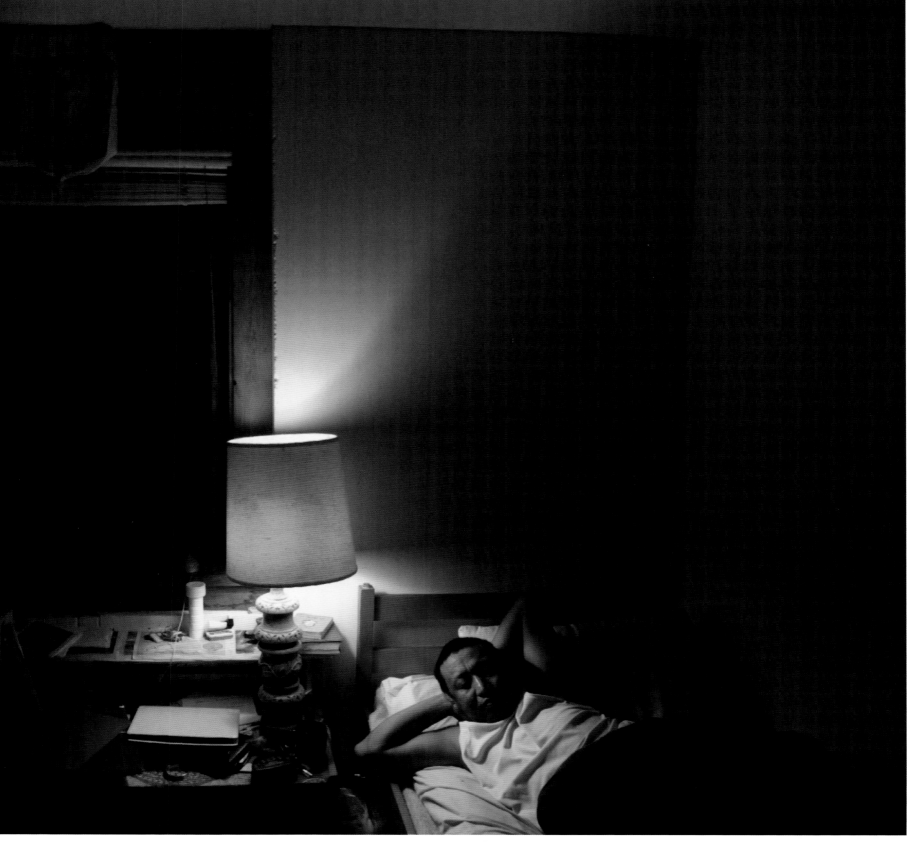

GARY
A congregant at Zion Progressive Baptist Church follows a verse cited by Pastor Norman Hairston during his Sunday-morning sermon.
Photo by Jeffrey D. Nicholls

MALACHI

CHAPTER 3

BEHOLD, I will send

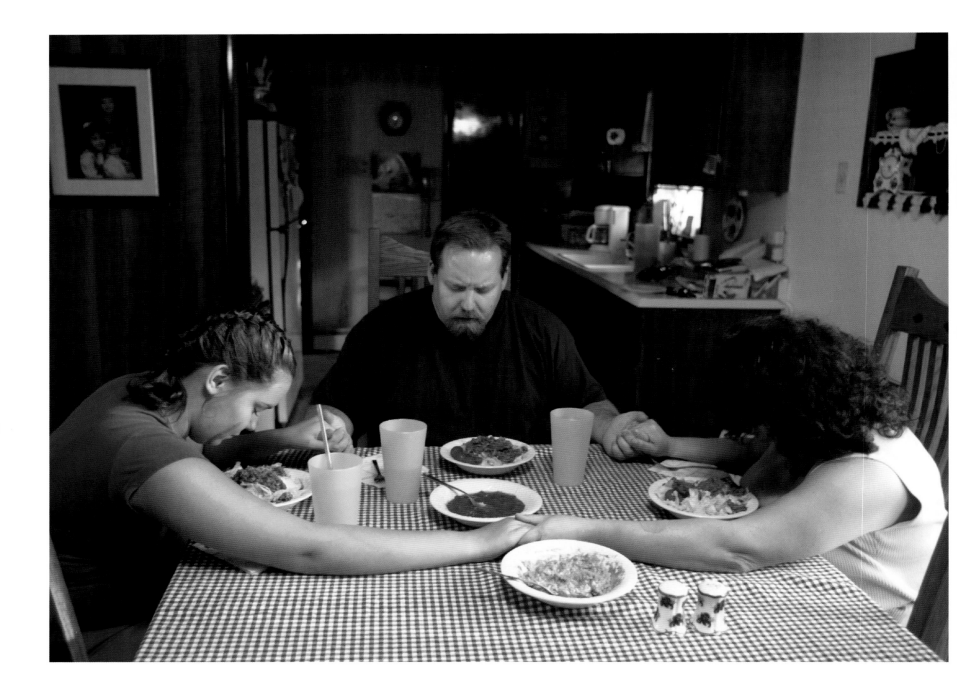

BLOOMINGTON

The two older kids are in college and working, but Rachel Peace and her parents Scott and Carrie Lynn still hold on to their tradition of eating dinner together every night. The one exception is "date night." Scott and Carrie Lynn believe that going out once a week keeps their 20-year marriage fresh and shows the kids that relationships need nurturing.
Photo by Jeremy Hogan

SANTA CLAUS

Sister sisters: Sister Elaine Knapp, 86, and Sister Mary Terence Knapp, 74, have been Benedictine nuns with the Immaculate Conception Monastery since 1949. For 13 years, they've lived in Santa Claus near St. Nicholas Church, where Sister Mary leads the parish. "When the job was offered, I said, 'It's a package deal. Sister has to come, too.'"
Photo by Vincent Pugliese

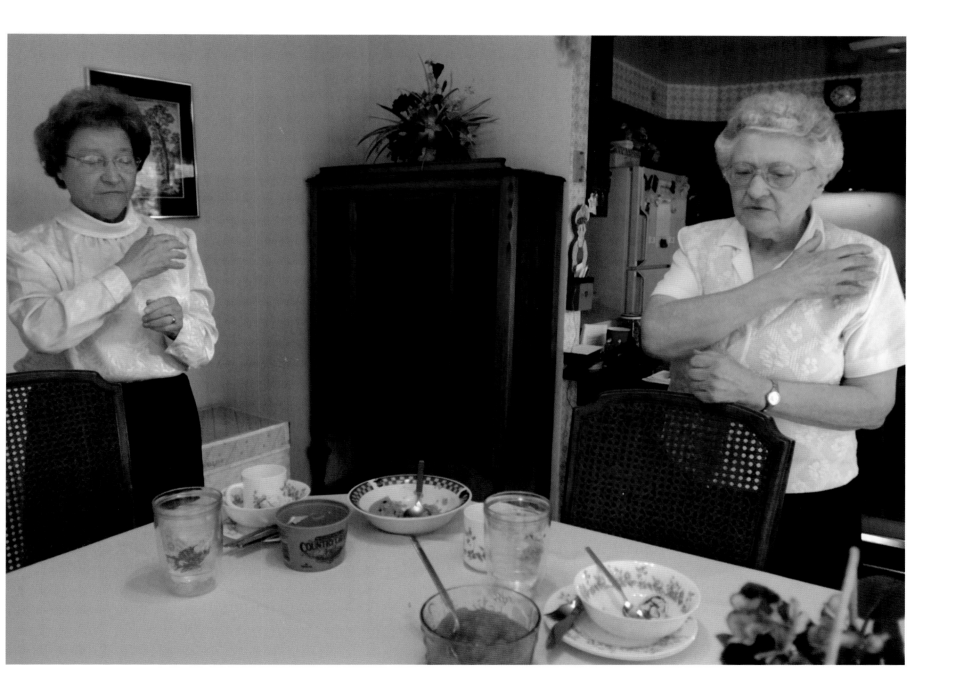

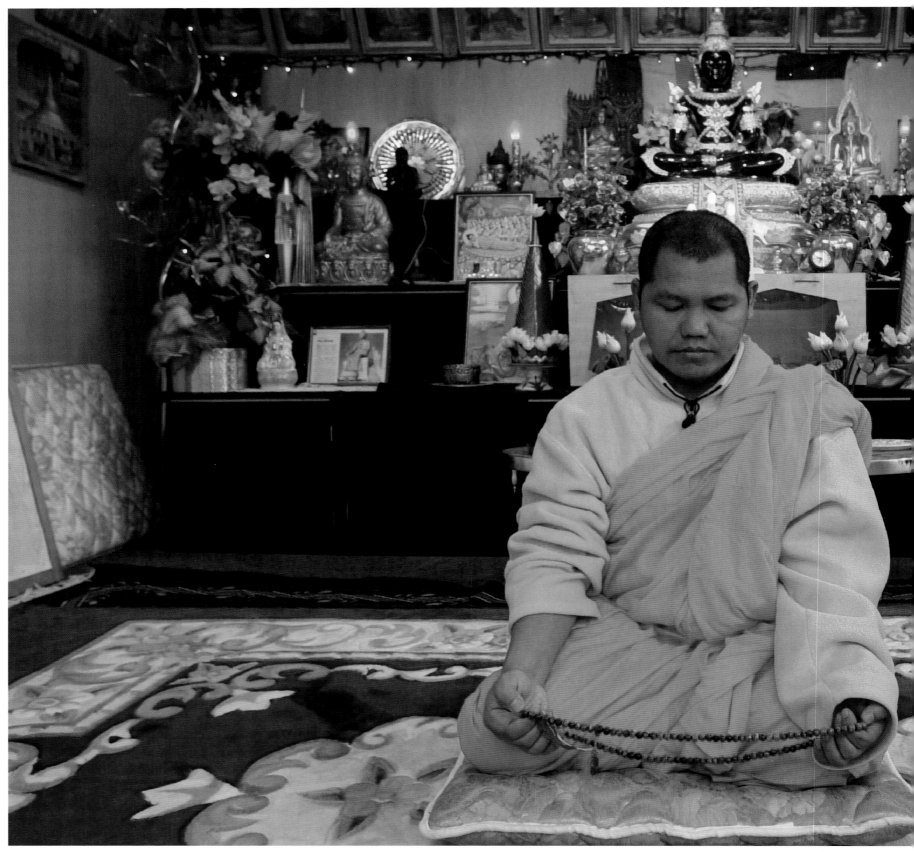

FORT WAYNE
U Thu Nan Da, a Mon Buddhist monk from Myanmar (formerly Burma), meditates at the Mon Buddhist Temple on Decatur Road. The temple hosts gatherings and services in its cavernous storefront, which used to house a car dealership. A UN refugee resettlement site since 1990, Fort Wayne is home to about 1,500 Burmese refugees, the largest such population in America.
Photos by Steve Linsenmayer,
The Fort Wayne News-Sentinel

FORT WAYNE

Can you hear me now? Monashin Dhamma Dinna, leader of the Mon Buddhist Temple, is running late and checks in with an immigrant who needs help with translation. Members of the temple donated the phone. Relying entirely on alms, Buddhist monks own no personal possessions.

FORT WAYNE

On behalf of Aung Win, Dhamma Dinna haggles over the price of a Ford Focus with salesman Chad Yates. Because of his fluency in English, the monk often helps members of Fort Wayne's Mon community secure life's basics, such as housing, transportation, and employment.

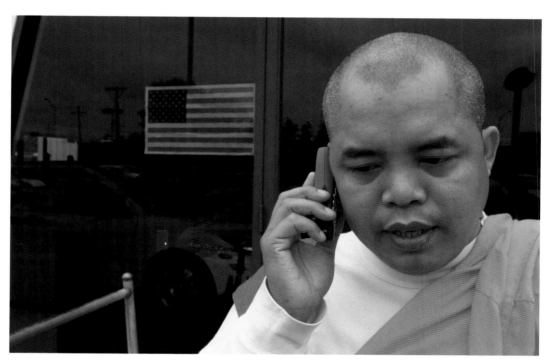

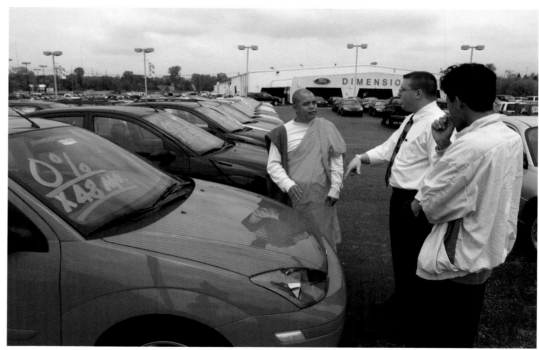

INDIANAPOLIS

"The Lord called me to preach," says 13-year-old Justin Williams. He began his scriptural studies at age 6 and gave his first sermon when he was 9. The youngest minister at the Mount Olive Missionary Baptist Church, he assists head pastor Reverend Donald Hudson with Sunday services and the church's youth group.

Photos by Matt Detrich, The Indianapolis Star

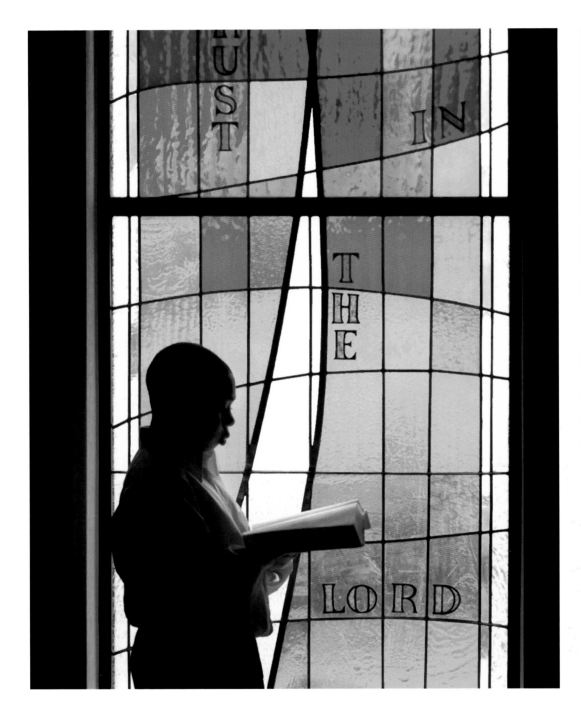

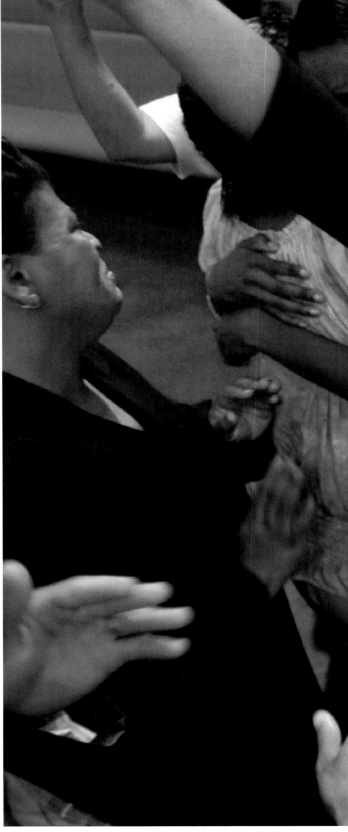

INDIANAPOLIS
Supported by other church members, Tonya
Green is "rededicated" into the Mount Olive
Missionary Baptist Church. A member for 10
years, Green attended a different church for a
year and a half and was ordained as a minister,
but then decided to return to Mount Olive's fold.

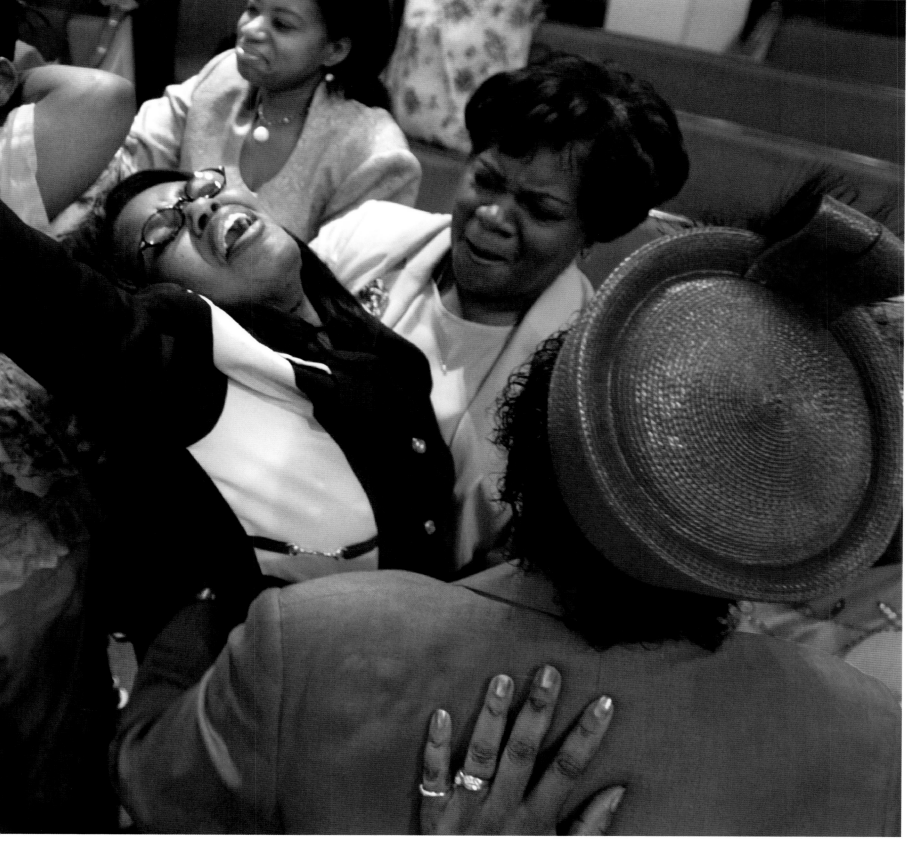

SCHNELLVILLE
In 1873 a clan of German immigrants built the first incarnation of Sacred Heart Catholic Church. The small, wood-framed structure, designed to hold 20 families, was replaced in 1914 with a larger brick church accommodating 250 families.
Photos by David Pierini, The Herald

FERDINAND
During a musical event at the Monastery Immaculate Conception infirmary, Sister Paulette Seng (right) sashays across an impromptu dance floor with Sister Blandina Wendholt, 92.

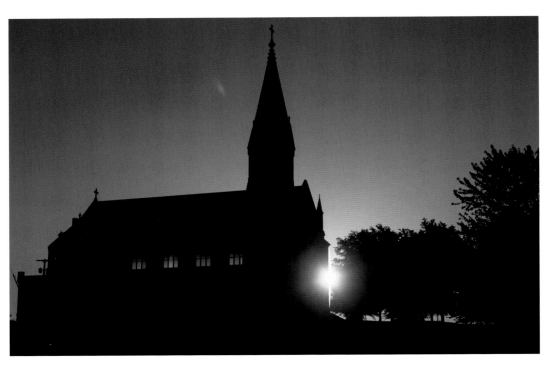

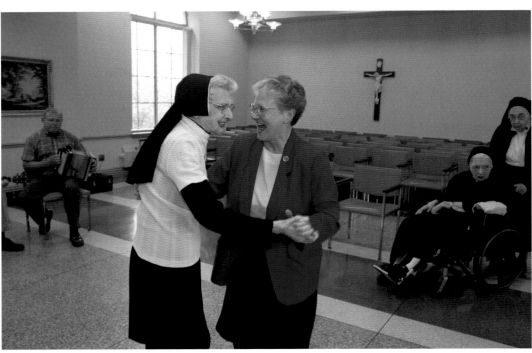

FERDINAND

In addition to praying the Liturgy of Hours seven times daily, many of the 216 nuns at the Monastery Immaculate Conception say extra prayers for prospective Benedictine nuns. Through an active recruiting program, interested women are paired with nuns and invited to spend a day, a weekend, or a week experiencing the monastic life.

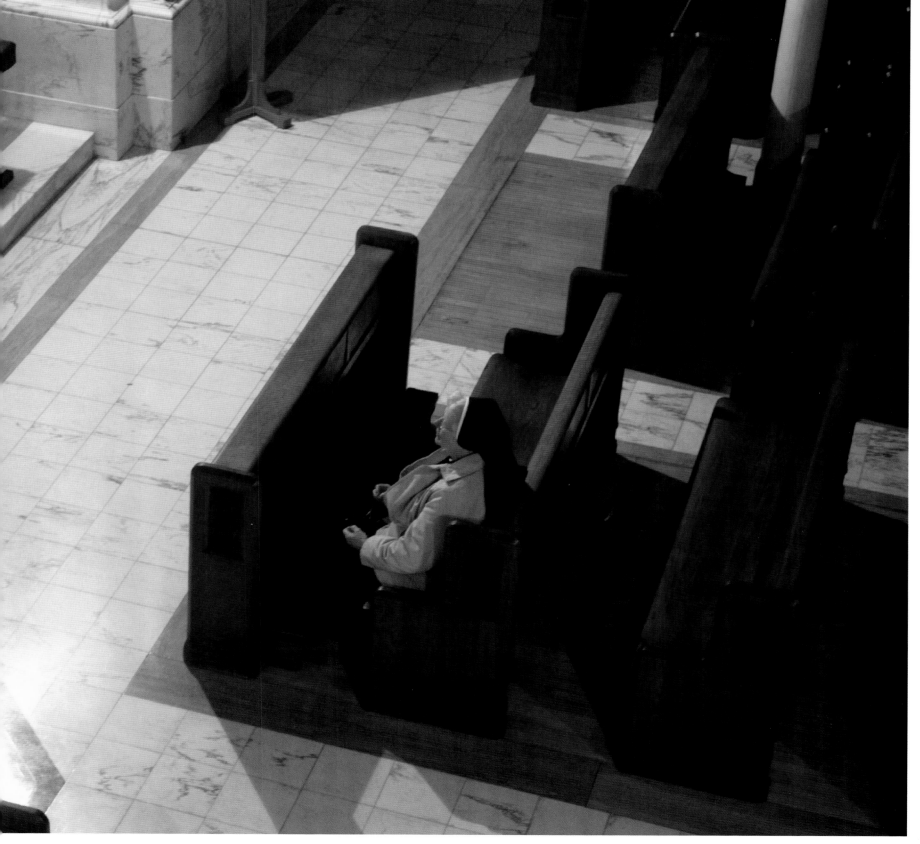

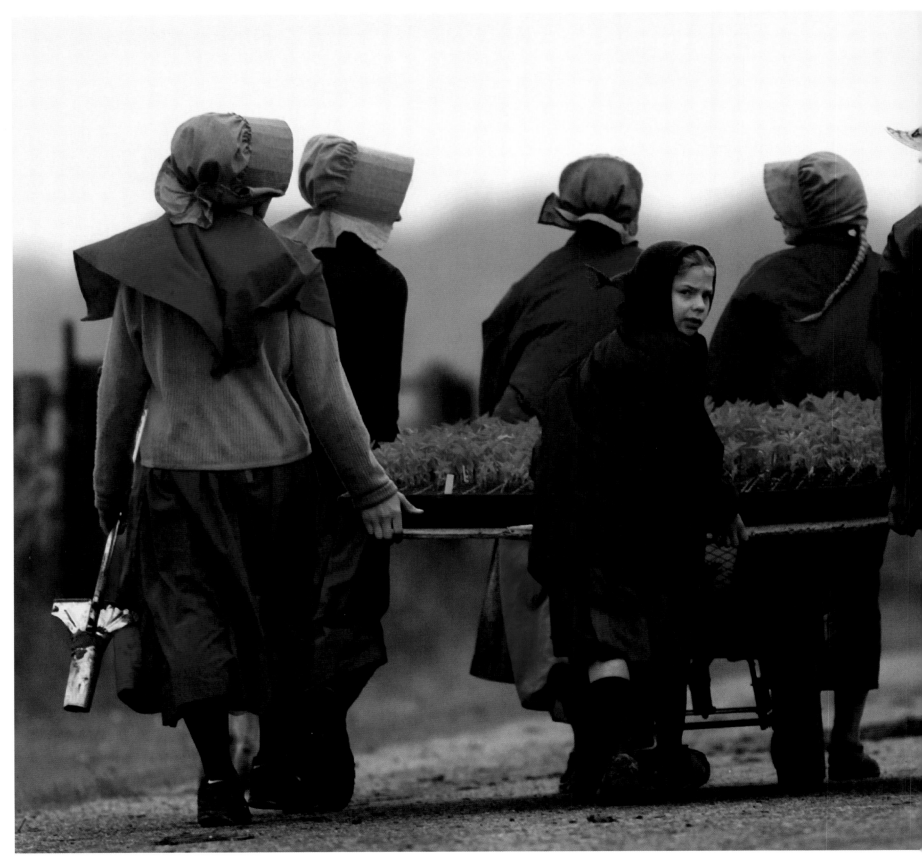

CAMDEN

Seven of David and Sharon Brumbaugh's 15 children take green pepper seedlings out for spring planting. The Brumbaughs are members of the Old German Baptist Brethren, the most conservative branch of a religious group that first arrived in Pennsylvania in 1719. Nicknamed "dunkers" for their full-immersion baptisms, the Brethren pride themselves on their nonviolence and nonconformity.

Photos by Frank Oliver

CAMDEN

The Brumbaughs hang their straw hats and jackets on the porch before going inside for their lunchtime meal.

CAMDEN

After a morning of plowing and planting, David Brumbaugh, 50, catches his breath. Sarah, one of his nine daughters, puts away the horses.

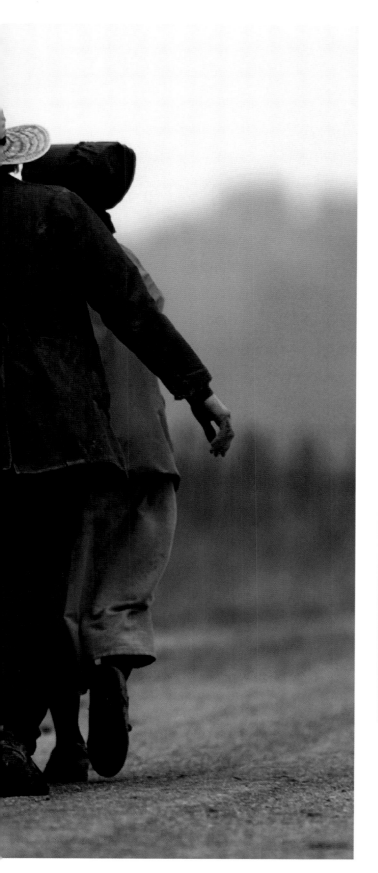

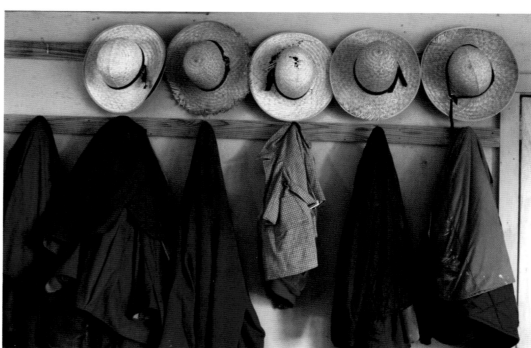

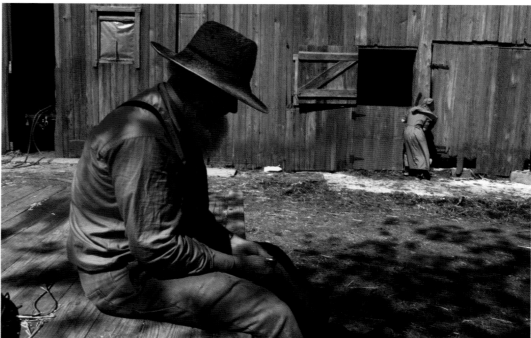

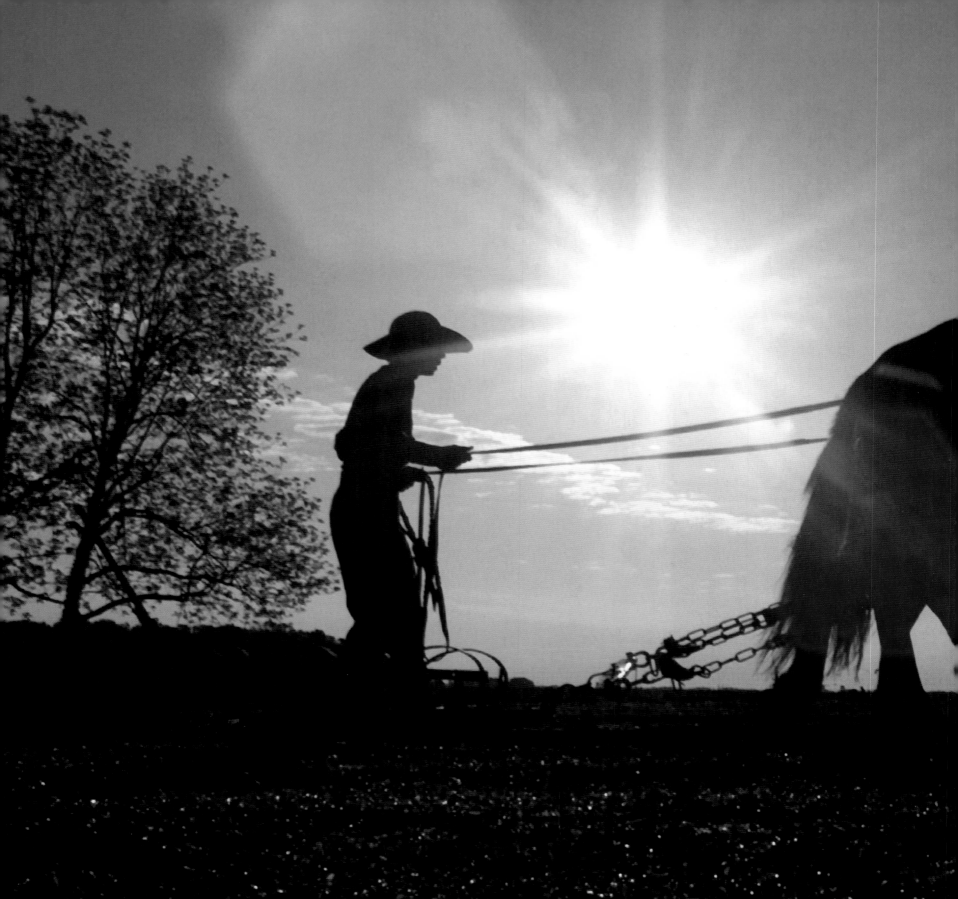

CAMDEN
Daryl Brumbaugh tills the family fields.
His father David is an impassioned organic
farmer who says he will not put "anything
that would harm an earthworm" in his soil.
The family grows 60 kinds of produce on
their 80-acre farm and sells what they do
not eat.
Photo by Frank Oliver

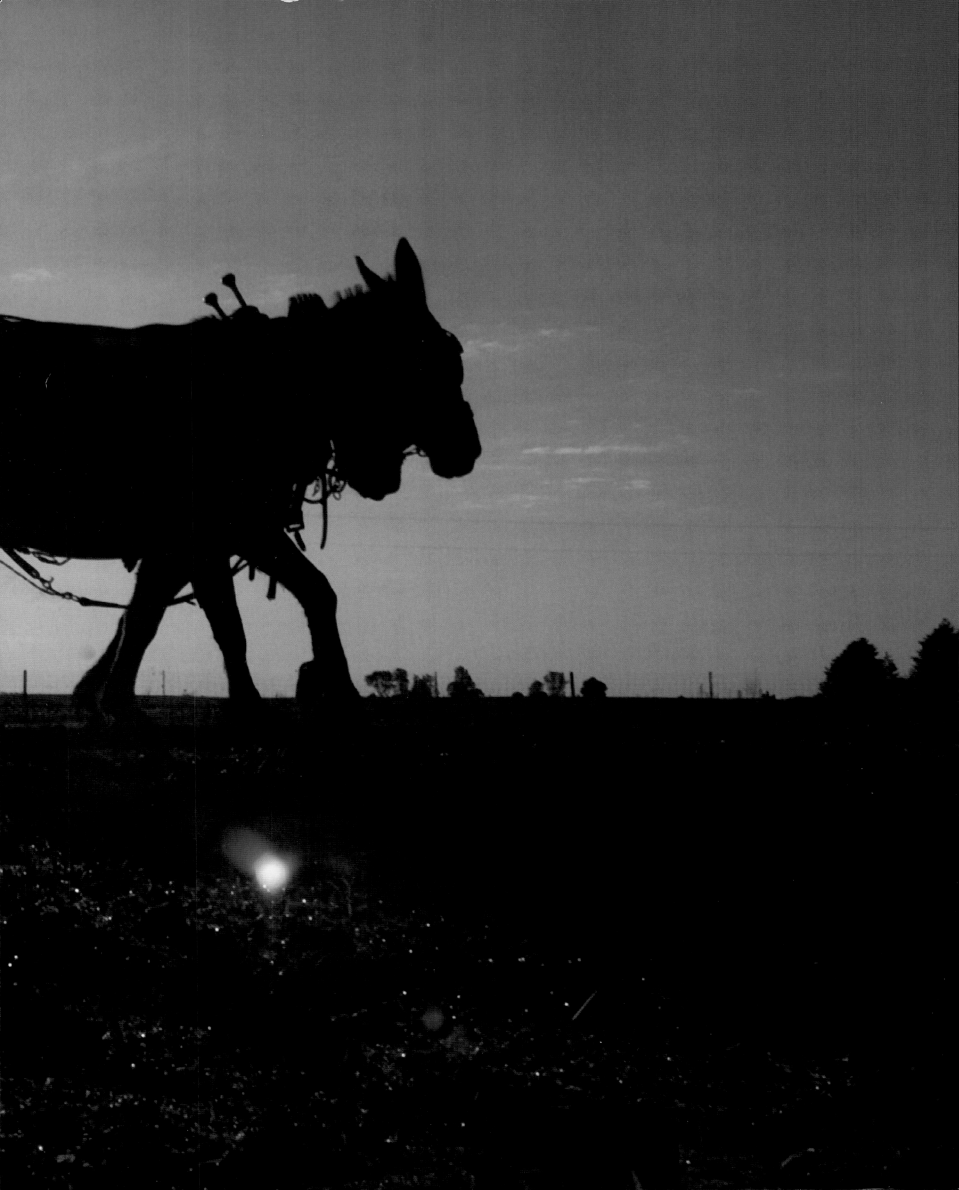

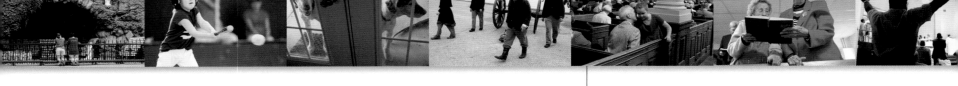

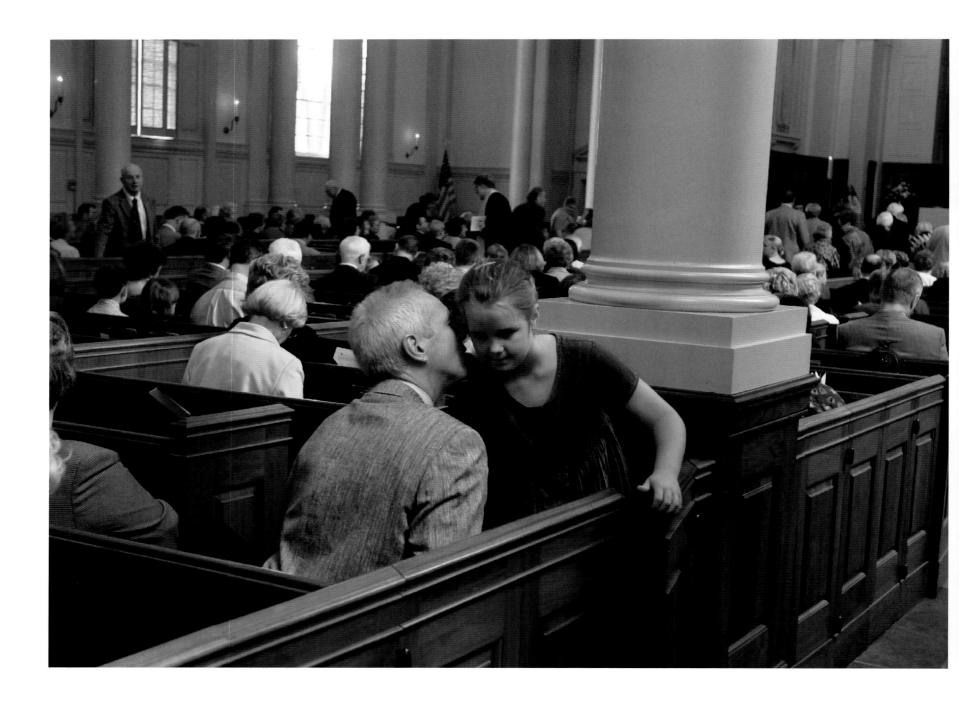

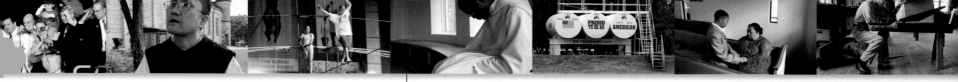

ST. MEINRAD

Brother Honoré Djilo of Togo meditates before noon prayers at St. Meinrad Archabbey. Founded in 1854 by Swiss Benedictines, the abbey is home to 125 monks, a seminary, lay theology school, publishing house, and casket marketing business that offers people inexpensive wooden burial boxes.

Photo by Steve Raymer

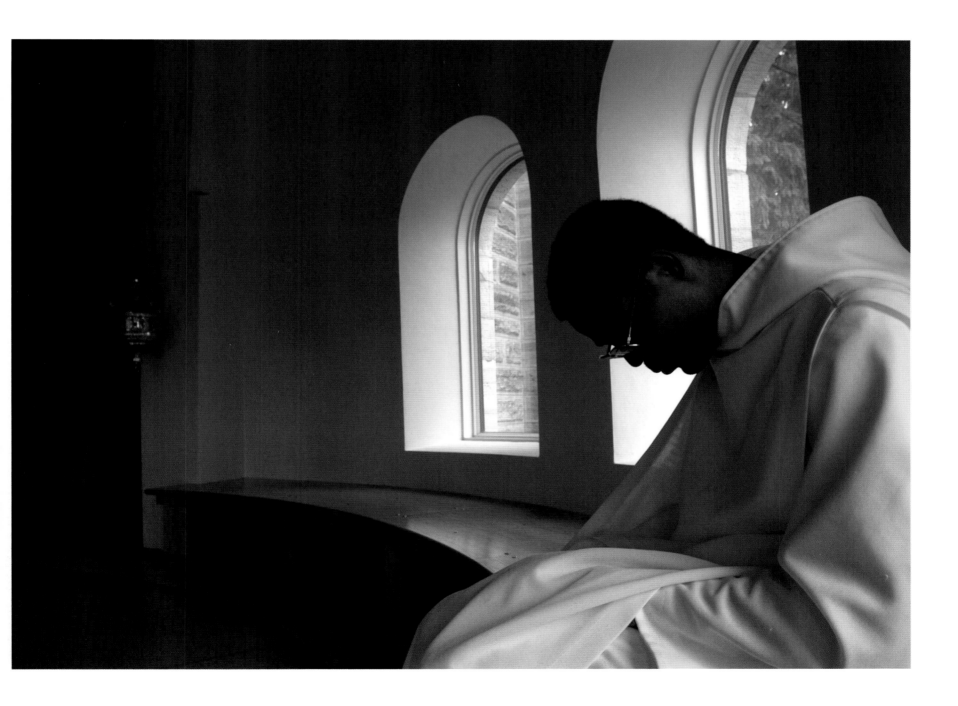

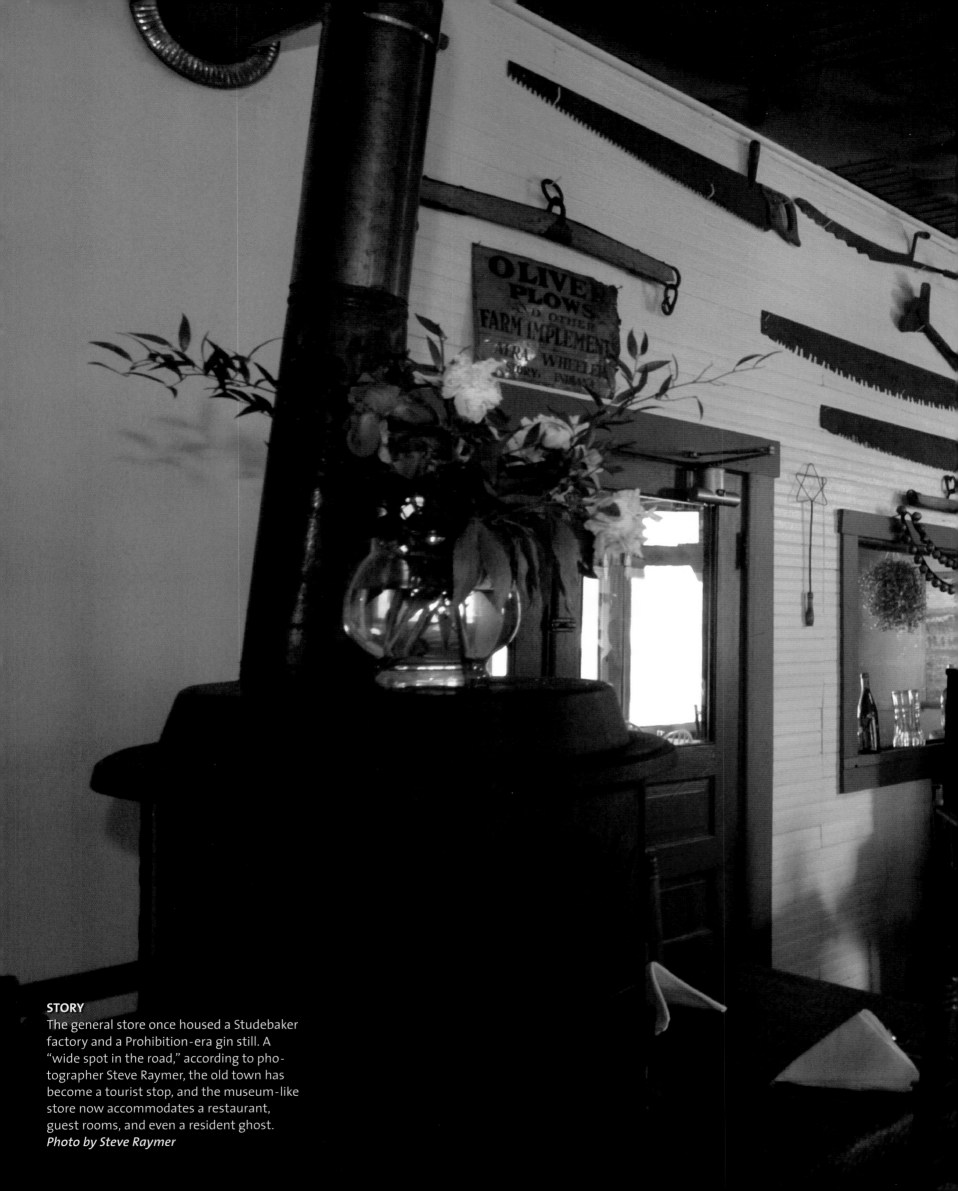

STORY
The general store once housed a Studebaker factory and a Prohibition-era gin still. A "wide spot in the road," according to photographer Steve Raymer, the old town has become a tourist stop, and the museum-like store now accommodates a restaurant, guest rooms, and even a resident ghost.
Photo by Steve Raymer

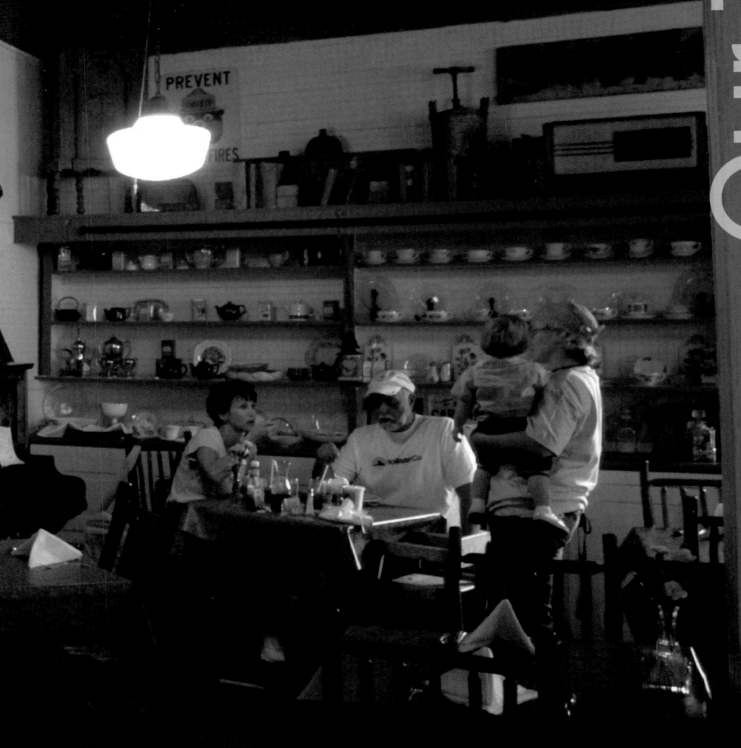

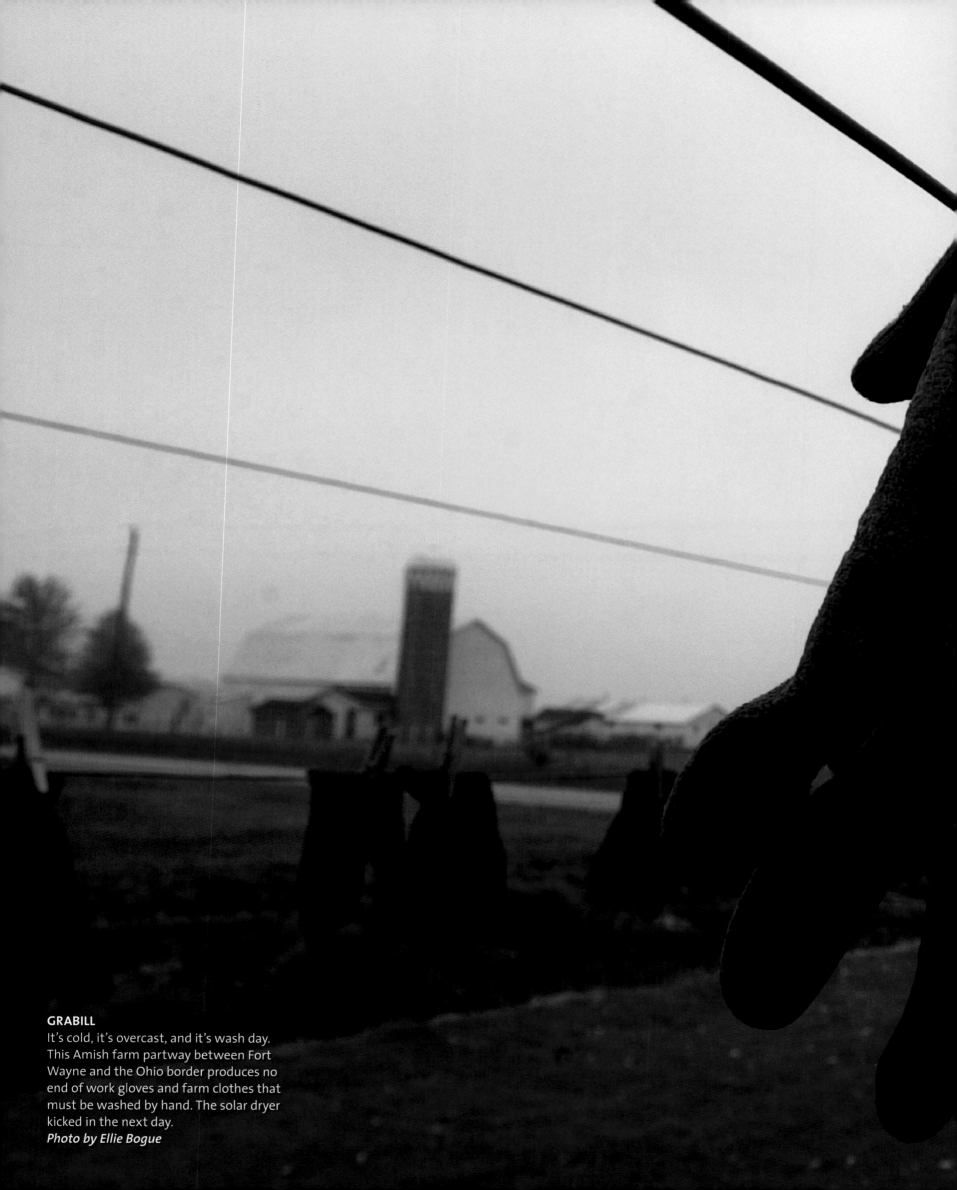

GRABILL
It's cold, it's overcast, and it's wash day. This Amish farm partway between Fort Wayne and the Ohio border produces no end of work gloves and farm clothes that must be washed by hand. The solar dryer kicked in the next day.
Photo by Ellie Bogue

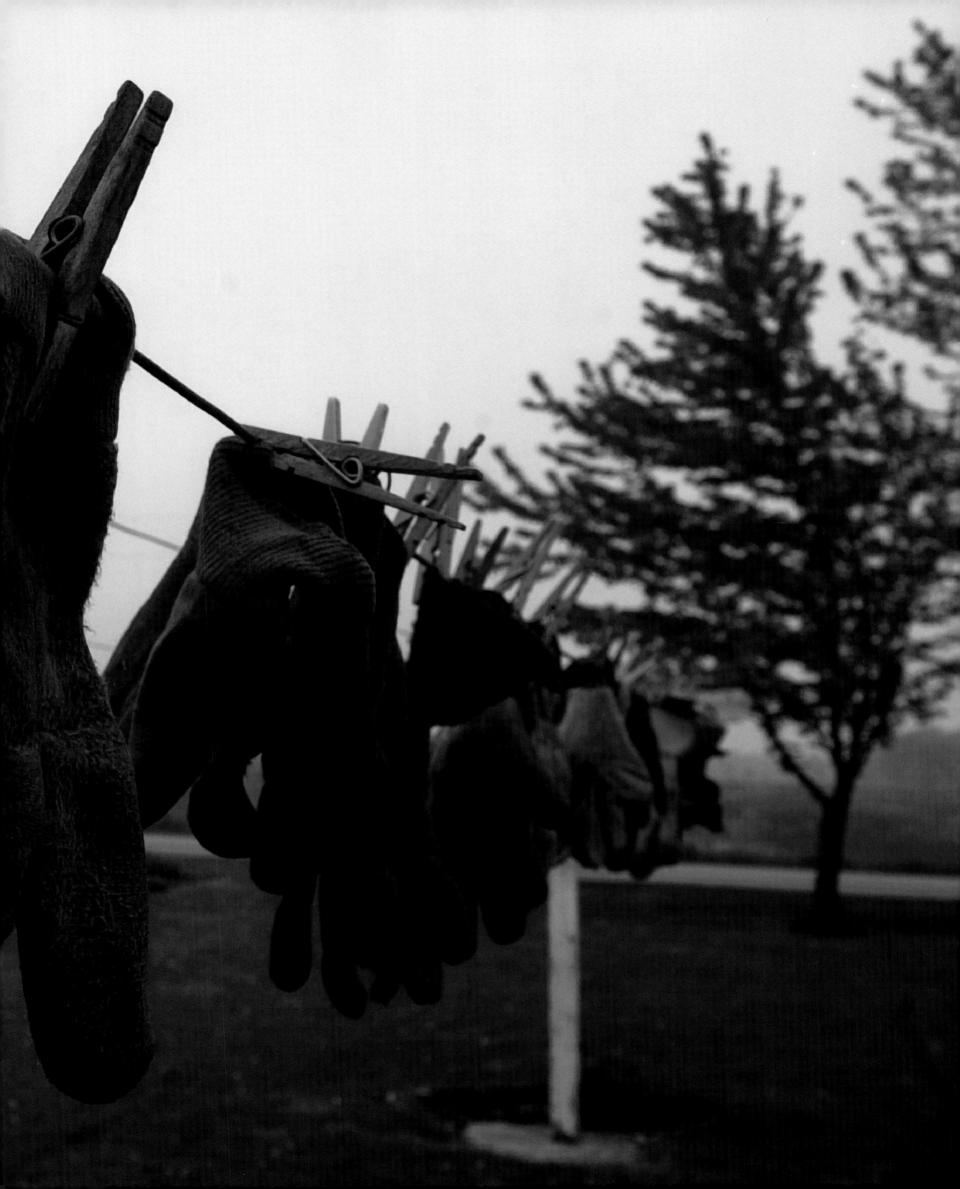

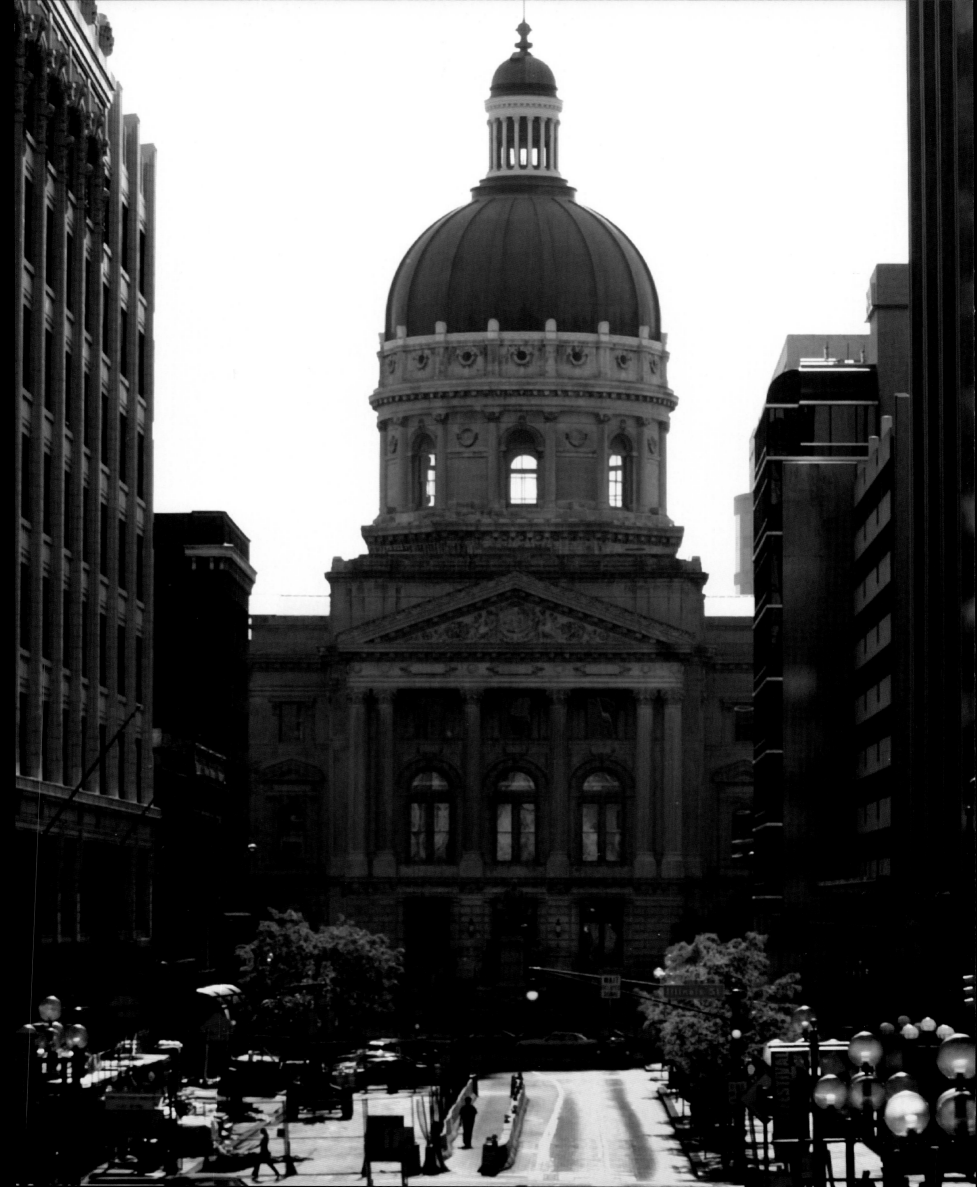

INDIANAPOLIS

The State House caps Market Street downtown. Designated the state capital in 1821, it avoided the fate of many rust belt cities in the 60s when it merged with suburban Marion County and spread out the tax burden. The strategy arrested urban flight, and Indianapolis is now uniquely fiscally healthy for its size.

Photo by Matt Detrich,
The Indianapolis Star

MONTGOMERY

Every Friday night 3,000 people from Indiana and neighboring states travel to Montgomery (pop. 300). At Dinky's Auction, started in 1996, they haggle over everything from llamas to laundry baskets. The auction serves as a gathering spot for many of Montgomery's Amish like Paul Raber, one of 12 table-top auctioneers.

Photo by David Pierini, The Herald

CROSS PLAINS

Once a working grain elevator, Cross Plains Feed Mill now purveys antiques and collectibles. As co-owner Dave Chandler (standing with grandson Dylan) says in his southern Indiana drawl, "We sell today what grandma threw away." Chandler's partner, Chester Vogel, sits in front of the daily specials chalkboard. The men use the board to let off a little steam.

Photo by Jeremy Hogan

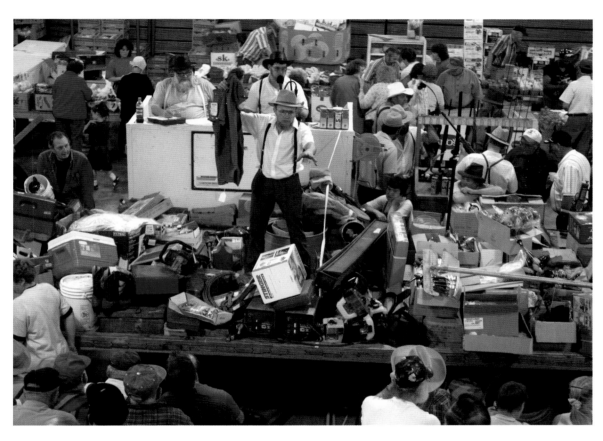

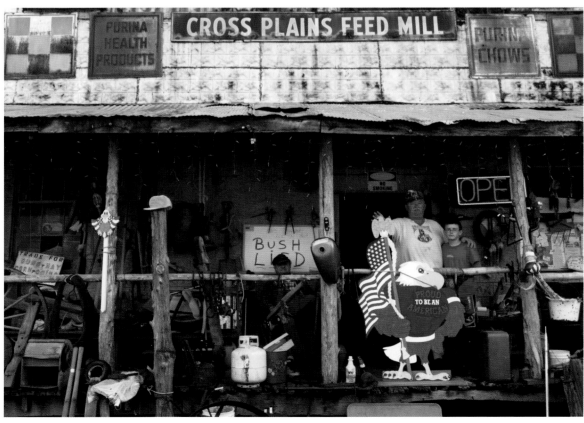

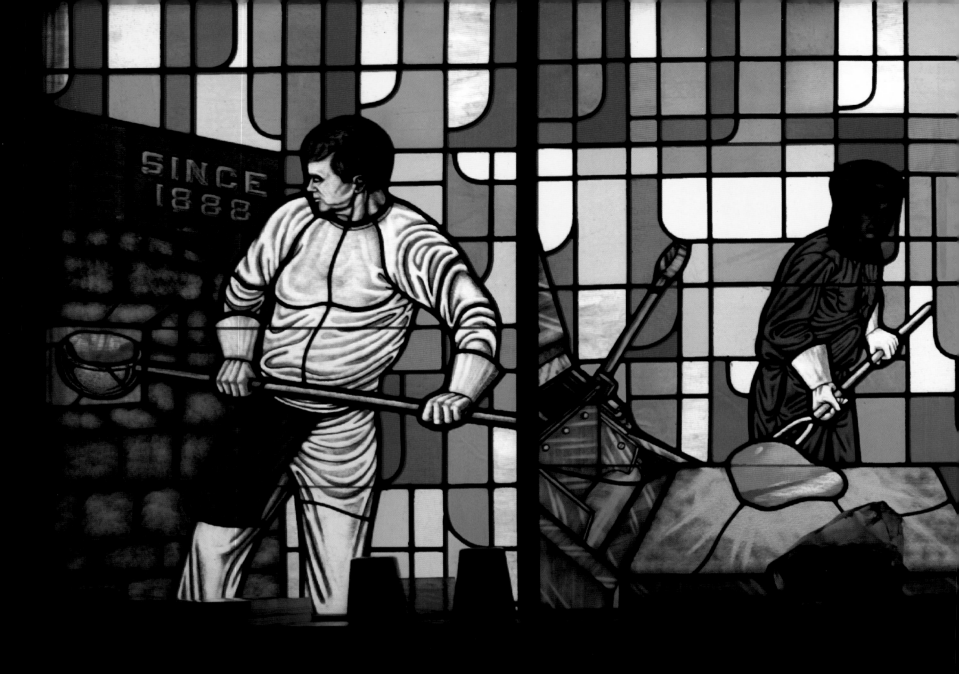

KOKOMO
This window in Kokomo Opalescent Glass's corporate offices depicts the steps required to produce stained glass. The company was founded in 1888 by Frenchman C. Edward Henry. It was taken over by three local entrepreneurs, whose families still run the firm. Louis C. Tiffany was the company's first big customer, purchasing glass for his trademark windows and lamps.
Photo by Tim Bath, Kokomo Tribune

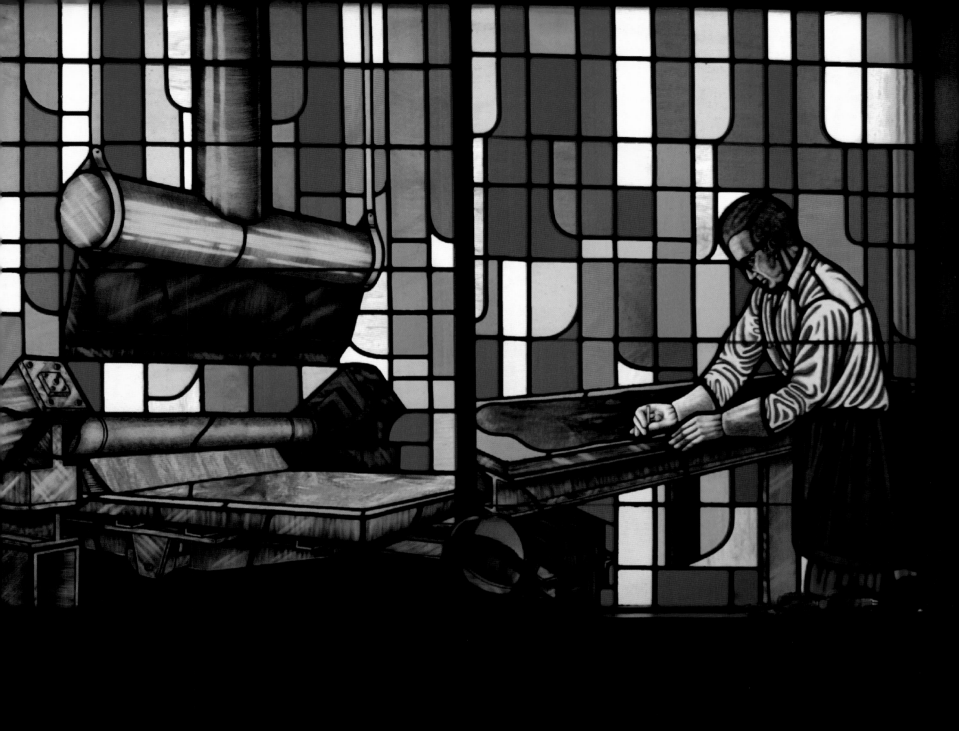

Edifice complex: Since the 1980s, graduating architecture students at the University of Notre Dame have taken to wearing models of favorite buildings on their mortarboards. The headdresses offer comic relief during the long ceremony.
Photo by Dan Uress

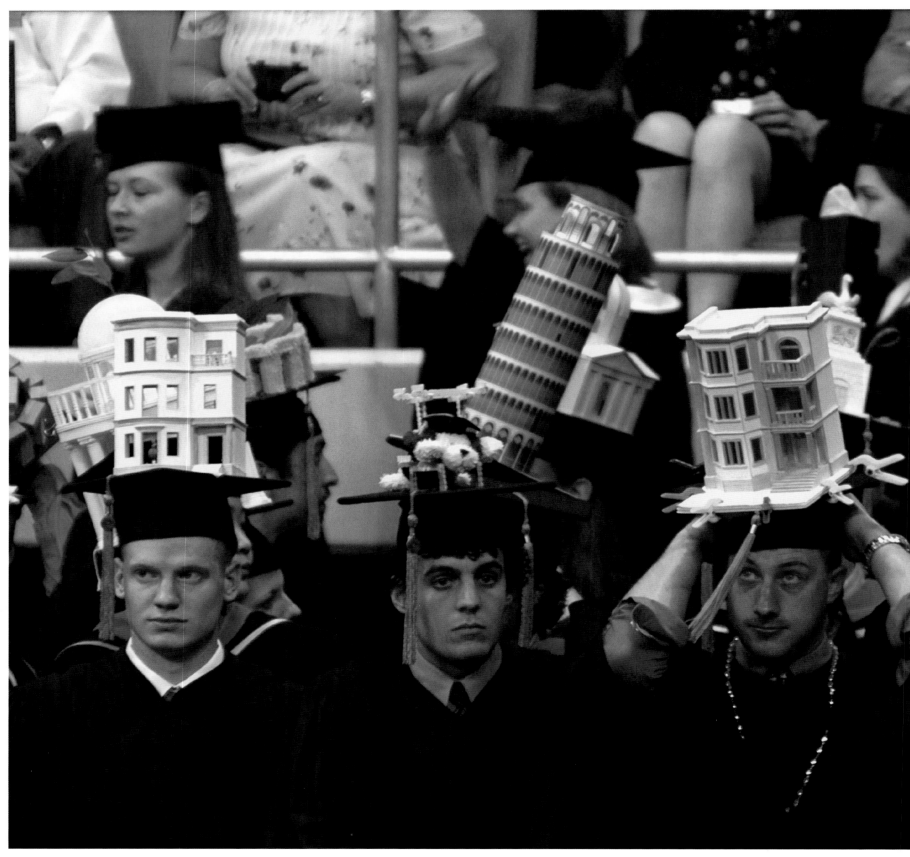

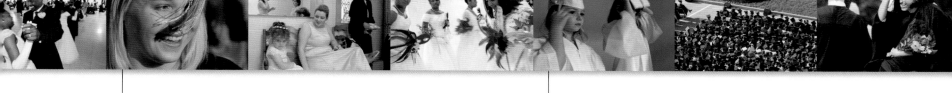

NEW ALBANY

Touch the future: Students at Indiana University Southeast's School of Education undergraduate program rise as they are called to receive their diplomas. The school graduated 149 aspiring educators.

Photo by Patrick L. Pfister, pfoto.com

NEWBURGH

The Young and The Restless: Diplomas await fidgety kindergartners Meredith Campbell, Madison Dora, and Logan McCormick at Kindergate Child Development Center's graduation ceremony.

Photo by Denny Simmons

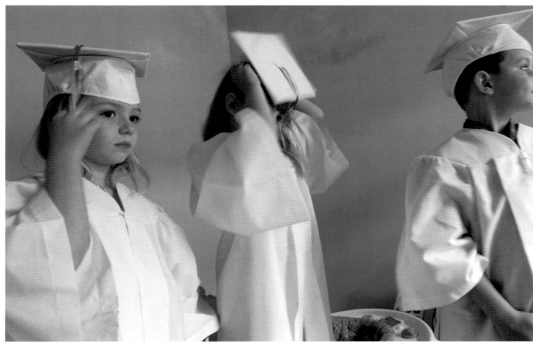

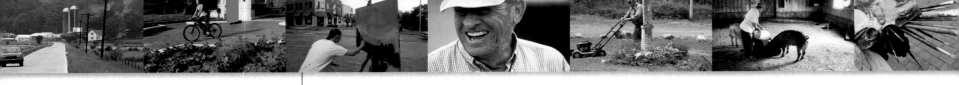

BLOOMINGTON

Artist Mark Ratzlaft paints at the intersection of Kirkwood and Indiana Avenues. The two-toned building on the corner is the renovated Carmichael Center, named for Hoagy Carmichael. The musician was born in Bloomington in 1899, graduated from Indiana University in 1926, and composed his most famous song, "Star Dust," in this building in 1927.
Photo by Steve Raymer

OAKLAND CITY

Retired coal miner John McGregor once raised cattle on his 28-acre ranch. Recently, he sold most of it to Solar Sources, Inc., for strip mining, leaving him with just a few acres that he shares with three roosters, four hens, and 12 cats.
Photo by Denny Simmons

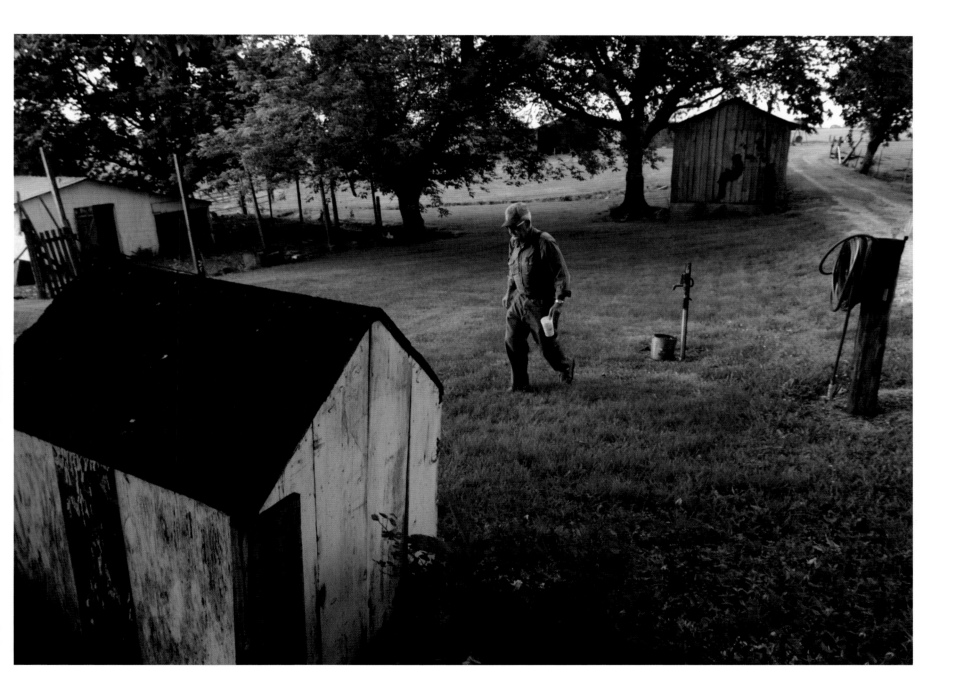

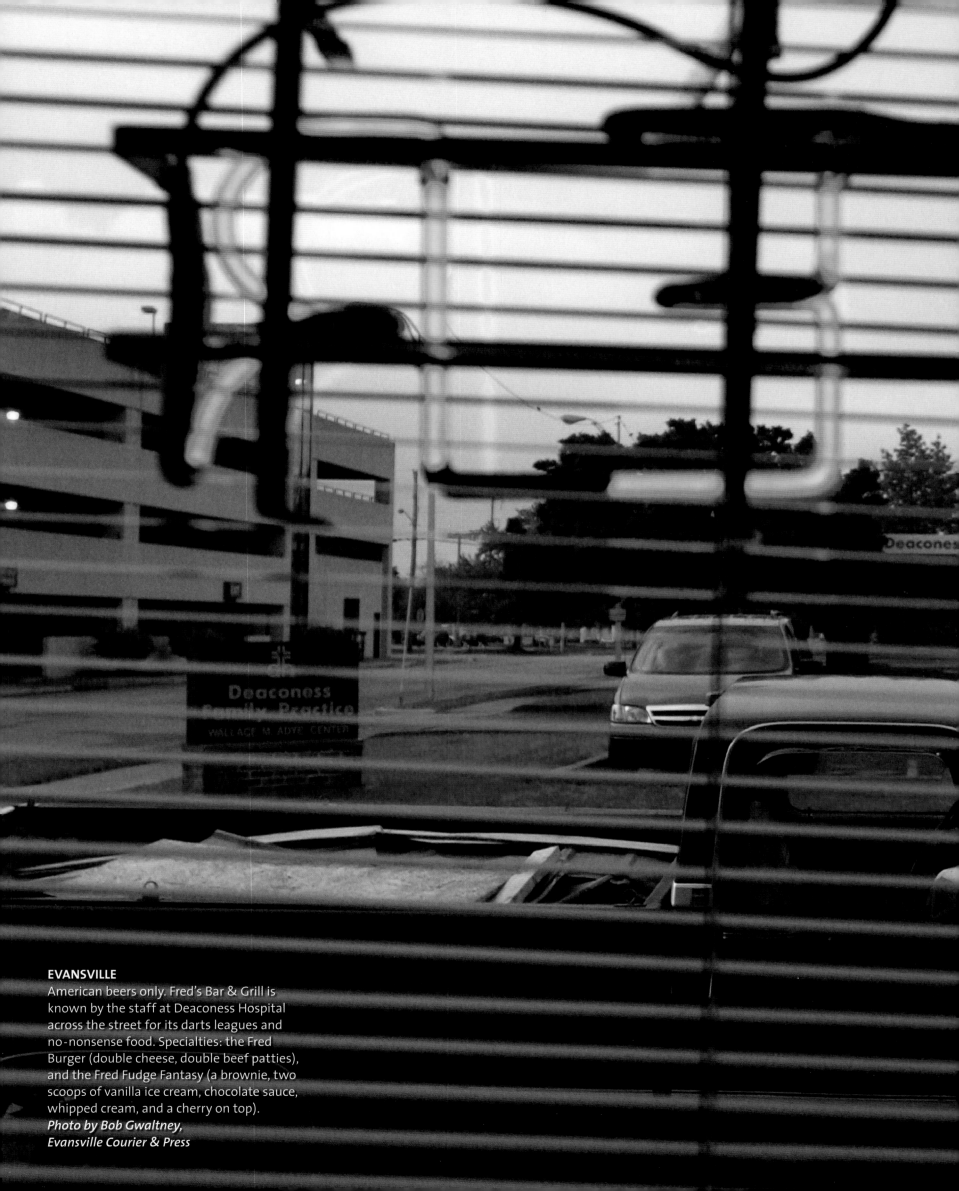

EVANSVILLE
American beers only. Fred's Bar & Grill is
known by the staff at Deaconess Hospital
across the street for its darts leagues and
no-nonsense food. Specialties: the Fred
Burger (double cheese, double beef patties),
and the Fred Fudge Fantasy (a brownie, two
scoops of vanilla ice cream, chocolate sauce,
whipped cream, and a cherry on top).
Photo by Bob Gwaltney,
Evansville Courier & Press

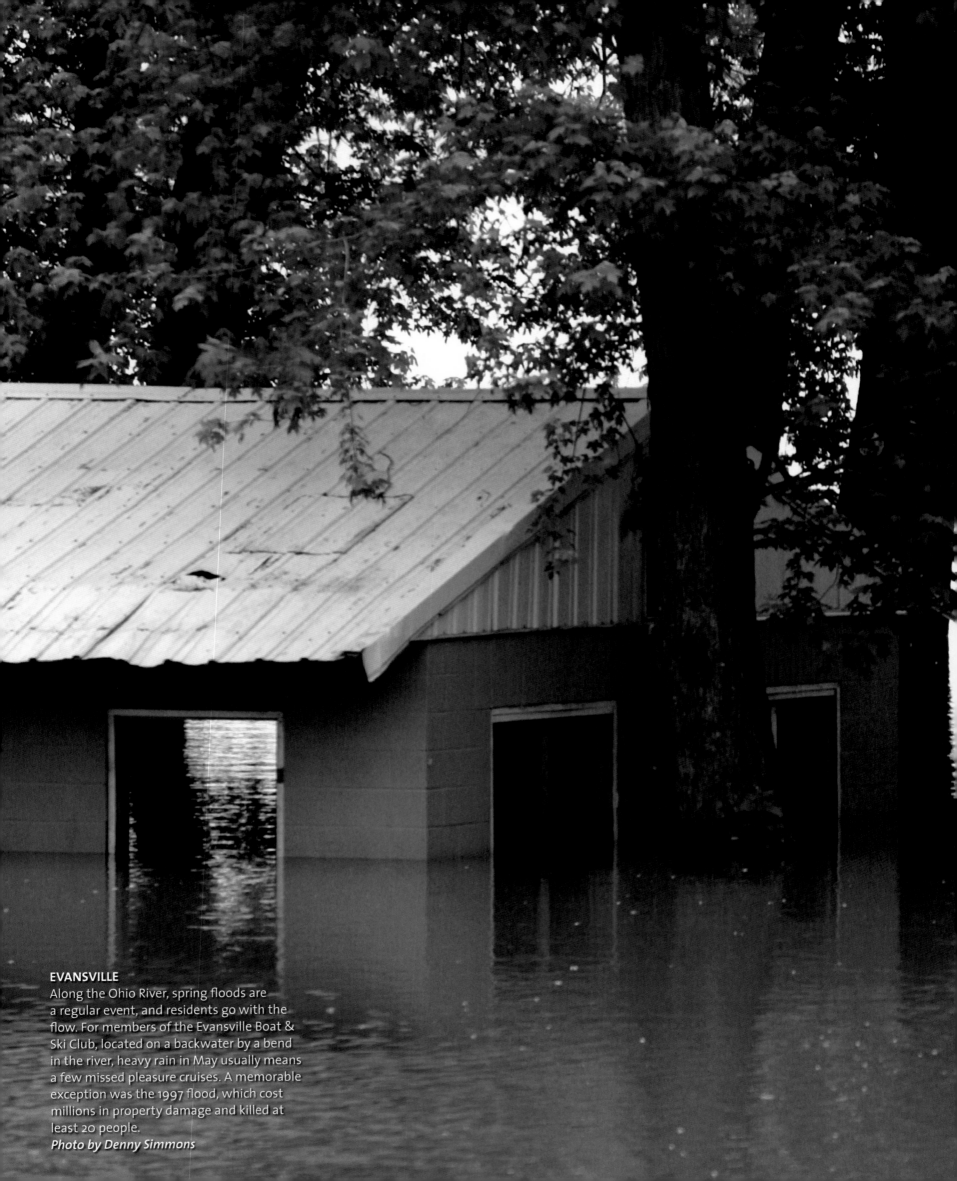

EVANSVILLE
Along the Ohio River, spring floods are a regular event, and residents go with the flow. For members of the Evansville Boat & Ski Club, located on a backwater by a bend in the river, heavy rain in May usually means a few missed pleasure cruises. A memorable exception was the 1997 flood, which cost millions in property damage and killed at least 20 people.
Photo by Denny Simmons

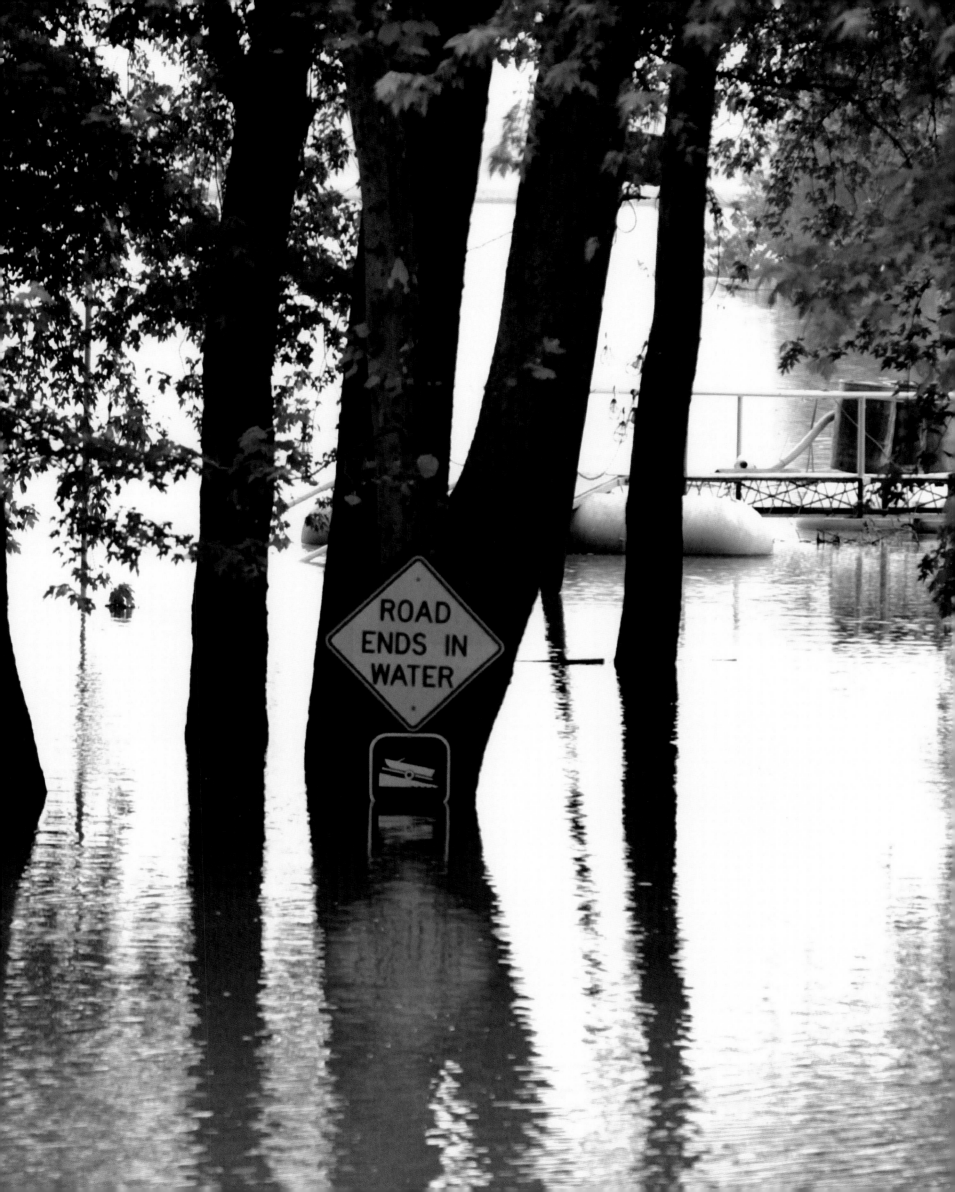

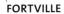

FORTVILLE

If she wants to stick her head out of the car window, Buddy the boxer knows she has to wear goggles. But not just any type will do—she only puts up with special goggles worn by sulkie drivers.

Photo by Jeri Reichanadter

FORTVILLE

At some point, Oreo the barn cat bonded with Randi, a wild mustang from out west adopted by the Reichanadter family. Now, every morning the cat follows Randi into the pasture for some warm repose.

Photo by Jeri Reichanadter

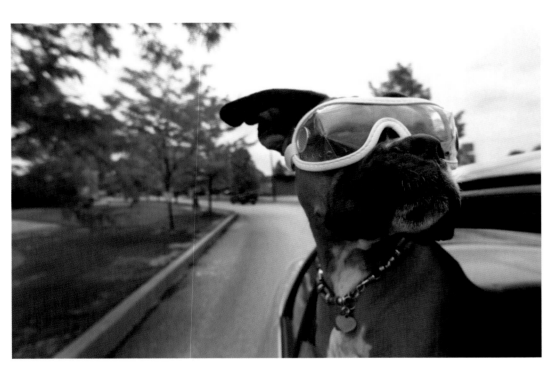

GARY
A Weimaraner watches intently as a Gary
Parks Department crew removes a fallen tree
from 26th Avenue.
Photo by Jeffrey D. Nicholls

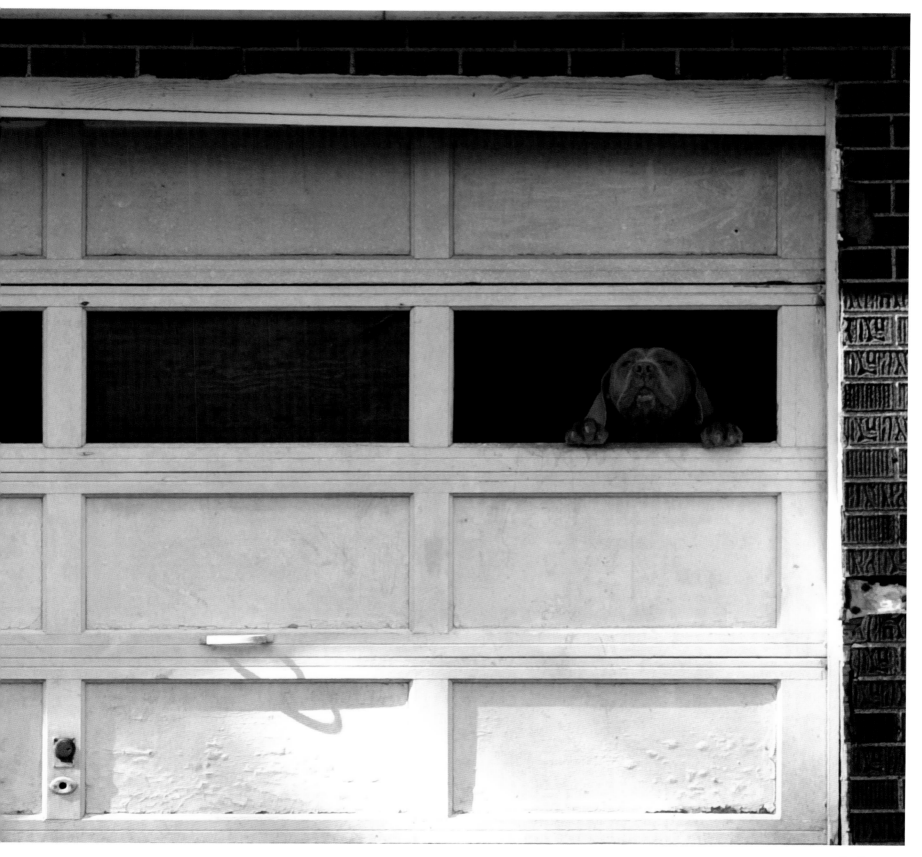

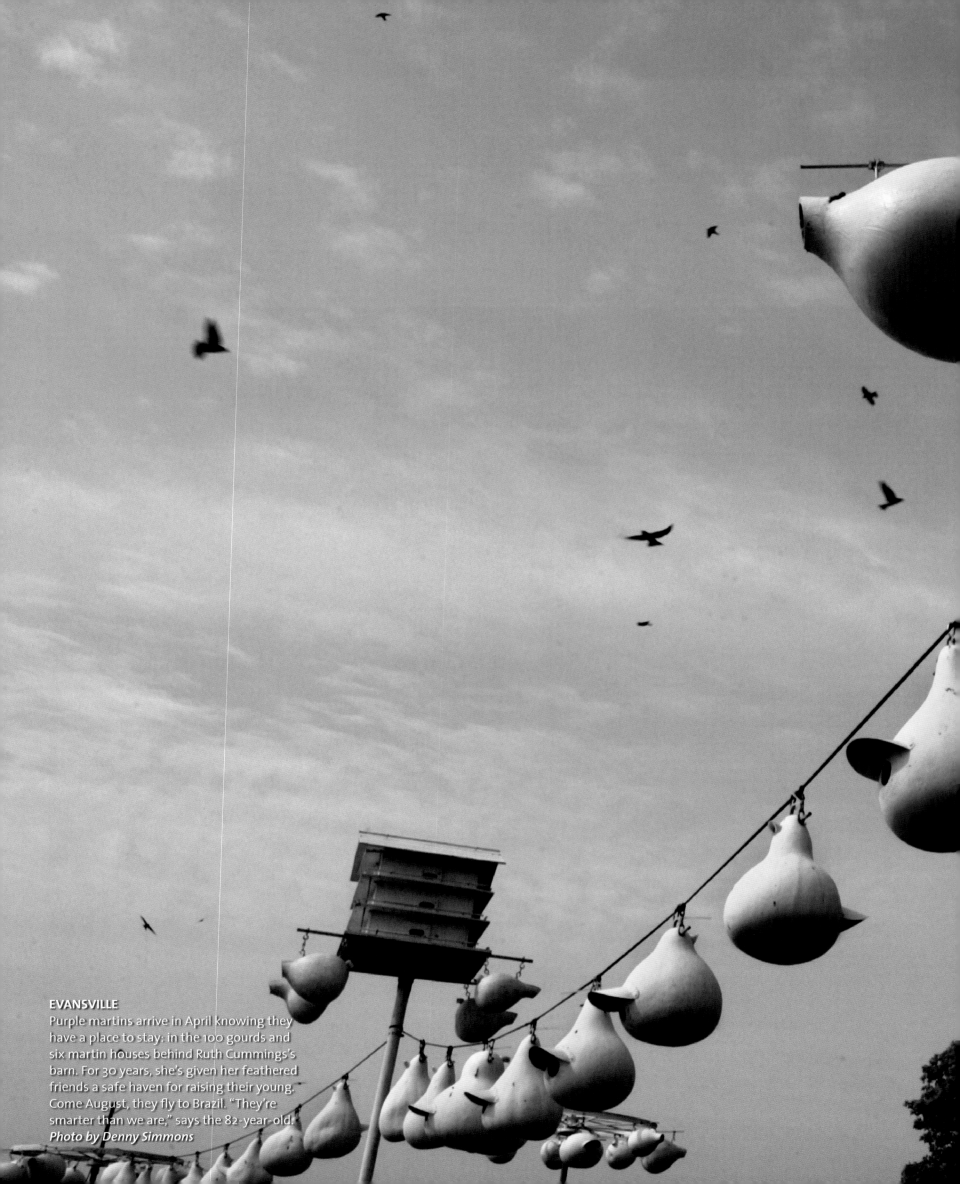

EVANSVILLE
Purple martins arrive in April knowing they have a place to stay: in the 100 gourds and six martin houses behind Ruth Cummings's barn. For 30 years, she's given her feathered friends a safe haven for raising their young. Come August, they fly to Brazil. "They're smarter than we are," says the 82-year-old.
Photo by Denny Simmons

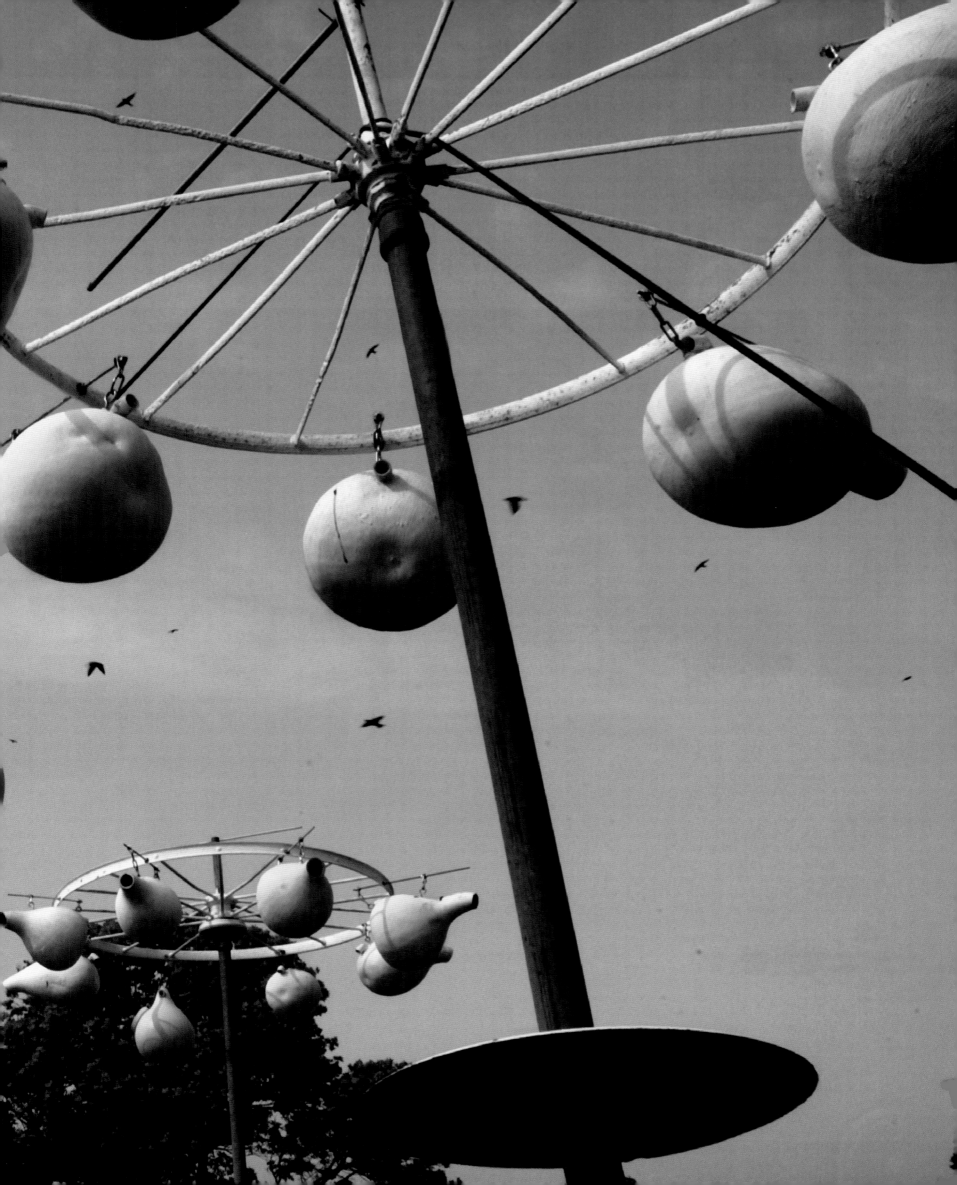

INDIANAPOLIS
George Peques and Valerie Worsham watch
protestors disperse along Maryland Street after
President George W. Bush's motorcade passes by.
Photos by Jeremy Hogan

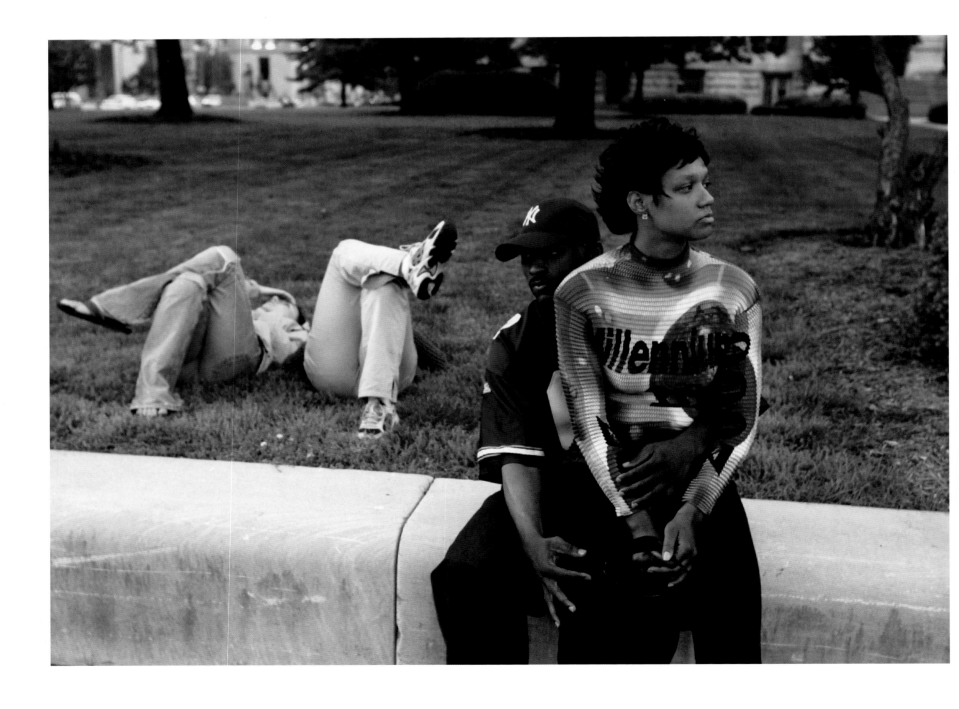

BLOOMINGTON

Seth Mahern and Brooke Hill grab some fresh air between acts at Rhino's. A city-sponsored youth center during the week and music club on the weekends, Rhino's is an "ATOD-free" zone (no alcohol, tobacco, or other drugs). The club has become a major showcase for alternative bands—Green Day and Fishbone played here before hitting it big.

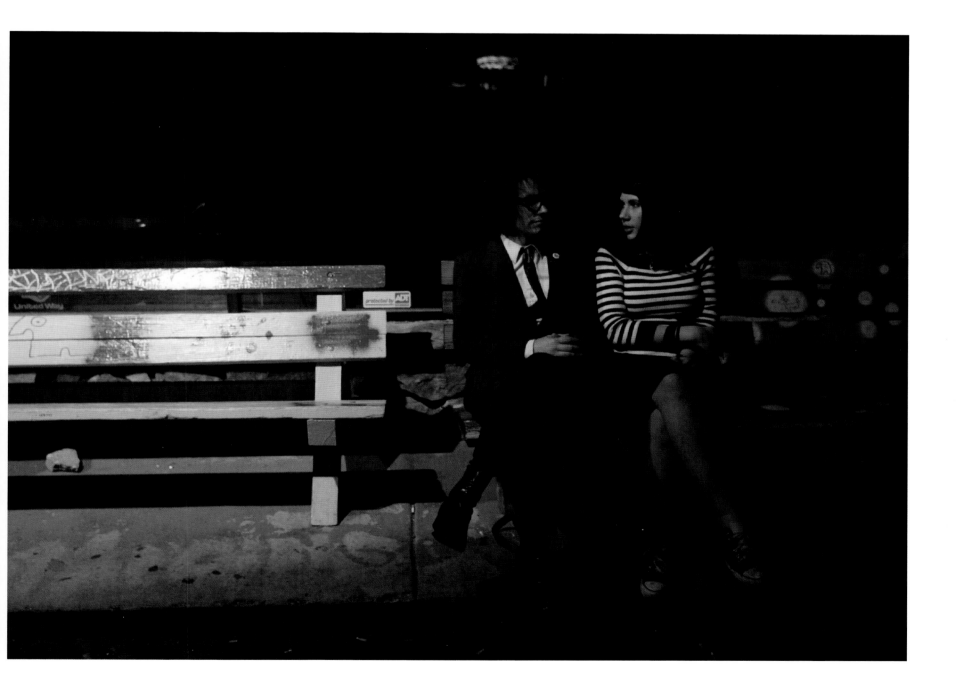

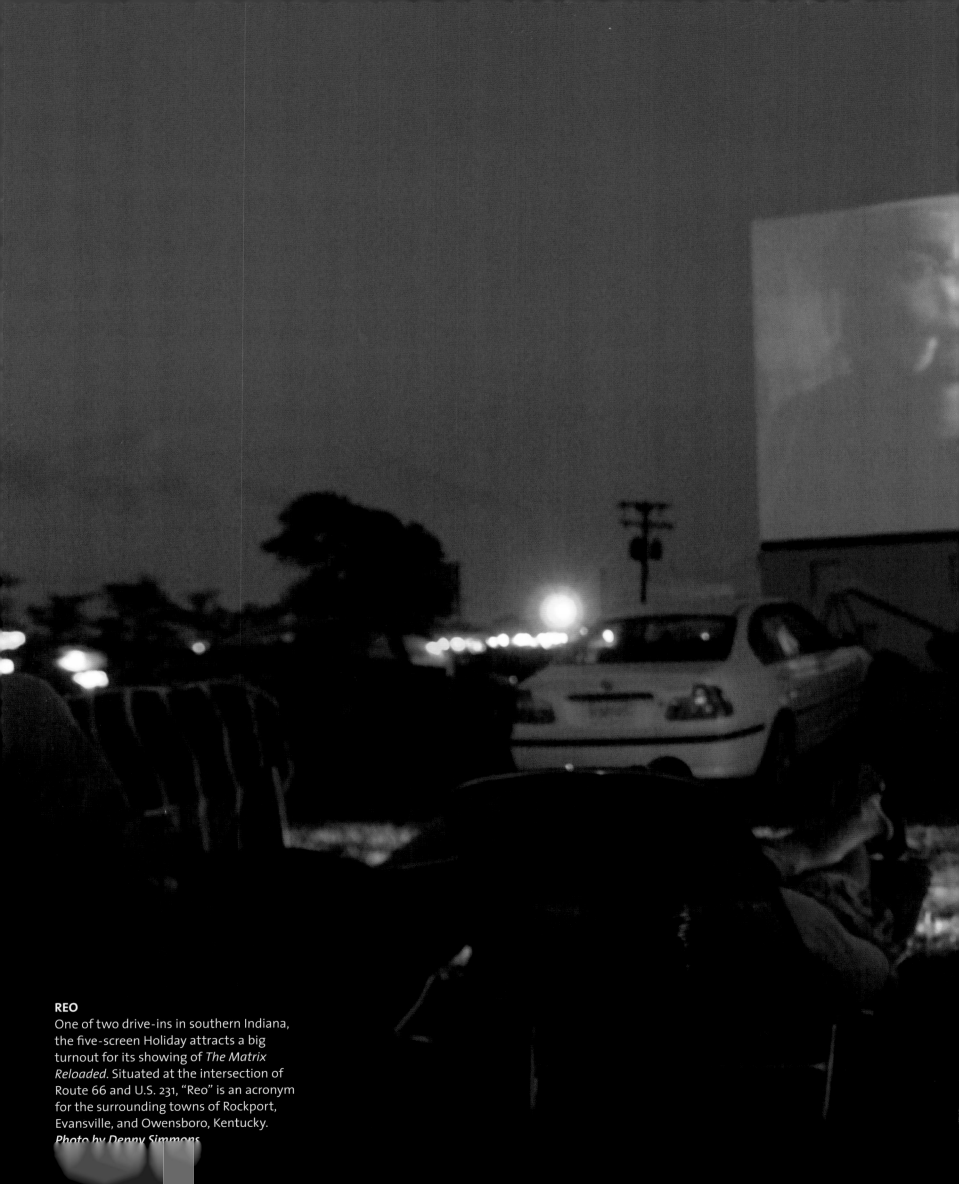

REO
One of two drive-ins in southern Indiana, the five-screen Holiday attracts a big turnout for its showing of *The Matrix Reloaded*. Situated at the intersection of Route 66 and U.S. 231, "Reo" is an acronym for the surrounding towns of Rockport, Evansville, and Owensboro, Kentucky.
Photo by Denny Simmons

HAMMOND

During the last dance of the night at Musician's Hall, Marie Filosa, Mary Cieplucha, Marie's husband Louis, Mary Pavlak, and Evelyn Tarne sing "Goodnight, Sweetheart" to honor friends who have passed away. The tradition was started in 1985 by Marie, who's been happily married to Louis for 60 years. "I don't listen to him—that's how it's lasted," cracks the Brooklyn-born octogenarian.
Photo by Jeffrey D. Nicholls

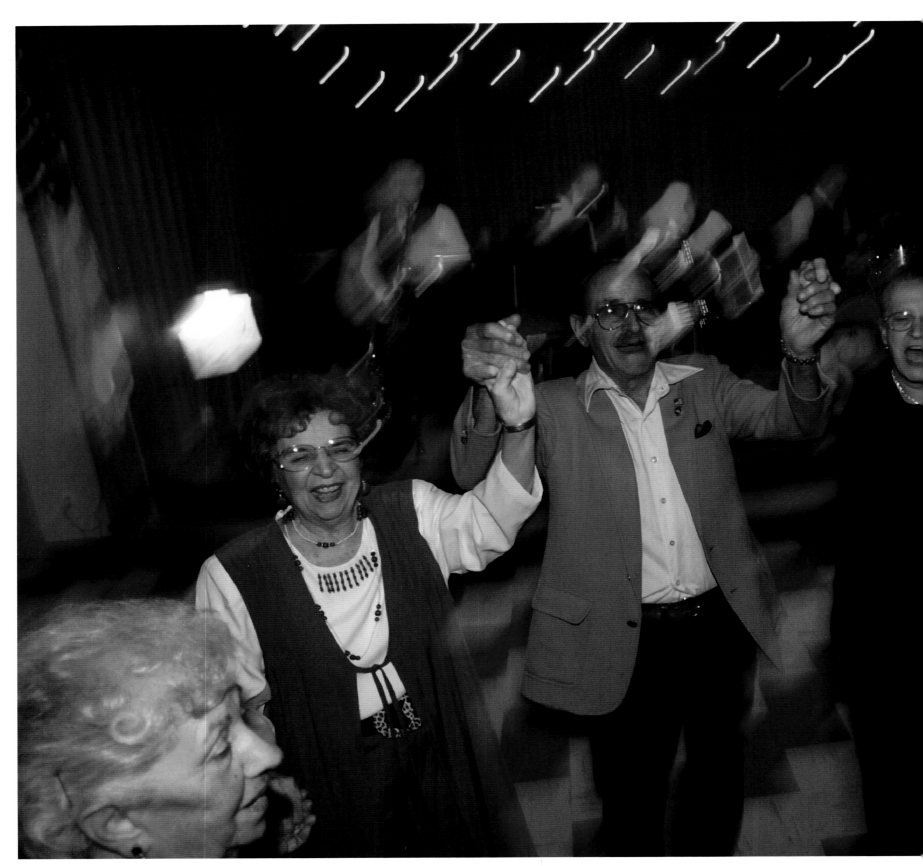

HAMMOND
Every Friday night at the 100-year-old Musician's Hall, seniors dance to the music of their youth. And usually Joe Arent and his quartet lead the way down memory lane. They play "Enjoy Yourself (It's Later Than You Think)," a song popularized by Doris Day in 1950.
Photo by Jeffrey D. Nicholls

FORT WAYNE
American Legion Post 296 is one happening place. Married couples and senior singles come for the full bar, dining room, and dancing. Betsy and James Graham cut the rug to favorites like the Dee Bees' rendition of "The Girl from Ipanema."
Photo by Ellie Bogue

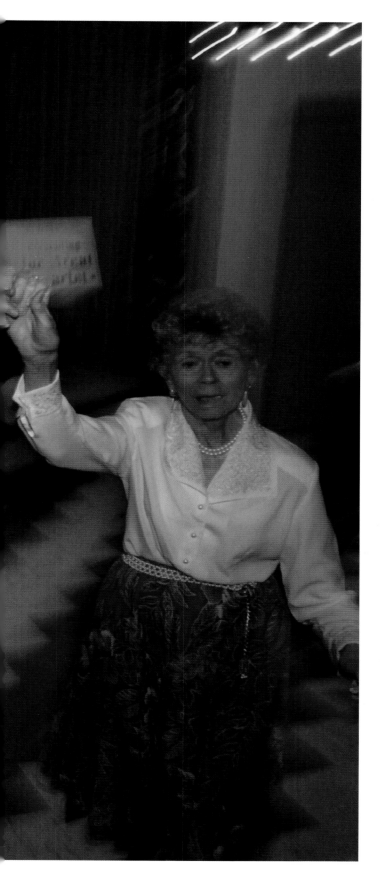

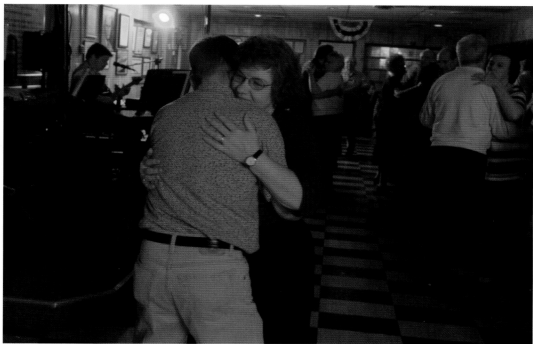

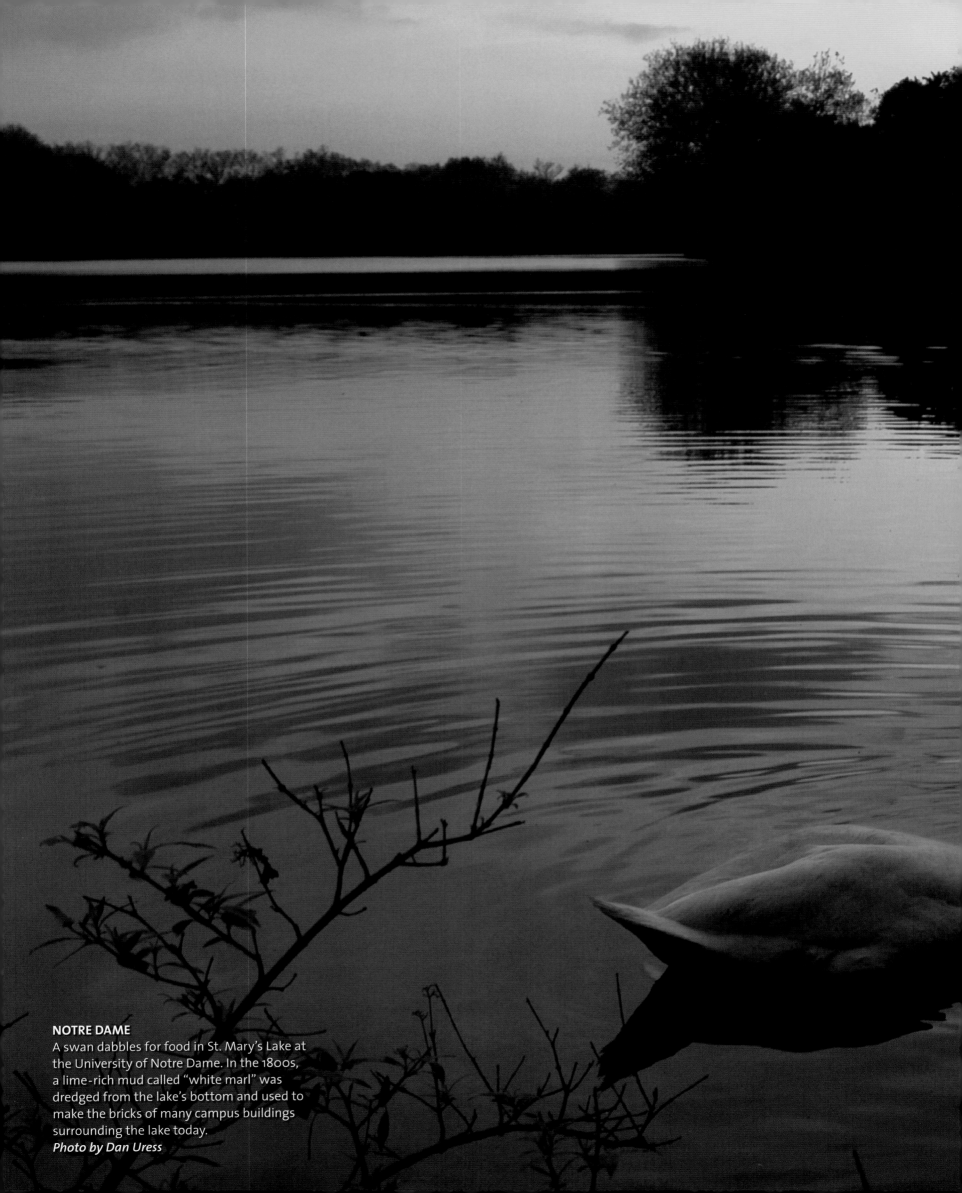

NOTRE DAME
A swan dabbles for food in St. Mary's Lake at the University of Notre Dame. In the 1800s, a lime-rich mud called "white marl" was dredged from the lake's bottom and used to make the bricks of many campus buildings surrounding the lake today.
Photo by Dan Uress

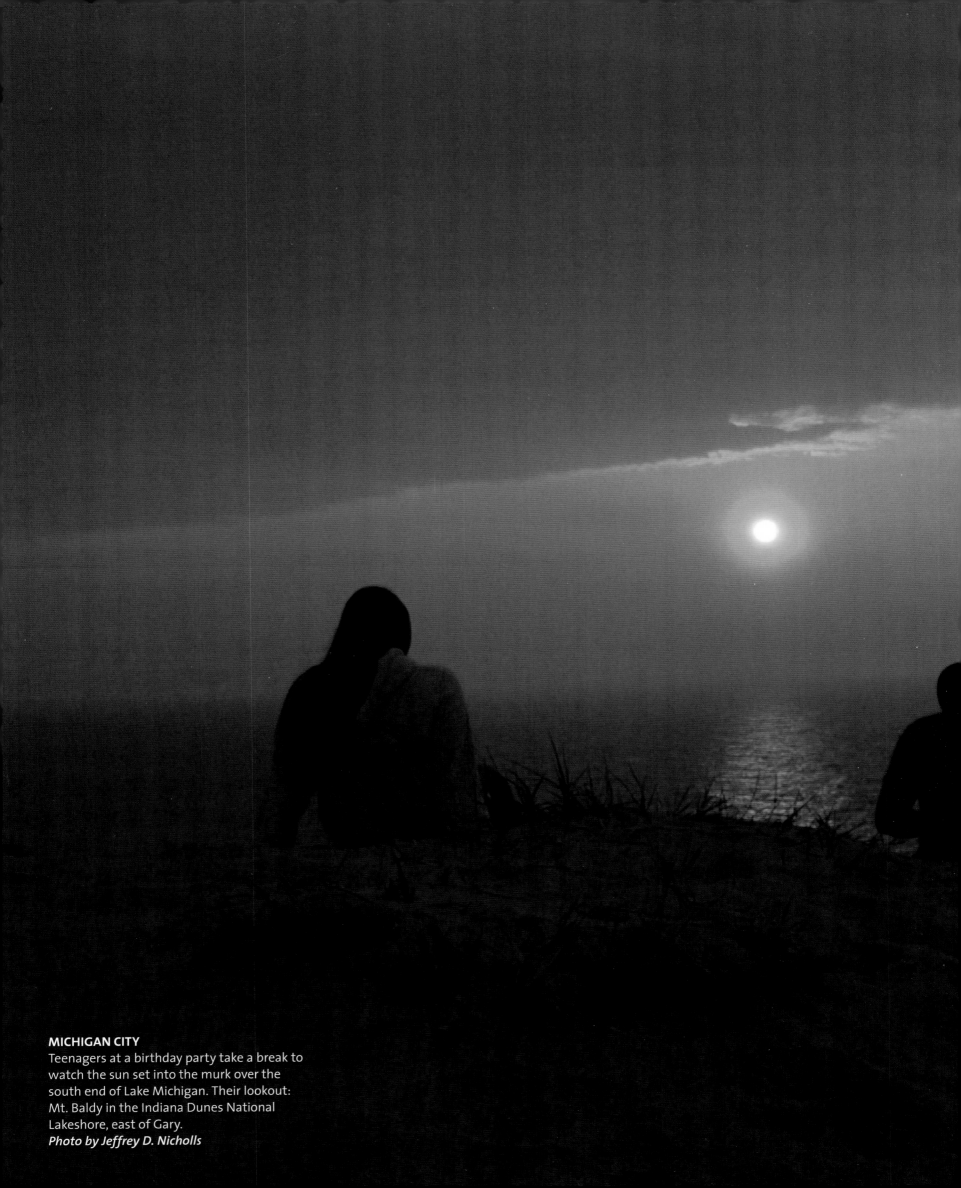

MICHIGAN CITY
Teenagers at a birthday party take a break to
watch the sun set into the murk over the
south end of Lake Michigan. Their lookout:
Mt. Baldy in the Indiana Dunes National
Lakeshore, east of Gary.
Photo by Jeffrey D. Nicholls

The week of May 12-18, 2003, more than 25,000 professional and amateur photographers spread out across the nation to shoot over a million digital photographs with the goal of capturing the essence of daily life in America.

The professional photographers were equipped with Adobe Photoshop and Adobe Album software, Olympus C-5050 digital cameras, and Lexar Media's high-speed compact flash cards.

The 1,000 professional contract photographers plus another 5,000 stringers and students sent their images via FTP (file transfer protocol) directly to the *America 24/7* website. Meanwhile, thousands of amateur photographers uploaded their images to Snapfish's servers.

At *America 24/7*'s Mission Control headquarters, located at CNET in San Francisco, dozens of picture editors from the nation's most prestigious publications culled the images down to 25,000 of the very best, using Photo Mechanic by Camera Bits. These photos were transferred into Webware's ActiveMedia Digital Asset Management (DAM) system, which served as a central image library and enabled the designers to track, search, distribute, and reformat the images for the creation of the 51 books, foreign language editions, web and magazine syndication, posters, and exhibitions.

Once in the DAM, images were optimized (and in some cases resampled to increase image resolution) using Adobe Photoshop. Adobe InDesign and Adobe InCopy were used to design and produce the 51 books, which were edited and reviewed in multiple locations around the world in the form of Adobe Acrobat PDFs. Epson Stylus printers were used for photo proofing and to produce large-format images for exhibitions. The companies providing support for the *America 24/7* project offer many of the essential components for anyone building a digital darkroom. We encourage you to read more on the following pages about their respective roles in making *America 24/7* possible.

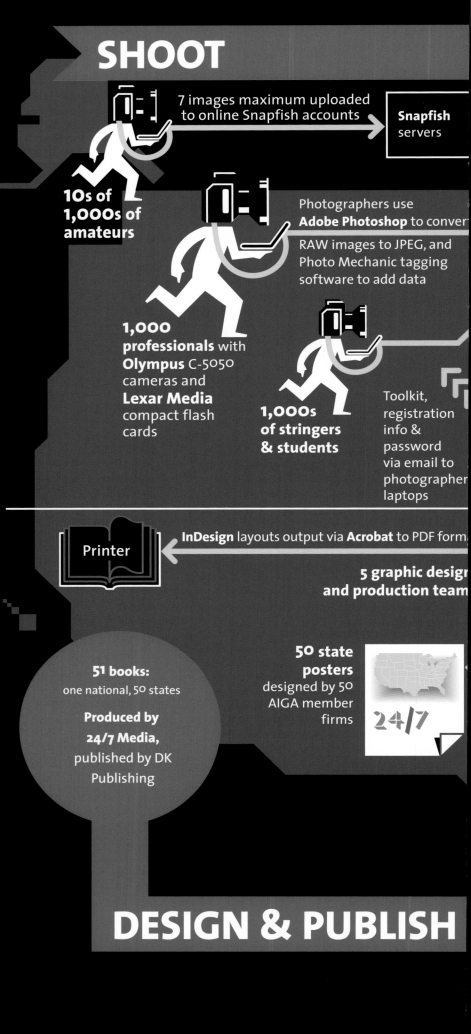

SHOOT

7 images maximum uploaded to online Snapfish accounts → **Snapfish** servers

10s of 1,000s of amateurs

Photographers use **Adobe Photoshop** to conver RAW images to JPEG, and Photo Mechanic tagging software to add data

1,000 professionals with **Olympus** C-5050 cameras and **Lexar Media** compact flash cards

1,000s of stringers & students

Toolkit, registration info & password via email to photographer laptops

InDesign layouts output via **Acrobat** to PDF form

Printer

5 graphic design and production team

51 books: one national, 50 states

Produced by 24/7 Media, published by DK Publishing

50 state posters designed by 50 AIGA member firms

24/7

DESIGN & PUBLISH

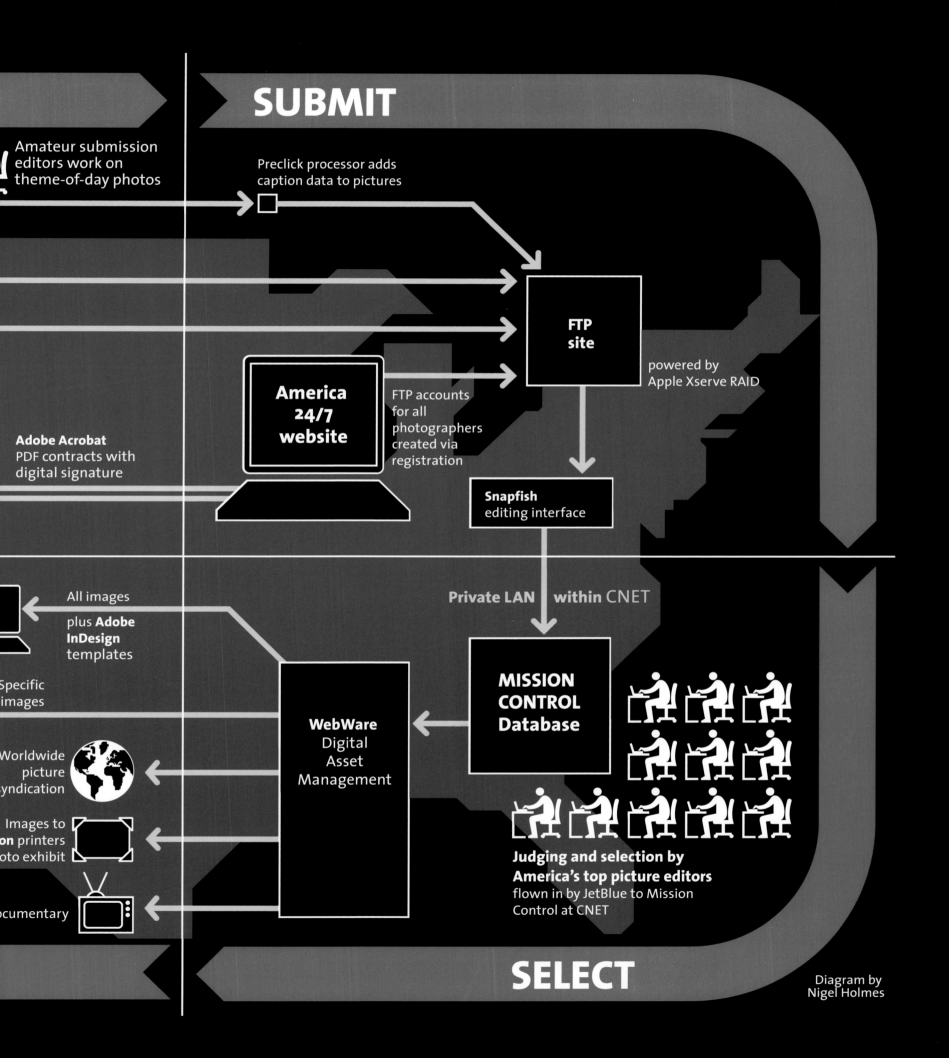

SUBMIT

Amateur submission
editors work on
theme-of-day photos

Preclick processor adds
caption data to pictures

**FTP
site**

powered by
Apple Xserve RAID

**America
24/7
website**

FTP accounts
for all
photographers
created via
registration

Adobe Acrobat
PDF contracts with
digital signature

Snapfish
editing interface

All images

plus **Adobe
InDesign**
templates

Private LAN within CNET

Specific
images

**MISSION
CONTROL
Database**

WebWare
Digital
Asset
Management

Worldwide
picture
syndication

Images to
on printers
oto exhibit

**Judging and selection by
America's top picture editors**
flown in by JetBlue to Mission
Control at CNET

ocumentary

SELECT

Diagram by
Nigel Holmes

About Our Sponsors

America 24/7 gave digital photographers of all levels the opportunity to share their visions of what it means to live in the United States. This project was made possible by a digital photography revolution that is dramatically changing and improving picture-taking for professionals and amateurs alike. And an Adobe product, Photoshop®, has been at the center of this sea change.

Adobe's products reflect our customers' passion for the creative process, be it the photographer, graphic designer, layout artist, or printer. Adobe is the Publishing and Imaging Software Partner for *America 24/7* and products such as Adobe InDesign®, Photoshop, Acrobat®, and Illustrator® were used to produce this stunning book in a matter of weeks. We hope that our software has helped do justice to the mythic images, contributed by well-known photographers and the inspired hobbyist.

Adobe is proud to be a lead sponsor of *America 24/7*, a project that celebrates the vibrancy of the American spirit: the same spirit that helped found Adobe and inspires our employees and customers to deliver the very best.

Bruce Chizen
President and CEO
Adobe Systems Incorporated

Olympus, a global technology leader in designing precision healthcare solutions and innovative consumer electronics, is proud to be the official digital camera sponsor of *America 24/7*. The opportunity to introduce Americans from coast to coast to the thrill, excitement, and possibility of digital photography makes the vision behind this book a perfect fit for Olympus, a leader in digital cameras since 1996.

For most people, the essence of digital photography is best grasped through firsthand experience with the technology, which is precisely what *America 24/7* is about. We understand that direct experience is the pathway to inspiration, and welcome opportunities like this sponsorship to bring the power of the digital experience into the lives of people everywhere. To Olympus, *America 24/7* offers a platform to help realize a core mission: to deliver and make accessible the power of the digital experience to millions of American photographers, amateurs, and professionals alike.

The 1,000 professional photographers contracted to shoot on the America 24/7 project were all equipped with Olympus C-5050 digital cameras. Like all Olympus products, the C-5050 is offered by a company well known for designing, manufacturing, and servicing products used by professionals to perform their work, every day. Olympus is a customer-centric company committed to working one-to-one with a diverse group of professionals. From biomedical researchers who use our clinical microscopes, to doctors who perform life-saving procedures with our endoscopes, to professional photographers who use cameras in their daily work, Olympus is a trusted brand.

The digital imaging technology involved with *America 24/7* has enabled the soul of America to be visually conveyed, not just by professional observers, but by the American public who participated in this project—the very people who collectively breath life into this country's existence each day.

We are proud to be enabling so many photographers to capture the pictures on these pages that tell the story of who we are as a nation. From sea to shining sea, digital imagery allows us to connect to one another in ways we never dreamed possible.

At Olympus, our ideas have proliferated as rapidly as technology has evolved. We have channeled these visions into breakthrough products and solutions to meet the demands of our changing world—products like microscopes, endoscopes, and digital voice recorders, supported by the highly regarded training, educational, and consulting services we offer our customers.

Today, 83 years after we introduced our first microscope, we remain as young, as curious, and as committed as ever.

Lexar Media has grown from the digital photography revolution, which is why we are proud to have supplied the digital memory cards used in the America 24/7 project. Lexar Media's high-performance memory cards utilize our unique and patented controller coupled with high-speed flash memory from Samsung, the world's largest flash memory supplier. This powerful combination brings out the ultimate performance of any digital camera.

Photographers who demand the most from their equipment choose our products for their advanced features like write speeds up to 40X, Write Acceleration technology for enabled cameras, and Image Rescue, which recovers previously deleted or lost images. Leading camera manufacturers bundle Lexar Media digital memory cards with their cameras because they value its performance and reliability.

Lexar Media is at the forefront of digital photography as it transforms picture-taking worldwide, and we will continue to be a leader with new and innovative solutions for professionals and amateurs alike.

Snapfish, which developed the technology behind the *America 24/7* amateur photo event, is a leading online photo service, with more than 5 million members and 100 million photos posted online. Snapfish enables both film and digital camera owners to share, print, and store their most important photo memories, at prices that cannot be equaled. Digital camera users upload photos into a password-protected online album for free. Users can also order film-quality prints on professional photographic paper for as low as 25¢. Film camera users get a full set of prints, plus online sharing and storage, for just $2.99 per roll.

Founded in 1995, eBay created a powerful platform for the sale of goods and services by a passionate community of individuals and businesses. On any given day, there are millions of items across thousands of categories for sale on eBay. eBay enables trade on a local, national and international basis with customized sites in markets around the world.

Through an array of services, such as its payment solution provider PayPal, eBay is enabling global e-commerce for an ever-growing online community.

JetBlue Airways is proud to be *America 24/7's* preferred carrier, flying photographers, photo editors, and organizers across the United States.

Winner of Condé Nast Traveler's Readers' Choice Awards for Best Domestic Airline 2002, JetBlue provides friendly service and low fares for travelers in 22 cities in nine states across America.

On behalf of JetBlue's 5,000 crew members, we're excited to be involved in this remarkable project, and for the opportunity to serve American travelers each and every day, coast to coast, 24/7.

DIGITAL POND

Digital Pond has been a leading creator of large graphic displays for museums, corporations, trade shows, retail environments and fine art since 1992.

We were proud to bring together our creative, print and display capabilities to produce signage and displays for mission control, critical retouching for numerous key images for the book, and art galleries for the New York Public Library and Bryant Park.

The Pond's team and SplashPic® Online service enabled us to nimbly design, produce and install over 200 large graphic panels in two NYC locations within the truly "24/7" production schedule of less than ten days.

WebWare Corporation is pleased to be a major sponsor of the America 24/7 project. We take pride in being part of a groundbreaking adventure that is stretching the boundaries—and the imagination—in digital photography, digital asset management, publishing, news, and global events.

Our ActiveMedia Enterprise™ digital asset management software is the "nerve center" of *America 24/7,* the central repository for managing, sharing, and collaborating on the project's photographs. From photo editors and book publishers to 24/7's media relations and marketing personnel, ActiveMedia provides the application support that links all facets of the project team to the content worldwide.

WebWare helps Global 2000 firms securely manage, reuse, and distribute media assets locally or globally. Its suite of ActiveMedia software products provide powerful media services platforms for integrating rich media into content management systems marketing and communication portals; web publishing systems; and e-commerce portals.

Google's mission is to organize the world's information and make it universally accessible and useful.

With our focus on plucking just the right answer from an ocean of data, we were naturally drawn to the America 24/7 project. The book you hold is a compendium of images of American life distilled from thousands of photographs and infinite possibilities. Are you looking for emotion? Narrative? Shadows? Light? It's all here, thanks to a multitude of photographers and writers creating links between you, the reader, and a sea of wonderful stories. We celebrate the connections that constitute the human experience and are pleased to help engender them. And we're pleased to have been a small part of this project, which captures the results of that interaction so vividly, so dynamically, and so dramatically.

Special thanks to additional contributors: FileMaker, Apple, Camera Bits, LaCie, Now Software, Preclick, Outpost Digital, Xerox, Microsoft, WoodWing Software, net-linx Publishing Solutions, and Radical Media. The Savoy Hotel, San Francisco; The Pan Pacific, San Francisco; Four Seasons Hotel, San Francisco; and The Queen Anne Hotel. Photography editing facilities were generously hosted by CNET Networks, Inc.

Participating Photographers

Coordinator: Mike Fender/Director of Photography, *The Indianapolis Star*

Barb Averill
Tim Bath, *Kokomo Tribune*
Jeremy Bingham
Ellie Bogue
Michael Christopher Brown
Darlayne Coughlin
Matt Detrich, *The Indianapolis Star*
Mike Fender, *The Indianapolis Star*
Elizabeth Fisco
Don Gagnon
Bob Gwaltney, *Evansville Courier & Press*
Michael Heinz
Jeremy Hogan
Kurt Hostetler, *The Star Press*
Wendy Kaveney
Joe Krupa, *The Star Press*
Lisa Lamberson
Steve Linsenmayer,
 The Fort Wayne News-Sentinel

Jeffrey D. Nicholls
Frank Oliver
Jeff Osborne
Andrew Otto, *The Herald*
Patrick L. Pfister, pfoto.com
David Pierini, *The Herald*
Vincent Pugliese
Steve Raymer
Juliane K. Rea
Jeri Reichanadter
Quentin Robinson
Denny Simmons
Chris Smith
Tom Strickland
Kevin Swank
Daniel Tinkel
Dan Uress

Thumbnail Picture Credits

Credits for thumbnail photographs are listed by the page number and are in order from left to right.

20 Mike Fender, *The Indianapolis Star*
Kevin Swank
Matt Detrich, *The Indianapolis Star*
Chris Smith
Barb Averill
Elizabeth Fisco
Chris Smith

21 Denny Simmons
David Pierini, *The Herald*
Matt Detrich, *The Indianapolis Star*
Matt Detrich, *The Indianapolis Star*
Denny Simmons
Matt Detrich, *The Indianapolis Star*
Quentin Robinson

24 Jeremy Hogan
Jeremy Hogan
Jeremy Hogan
Jeremy Hogan
Jeremy Hogan
Jeremy Hogan
Bobbie Leigh Weeks

25 Barb Averill
Barb Averill
Vincent Pugliese
Quentin Robinson
Barb Averill
Jeremy Hogan
Barb Averill

29 Frank Oliver
David Pierini, *The Herald*
David Pierini, *The Herald*
Frank Oliver
Denny Simmons
Denny Simmons
Jeremy Hogan

30 Bobbie Leigh Weeks
Jeri Reichanadter
Jeri Reichanadter
Jeri Reichanadter
David Pierini, *The Herald*
Chris Smith
Jeri Reichanadter

31 Jeri Reichanadter
Jeri Reichanadter
Denny Simmons
Jeri Reichanadter
Bobbie Leigh Weeks
Jeri Reichanadter
Jeri Reichanadter

40 Denny Simmons
David Pierini, *The Herald*
David Pierini, *The Herald*
Tim Bath, *Kokomo Tribune*
Tim Bath, *Kokomo Tribune*
Tim Bath, *Kokomo Tribune*
Tim Bath, *Kokomo Tribune*

41 Denny Simmons
David Pierini, *The Herald*
David Pierini, *The Herald*
David Pierini, *The Herald*
Tom Strickland
Quentin Robinson
Denny Simmons

42 Debbie Winchester
Tom Strickland
Debbie Winchester
Ellie Bogue
Tom Strickland
Frank Oliver
Frank Oliver

43 Tom Strickland
Tom Strickland
Michael Heinz
Matt Detrich, *The Indianapolis Star*
Tom Strickland
Denny Simmons
Jeremy Hogan

46 Kurt Hostetler, *The Star Press*
Frank Oliver
Steve Linsenmayer,
The Fort Wayne News-Sentinel
Steve Linsenmayer,
The Fort Wayne News-Sentinel
Steve Linsenmayer,
The Fort Wayne News-Sentinel
Joe Krupa, *The Star Press*
Joe Krupa, *The Star Press*

47 Joe Krupa, *The Star Press*
Joe Krupa, *The Star Press*
Joe Krupa, *The Star Press*
Frank Oliver
Joe Krupa, *The Star Press*
Frank Oliver
David Pierini, *The Herald*

50 Darlayne Coughlin
Matt Detrich, *The Indianapolis Star*
Darlayne Coughlin
Debbie Winchester
Steve Raymer
Dan Uress
Debbie Winchester

51 Darlayne Coughlin
Darlayne Coughlin
Jeri Reichanadter
Tom Strickland
Jeremy Hogan
Jeremy Hogan
Jeri Reichanadter

52 Denny Simmons
Mike Fender, *The Indianapolis Star*
Frank Oliver
David Pierini, *The Herald*
Jeri Reichanadter
Patrick L. Pfister, pfoto.com
Kurt Hostetler, *The Star Press*

53 Kurt Hostetler, *The Star Press*
Kurt Hostetler, *The Star Press*
Mike Fender, *The Indianapolis Star*
Quentin Robinson
Jeremy Hogan
Denny Simmons
Denny Simmons

56 Dan Uress
Dan Uress
Dan Uress
Dan Uress
Dan Uress
Dan Uress
Dan Uress

57 Dan Uress
Dan Uress
Dan Uress
Dan Uress
Dan Uress
Dan Uress

Dan Uress
Dan Uress

60 Quentin Robinson
Jeffrey D. Nicholls
Jeffrey D. Nicholls
Quentin Robinson
Jeffrey D. Nicholls
Matt Detrich, *The Indianapolis Star*
Jeffrey D. Nicholls

61 Quentin Robinson
Jeffrey D. Nicholls
Matt Detrich, *The Indianapolis Star*
Matt Detrich, *The Indianapolis Star*
Jeffrey D. Nicholls
Jeffrey D. Nicholls
Jeffrey D. Nicholls

64 Jeremy Hogan
Jeremy Hogan
Jeremy Hogan
Kurt Hostetler, *The Star Press*
David Pierini, *The Herald*
Jeremy Hogan
Mike Fender, *The Indianapolis Star*

65 Mike Fender, *The Indianapolis Star*
Jeremy Hogan
Mike Fender, *The Indianapolis Star*
Kurt Hostetler, *The Star Press*
Vincent Pugliese
David Pierini, *The Herald*
Mike Fender, *The Indianapolis Star*

70 Jeremy Hogan
Bob Gwaltney, *Evansville Courier & Press*
Jeremy Hogan
David Pierini, *The Herald*
Jeremy Hogan
Kurt Hostetler, *The Star Press*
Kurt Hostetler, *The Star Press*

71 Wendy Kaveney
Tim Bath, *Kokomo Tribune*
Kurt Hostetler, *The Star Press*
Matt Detrich, *The Indianapolis Star*
Frank Oliver
Bob Gwaltney, *Evansville Courier & Press*
Kurt Hostetler, *The Star Press*

73 David Pierini, *The Herald*
Quentin Robinson
Kurt Hostetler, *The Star Press*
Matt Detrich, *The Indianapolis Star*
Matt Detrich, *The Indianapolis Star*
Chris Smith
David Pierini, *The Herald*

76 Wendy Kaveney
Mike Fender, *The Indianapolis Star*
Matt Detrich, *The Indianapolis Star*
Mike Fender, *The Indianapolis Star*
Mike Fender, *The Indianapolis Star*
Tim Bath, *Kokomo Tribune*
Tim Bath, *Kokomo Tribune*

77 Tim Bath, *Kokomo Tribune*
Mike Fender, *The Indianapolis Star*
Tim Bath, *Kokomo Tribune*
Mike Fender, *The Indianapolis Star*
Tim Bath, *Kokomo Tribune*

Tim Bath, *Kokomo Tribune*
Mike Fender, *The Indianapolis Star*

78 Mike Fender, *The Indianapolis Star*
Mike Fender, *The Indianapolis Star*
Mike Fender, *The Indianapolis Star*
Joe Krupa, *The Star Press*
Joe Krupa, *The Star Press*
Mike Fender, *The Indianapolis Star*
Joe Krupa, *The Star Press*

79 Mike Fender, *The Indianapolis Star*
Mike Fender, *The Indianapolis Star*
Mike Fender, *The Indianapolis Star*
Mike Fender, *The Indianapolis Star*
Joe Krupa, *The Star Press*
Mike Fender, *The Indianapolis Star*
Mike Fender, *The Indianapolis Star*

80 Barb Averill
David Pierini, *The Herald*
Debbie Winchester
Michael Heinz
Jeremy Hogan
Kurt Hostetler, *The Star Press*
Jeremy Hogan

81 Quentin Robinson
Mike Fender, *The Indianapolis Star*
Quentin Robinson
Vincent Pugliese
Wendy Kaveney
Patrick Reddy, *Cincinnati Enquirer*
Steve Raymer

83 Denny Simmons
Mike Fender, *The Indianapolis Star*
Andrew Otto, *The Herald*
Denny Simmons
Mike Fender, *The Indianapolis Star*
Tom Strickland
Andrew Otto, *The Herald*

84 Michael Heinz
Quentin Robinson
Denny Simmons
Andrew Otto, *The Herald*
Jeremy Hogan
Frank Oliver
Quentin Robinson

85 Denny Simmons
Jeremy Hogan
Tim Bath, *Kokomo Tribune*
Jeffrey D. Nicholls
Jeremy Hogan
Denny Simmons
Steve Raymer

86 Jeremy Hogan
Mike Fender, *The Indianapolis Star*
Jeremy Hogan
Denny Simmons
David Pierini, *The Herald*
Jeremy Hogan
Quentin Robinson

87 Tim Bath, *Kokomo Tribune*
Tim Bath, *Kokomo Tribune*
Tim Bath, *Kokomo Tribune*
Tim Bath, *Kokomo Tribune*

Andrew Otto, *The Herald*
Denny Simmons
Jeremy Hogan

90 Kurt Hostetler, *The Star Press*
Kurt Hostetler, *The Star Press*
Kurt Hostetler, *The Star Press*
Frank Oliver
Kurt Hostetler, *The Star Press*
Barb Averill
Kurt Hostetler, *The Star Press*

91 Matt Detrich, *The Indianapolis Star*
Steve Raymer
Bob Gwaltney, *Evansville Courier & Press*
Jeremy Hogan
Kurt Hostetler, *The Star Press*
Steve Raymer
Steve Raymer

94 Kurt Hostetler, *The Star Press*
Jeremy Hogan
Jeffrey D. Nicholls
Bobbie Leigh Weeks
Jeremy Hogan
Barb Averill
Jeremy Hogan

95 Denny Simmons
Darlayne Coughlin
Vincent Pugliese
Denny Simmons
Tim Bath, *Kokomo Tribune*
Darlayne Coughlin
Michael Heinz

96 Jeffrey D. Nicholls
Jeremy Hogan
Steve Linsenmayer,
The Fort Wayne News-Sentinel
Jeremy Hogan
Jeremy Hogan
Jeremy Hogan
Jeremy Hogan

97 Jeremy Hogan
Steve Linsenmayer,
The Fort Wayne News-Sentinel
Jeremy Hogan
Steve Linsenmayer,
The Fort Wayne News-Sentinel
Steve Linsenmayer,
The Fort Wayne News-Sentinel
Bob Gwaltney, *Evansville Courier & Press*
Steve Linsenmayer,
The Fort Wayne News-Sentinel

98 Kurt Hostetler, *The Star Press*
Ellie Bogue
Matt Detrich, *The Indianapolis Star*
Ellie Bogue
Jeffrey D. Nicholls
Jeffrey D. Nicholls
Jeremy Hogan

99 Jeremy Hogan
Kurt Hostetler, *The Star Press*
Kurt Hostetler, *The Star Press*
Michael Heinz
Matt Detrich, *The Indianapolis Star*
Matt Detrich, *The Indianapolis Star*
Matt Detrich, *The Indianapolis Star*

100 David Pierini, *The Herald*
David Pierini, *The Herald*
Tim Bath, *Kokomo Tribune*
Jeffrey D. Nicholls
David Pierini, *The Herald*
Kurt Hostetler, *The Star Press*
Kurt Hostetler, *The Star Press*

101 Mike Fender, *The Indianapolis Star*
Ellie Bogue
David Pierini, *The Herald*
Steve Raymer
Jeri Reichanadter
Steve Raymer
Tim Bath, *Kokomo Tribune*

102 Frank Oliver
Frank Oliver
Frank Oliver
Frank Oliver
Frank Oliver
Frank Oliver
Frank Oliver

103 Frank Oliver
Frank Oliver
Frank Oliver
Frank Oliver
Frank Oliver
Frank Oliver
Frank Oliver

106 Dan Uress
Mike Fender, *The Indianapolis Star*
Jeremy Hogan
Jeremy Hogan
Ellie Bogue
Kurt Hostetler, *The Star Press*
Matt Detrich, *The Indianapolis Star*

107 Matt Detrich, *The Indianapolis Star*
Steve Raymer
Tim Bath, *Kokomo Tribune*
Steve Raymer
Denny Simmons
Matt Detrich, *The Indianapolis Star*
Steve Raymer

113 Ellie Bogue
Matt Detrich, *The Indianapolis Star*
David Pierini, *The Herald*
David Pierini, *The Herald*
Matt Detrich, *The Indianapolis Star*
Jeremy Hogan
Kurt Hostetler, *The Star Press*

116 Michael Heinz
Denny Simmons
Steve Raymer
Steve Raymer
Dan Uress
Patrick L. Pfister, pfoto.com
Bobbie Leigh Weeks

117 Tim Bath, *Kokomo Tribune*
Patrick L. Pfister, pfoto.com
Steve Raymer
Tim Bath, *Kokomo Tribune*
Denny Simmons
Patrick L. Pfister, pfoto.com
Michael Heinz

118 Andrew Otto, *The Herald*
Steve Raymer
Steve Raymer
David Pierini, *The Herald*
Kurt Hostetler, *The Star Press*
Matt Detrich, *The Indianapolis Star*
Steve Raymer

119 Jeri Reichanadter
Denny Simmons
Matt Detrich, *The Indianapolis Star*
Jeri Reichanadter
Steve Raymer
Andrew Otto, *The Herald*
Wendy Kaveney

124 Jeri Reichanadter
Jeri Reichanadter
Michael Heinz
Kurt Hostetler, *The Star Press*
Jeri Reichanadter
Kurt Hostetler, *The Star Press*
Matt Detrich, *The Indianapolis Star*

125 Matt Detrich, *The Indianapolis Star*
Denny Simmons
Denny Simmons
Jeffrey D. Nicholls
Wendy Kaveney
Vincent Pugliese
Denny Simmons

128 Ellie Bogue
Quentin Robinson
Jeremy Hogan
Ellie Bogue
Jeremy Hogan
Bob Gwaltney, *Evansville Courier & Press*
Denny Simmons

129 Steve Linsenmayer,
The Fort Wayne News-Sentinel
Steve Raymer
Jeremy Hogan
Steve Raymer
Steve Raymer
Steve Linsenmayer,
The Fort Wayne News-Sentinel
Denny Simmons

132 Ariana Lindquist, Ohio University
Jeremy Hogan
Jeffrey D. Nicholls
Kurt Hostetler, *The Star Press*
Ariana Lindquist, Ohio University
Ariana Lindquist, Ohio University
Kourtney K. Hoffman

133 Denny Simmons
Jeffrey D. Nicholls
Steve Linsenmayer,
The Fort Wayne News-Sentinel
Michael Christopher Brown
Ellie Bogue
Michael Christopher Brown
Michael Christopher Brown

Staff

The *America 24/7* series was imagined years ago by our friend Oscar Dystel, a publishing legend whose vision and enthusiasm have been a source of great inspiration.

We also wish to express our gratitude to our truly visionary publisher, DK.

Rick Smolan, Project Director
David Elliot Cohen, Project Director

Administrative
Katya Able, Operations Director
Gina Privitere, Communications Director
Chuck Gathard, Technology Director
Kim Shannon, Photographer Relations Director
Erin O'Connor, Photographer Relations Intern
Leslie Hunter, Partnership Director
Annie Polk, Publicity Manager
John McAlester, Website Manager
Alex Notides, Office Manager
C. Thomas Hardin, State Photography Coordinator

Design
Brad Zucroff, Creative Director
Karen Mullarkey, Photography Director
Judy Zimola, Production Manager
David Simoni, Production Designer
Mary Dias, Production Designer
Heidi Madison, Associate Picture Editor
Don McCartney, Production Designer
Diane Dempsey Murray, Production Designer
Jan Rogers, Associate Picture Editor
Bill Shore, Production Designer and Image Artist
Larry Nighswander, Senior Picture Editor
Bill Marr, Sarah Leen, Senior Picture Editors
Peter Truskier, Workflow Consultant
Jim Birkenseer, Workflow Consultant

Editorial
Maggie Canon, Managing Editor
Curt Sanburn, Senior Editor
Teresa L. Trego, Production Editor
Lea Aschkenas, Writer
Olivia Boler, Writer
Korey Capozza, Writer
Beverly Hanly, Writer
Bridgett Novak, Writer
Alison Owings, Writer
Fred Raker, Writer
Joe Wolff, Writer
Elise O'Keefe, Copy Chief
Daisy Hernández, Copy Editor
Jennifer Wolfe, Copy Editor

Infographic Design
Nigel Holmes

Literary Agent
Carol Mann, The Carol Mann Agency

Legal Counsel
Barry Reder, Coblentz, Patch, Duffy & Bass, LLP
Phil Feldman, Coblentz, Patch, Duffy & Bass, LLP
Gabe Perle, Ohlandt, Greeley, Ruggiero & Perle, LLP
Jon Hart, Dow, Lohnes & Albertson, PLLC
Mike Hays, Dow, Lohnes & Albertson, PLLC
Stephen Pollen, Warshaw Burstein, Cohen, Schlesinger & Kuh, LLP
Rick Pappas

Accounting and Finance
Rita Dulebohn, Accountant
Robert Powers, Calegari, Morris & Co. Accountants
Eugene Blumberg, Blumberg & Associates
Arthur Langhaus, KLS Professional Advisors Group, Inc.

Picture Editors
J. David Ake, Associated Press
Caren Alpert, formerly *Health* magazine
Simon Barnett, *Newsweek*
Caroline Couig, *San Jose Mercury News*
Mike Davis, formerly *National Geographic*
Michel duCille, *Washington Post*
Deborah Dragon, *Rolling Stone*
Victor Fisher, formerly Associated Press
Frank Folwell, *USA Today*
MaryAnne Golon, *Time*
Liz Grady, formerly *National Geographic*
Randall Greenwell, *San Francisco Chronicle*
C. Thomas Hardin, formerly *Louisville Courier-Journal*
Kathleen Hennessy, *San Francisco Chronicle*
Scot Jahn, *U.S. News & World Report*
Steve Jessmore, *Flint Journal*
John Kaplan, University of Florida
Kim Komenich, *San Francisco Chronicle*
Eliane Laffont, *Hachette Filipacchi Media*
Jean-Pierre Laffont, *Hachette Filipacchi Media*
Andrew Locke, MSNBC
Jose Lopez, *The New York Times*
Maria Mann, formerly AFP
Bill Marr, formerly *National Geographic*
Michele McNally, *Fortune*
James Merithew, *San Francisco Chronicle*
Eric Meskauskas, *New York Daily News*
Maddy Miller, *People* magazine
Michelle Molloy, *Newsweek*
Dolores Morrison, *New York Daily News*
Karen Mullarkey, formerly *Newsweek, Rolling Stone, Sports Illustrated*
Larry Nighswander, Ohio University School of Visual Communication
Jim Preston, *Baltimore Sun*
Sarah Rozen, formerly *Entertainment Weekly*
Mike Smith, *The New York Times*
Neal Ulevich, formerly Associated Press

Website and Digital Systems
Jeff Burchell, Applications Engineer

Television Documentary
Sandy Smolan, Producer/Director
Rick King, Producer/Director
Bill Medsker, Producer

Video News Release
Mike Cerre, Producer/Director

Digital Pond
Peter Hogg
Kris Knight
Roger Graham
Philip Bond
Frank De Pace
Lisa Li

Senior Advisors
Jennifer Erwitt, Strategic Advisor
Tom Walker, Creative Advisor
Megan Smith, Technology Advisor
Jon Kamen, Media and Partnership Advisor
Mark Greenberg, Partnership Advisor
Patti Richards, Publicity Advisor
Cotton Coulson, Mission Control Advisor

Executive Advisors
Sonia Land
George Craig
Carole Bidnick

Advisors
Chris Anderson
Samir Arora
Russell Brown
Craig Cline
Gayle Cline
Harlan Felt
George Fisher
Phillip Moffitt
Clement Mok
Laureen Seeger
Richard Saul Wurman

DK Publishing
Bill Barry
Joanna Bull
Therese Burke
Sarah Coltman
Christopher Davis
Todd Fries
Dick Heffernan
Jay Henry
Stuart Jackman
Stephanie Jackson
Chuck Lang
Sharon Lucas
Cathy Melnicki
Nicola Munro
Eunice Paterson
Andrew Welham

Colourscan
Jimmy Tsao
Eddie Chia
Richard Law
Josephine Yam
Paul Koh
Chee Cheng Yeong
Dan Kang

Chief Morale Officer
Goose, the dog